GEORGE OHR

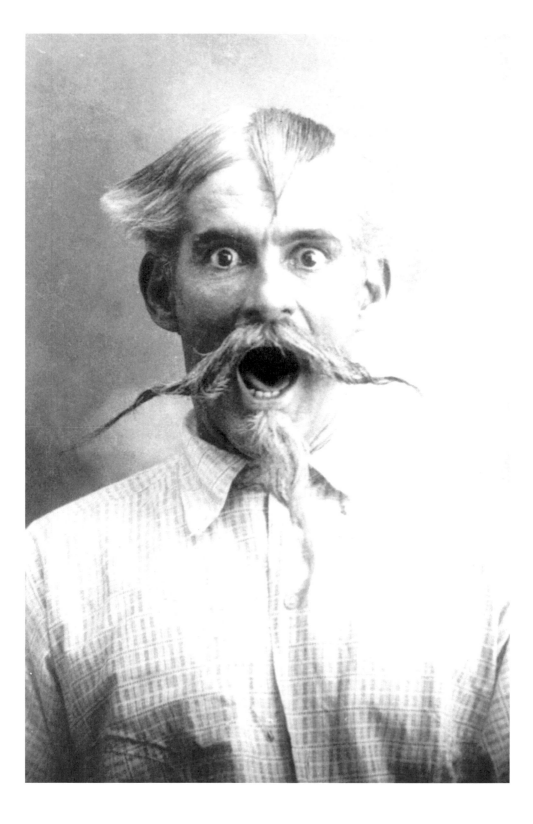

GEORGE OHR
Sophisticate and Rube

Ellen J. Lippert

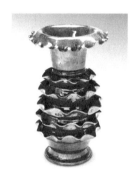 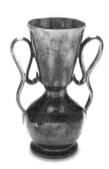

University Press of Mississippi
Jackson

www.upress.state.ms.us

Designed by Peter D. Halverson

The University Press of Mississippi is a member of the Association of
American University Presses.

Copyright © 2013 by University Press of Mississippi
All rights reserved
Manufactured in the United States of America

First printing 2013

∞

Library of Congress Cataloging-in-Publication Data

Lippert, Ellen J.

George Ohr : sophisticate and rube / Ellen J. Lippert.

pages cm

Includes bibliographical references and index.

ISBN 978-1-61703-901-0 (hardback) — ISBN 978-1-61703-902-7 (ebook)

ISBN 978-1-4968-5371-4 (paperback)

1. Ohr, George E., 1857–1918—Criticism and interpretation. 2. Art and so-
ciety—United States—History—19th century. 3. Art and society—United
States—History—20th century. I. Title.

NK4210.O42L57 2013

738.092—dc23

[B] 2013014727

British Library Cataloging-in-Publication Data available

Doug, Elias, and Adeline,

these stars are for you, my loves

CONTENTS

Acknowledgments ix

Introduction 3

PART I: OHR THE MAN

Chapter 1.
Queer Genius and Freakish Fool
Ohr in His Own Time 11

Chapter 2.
Make a Spectacle of Yourself
Ohr at World's Fairs and Expositions 22

Chapter 3.
Twixt Genius and Humbug
Ohr, Mass Media, and Self-Promotion 33

Chapter 4.
"Smart Aleck, Damphool Potter"
Ohr as a Southern Character 46

Chapter 5.
Real Head-Heart-Hand-and-Soul Art
Ohr, Socialism, and Individual Purpose 58

Chapter 6.
Beauty of the Grotesque
The Malformed, Marginalized, and Mudbabies 72

PART II: OHR THE POTTER

Chapter 7.
George Ohr, Art Potter 87

Chapter 8.
Ruffling, Crumpling, and Twisting
Ohr's Visual Vocabulary 101

Chapter 9.
Strategy and Meaning in Ohr's Pots 114

Conclusion 128

Notes 135

Bibliography 147

Index 156

ACKNOWLEDGMENTS

THE RESEARCH, COGITATIONS, AND THEORIES THAT CONSTITUTE THIS book have existed in one form or another, for one purpose or another, for more than a decade. Without the initial support of Dr. Henry Adams, it would never have come to fruition. Under his guidance, I was able to better identify and articulate why Ohr matters to me, to ceramicists, and to the art world at large.

Many thanks to Richard Mohr, whose encouragement and, at times, brutal honesty provided equal parts motivation, confidence, and appropriate mental anguish.

Thanks to *Style 1900*, which published parts of this book early on, and to the staff at the Biloxi Public Library, who graciously provided me with generous work space and answered all of my hounding research questions.

The staff members at the Ohr-O'Keefe Museum of Art in Biloxi, Mississippi, have illuminated many of these pages with photographs from their collection. Special thanks to Barbara Johnson Ross, who never failed to provide me with whatever it was I needed. Her patience and tolerance were not deserved but much appreciated.

Thank you to Dick Walcott, Tressa Snyder, Alan Morrill, and the entire staff of Thiel College's Langeheim Memorial Library, who never encountered an article, image, or piece of information they could not track down. Their interest and curiosity never failed to encourage me.

Thanks to the British Museum, the Chicago History Museum, the Wisconsin Historical Society, the Roycroft Campus Corporation, and Bonnie Campbell Lilienfeld at the Smithsonian Museum for providing me with many necessary images for this book. Special thanks to David Rago for his limitless generosity and to Anthony Barnes at Rago Arts and Auction

Center, who graciously helped with my repeated and never-ending image requests.

The publication of this book provided me the opportunity to finally come in contact with Marty and Estelle Shack, whose knowledge of Ohr and generosity are matched only by the exquisite examples in their collection.

Thanks to my sister, Barb, who was and is my earliest, most enduring, and most necessary ally. Thanks to my mom and dad, who never said I couldn't or shouldn't. Finally, and most importantly, thank you to my husband, Doug, and our children. For me, they make anything possible.

GEORGE OHR

INTRODUCTION

THE STORY IS LEGENDARY: IN THE 1960S ANTIQUES DEALER JAMES Carpenter stumbled upon the boxed-up remnants of Biloxi potter George Ohr's clay creations stored by his surviving children, Ojo and Leo, in their garage in Biloxi, Mississippi. Gambling on their worth, Carpenter mortgaged his home, purchased all six to ten thousand pieces and made history by obtaining by far the largest collection of his works. Regarded as an eccentric in his lifetime, Ohr has since emerged as a major figure in American art.[1]

In the 1960s ceramic market, Ohr's radical bulging, collapsing, crusted, and bruised forms were difficult to categorize or define (plates 1 through 4). They were radically different from the traditional and graceful vessels of his more popular contemporaries like Adelaide Robineau, Susan Frackelton, Rookwood Pottery, Teco Pottery, and Newcomb College Pottery. Nor could Ohr's constructions be categorized as folk because they were too strange and impractical.

Thanks to Carpenter's astute promotional strategies, today Ohr's works are considered fine art. His pots can be found in the collections of figures on the cutting edge of modern art, such as Andy Warhol and Jasper Johns. Johns has featured Ohr's pottery in his paintings *Ventriloquist*, *Racing Thoughts*, and *The Seasons*. The Metropolitan Museum of Art has recently acquired a significant collection of his pottery for its American wing. As appreciation for, and value of, his work increased, Ohr's artistic reputation

soared from oblivion to amazing heights. He has even been called "America's first and foremost art potter."[2]

Such attention has encouraged research into the background of his work, but it has also colored the tone of most major scholarship. Ohr is widely regarded as the "solitary genius from Biloxi," whose "unparalleled vessel-sculpture . . . spoke a rich though arcane language that would not become aesthetic currency for well over half a century." He borders on the supernatural with his ability to anticipate, perhaps even predict, future art movements. Indeed, he is considered to be "the most prescient prophet in Western ceramic art," and the world "took nearly half a century to catch up with him." In short, scholarship has invoked the word "genius" to imply that Ohr's abilities were inexplicable and perhaps God-given; that he existed outside of and was misunderstood by common society; that his anticipation of future art movements was magical and clairvoyant; and that his work was superior to and unaffected by the context in which it was made.[3]

Though captivating, such extravagant claims have eclipsed sober analyses of the actual context in which he worked. The intention of this book is to bring Ohr back to earth and explore how his artistry drew on themes within nineteenth-century culture and combined them in unusual ways.

FACTS OF A UNIQUE PERSONALITY: OHR'S LIFE

To be fair, piecing together Ohr's life is a tricky proposition. A handful of articles, photographs, inscribed pots, and a single three-page autobiography ("Some Facts in the History of a Unique Personality") in large part constitute extant primary evidence. Ohr's biography has been artfully relayed by Eugene Hecht and others, and there is no need to fully recount it here. What follows are the known facts of Ohr's life, often told using his own peculiar style of writing and voice.

Ohr, born in 1857, was the son of second-generation immigrants—his mother German and his father an Alsatian blacksmith. He was the second of five siblings and felt out of place, describing the group as "3 hens, 1 rooster and a duck—I'm that duck."[4]

He held a number of jobs but found his true calling upon receipt of a letter from family friend and potter Joseph Meyer offering "$10 a month and a chance to swipe a trade." After receiving the invitation Ohr "stole a freight

train at 11:65, and p.d.q went under the night and over terra firma" to New Orleans, where Meyer worked.[5]

By 1883 Ohr constructed a studio and launched his own business in Biloxi while still working with Meyer in New Orleans. During this time Ohr also began attending fairs and expositions, a practice he continued into the twentieth century.

Curiously, 1883 is when his brief autobiography ends. It must have been written at least as late as 1896 or 1897, as he describes Meyer as "the Sophy Newcome [Newcomb] potter" and he was not employed with Newcomb Pottery until 1896. Ohr's retelling was not published until 1901, yet it omits the major events of his life subsequent to 1883. And they were many.

On 15 September 1886, Ohr married seventeen-year-old Josephine Gehring. Sadly, their first child, Ella Louise, born in 1887, died six months later. Their second child, Asa, was born in 1889 but died in 1893. Only five of George and Josephine's ten children would survive them. In 1894 the Ohrs suffered more hardship when a fire, originating at the Bijous Oyster Saloon, consumed more than twenty businesses, including Ohr's. The pots damaged in the flames were referred to by Ohr as his "killed" or "burned babies."[6]

This setback did not discourage Ohr for long. Later that same year he constructed a new studio, a five-story pagoda oddly juxtaposed with a wrap-around porch, common in antebellum southern architecture (plate 5). Set in a neighborhood of thoroughly conventional buildings of no particular distinction, it quickly became a peculiar but beloved landmark for tourists. Ohr adorned the structure with signs proclaiming his own greatness (plate 6) and famously predicted, "When I am gone . . . my work will be praised, honored and cherished. It will come."[7]

In 1908 Ohr stopped producing work. With money he received from an inheritance, Ohr bought a car dealership and went into business with his sons. He boxed up his wares and tucked them away in the attic, where they were found more than half a century later by Carpenter. Exactly why he stopped producing in 1908 is unknown, though some speculate it was weariness from rejection, the loss of loved ones (both his parents had died and he had buried four of his ten children), or simply old age.[8]

In the last year of his life his health began to decline, and in 1918, at the age of sixty-one, he died of throat cancer. On 8 April 1918 the front page of the *Biloxi Daily Herald* reported his death with the headline "Pottery Wizard Dies in Biloxi" and then observed: "Mr. Ohr had been in poor health for

years and recently his ailment became more serious. He sought relief at New Orleans and elsewhere, but failed to find health."

Ohr's obituary claims that "his fame as a fashioner of pottery spread to all parts of the United States." Journalist Della Campbell McLeod asserts that "artists from all parts of the world make pilgrimages to this queer little spider-webbed rookery," yet fails to identify any of these putative visitors.[9]

Had Ohr achieved fame? Certainly, but how much is a source of debate that will be discussed in the following pages. Nonetheless, the fact that his death was front-page news indicates his importance to the town. The choice of the word "wizard" is likewise telling. Whether or not they entirely believed it, Biloxians chose to celebrate Ohr as numinous and magical.

OHR'S GILDED AGE

The historical moment that Ohr inhabited was tumultuous, exciting, and inexorably a formative force in his life and work. As gilding is a thin covering masking a baser material, so too was the rampant corruption of the last quarter of the nineteenth century concealed by wealth and extravagance. The Gilded Age was the period that witnessed the beginning of large-scale corporations and mass production, as well as the advent of modern mass culture—new methods of advertising and commercial display, and a proliferation of newspapers, magazines, and books. Paradoxically, this period of increased material well-being was also one of social turmoil and spiritual crisis. Various threads of individualism endeavored to combat the growing mechanization of society while diverse models of socialism sought to redress the unequal distribution of wealth. New scientific theories, such as Darwinism, undermined traditional religious beliefs, yet figures such as Ralph Waldo Emerson and Henry David Thoreau struggled to restore spiritual values to daily life. In the artistic sphere, "decadents" such as Oscar Wilde, J. K. Huysmans, and the Symbolists rejected classicizing idealism and projected a more disturbing view of reality, which focused on irrationality, corruption, and the strange beauty of diseased things.[10]

The study presented here does not survey all the events and conflicts of the Gilded Age but does identify and examine specific cultural changes that had the most impact on Ohr. These include developments in visual display and the altered role of artists; the South redefined by its defeat in the Civil

War and the North's emerging industrial and cultural power; enhanced interest in handicrafts as an alternative to widespread mass production; socialism, communism, and other conceptions of social thought seeking to remedy worker exploitation; and new assessments of morals and beauty as a result of collapsed ideals.

This book is divided into two parts. The first considers Ohr the man and how cultural events and themes of his specific historical moment affected him. The second investigates key figures in his life while considering closely the physical form of his pottery. The broader cultural sphere outlined in the first half is used to illuminate the smaller sphere of his personal life and experiences. Together they reveal that Ohr's creations are cultural expressions that probe the tensions within Gilded Age society and contradict the romanticized and fabled caricature that currently dominates Ohr scholarship. Far from the isolated genius with inborn talent, Ohr was a sophisticated, aware, and paradoxical artist firmly entrenched within his late nineteenth-century milieu.

PART I
OHR THE MAN

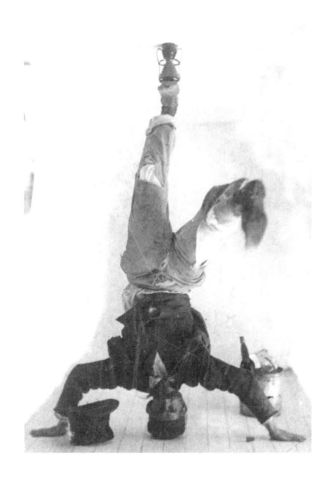

Chapter 1

QUEER GENIUS AND FREAKISH FOOL

Ohr in His Own Time

CURIOUSLY, THE FIRST MAJOR PIECE ABOUT OHR WAS NOT A JOURNALISTIC account but a work of fiction, *The Wonderful Wheel*, written by Mary Tracy Earle and published in 1896. Earle was the daughter of Parker Earle, horticultural director at the New Orleans Cotton Centennial Exposition in 1884, which Ohr attended. Two of Earle's stepsisters would eventually marry Peter and Walter Anderson, who, along with their brother James, would build the internationally recognized Shearwater Pottery located in Ocean Springs, Mississippi, about twenty minutes from Biloxi. Earle's family also owned property in Ocean Springs, where Mary Tracy Earle often vacationed. It was here that she wrote *The Wonderful Wheel*. These associations gave Earle firsthand knowledge of the local lore that surrounded Biloxi's famous character.[1]

The Wonderful Wheel tells the story of widowed potter Giacomo Barse and his daughter, Clothilde, who live as outcasts in the small Creole town of Potosi. The superstitious residents fear and reject Barse because of his "hoodoo" wheel, which has been seen to glow at night. When Barse breaks his leg and becomes bedridden, he is forced to engage the community for the sake of his daughter. The local doctor and a distant cousin offer to care for Clothilde and in so doing discover that Barse's wheel is not black magic, but merely covered with a luminous paint, causing it to glow at night. When a yellow fever epidemic breaks out, during which the doctor falls sick, it is up to Barse to quarantine and nurse the rest of the community. He does so

successfully, thus gaining social acceptance and a loving environment for his daughter.

Barse's "strange flashing black eyes, and a black mustache so long that he draped it over his ears when he worked" patently mirror Ohr's likeness. Other similarities link the two characters. Like Barse, Ohr had achieved localized fame for his assistance during a yellow fever epidemic. Also analogous is the painful rejection and isolation Clothilde and Barse experience at the hands of the unwelcoming community. So far as we know, Ohr was never described as supernatural or accused of practicing black magic, but he was perceived as an eccentric and a "crank" by both his neighbors and the art world. Though Barse was a product of Earle's imagination, Ohr was her muse. Subsequent journalistic articles about Ohr adopted these physical and emotional characterizations and reprised them with virtually no changes.[2]

In 1897 the first known nonfiction article on Ohr, "A Biloxi Pottery," was published in *Brick* magazine. Like most articles written in Ohr's lifetime, the author emphasized Ohr's "no two alike" philosophy and prideful individuality but offered no critical analysis of his works. The pottery is treated as little more than a gimmick to attract tourists: "But of all the points of interest and historic scenes which attract the thousands of yearly visitors to Biloxi, the best known and most fascinating is the Biloxi Pottery and its entertaining potter." In the final lines of the article the author gave brief mention of three Ohr pots, describing the forms as "graceful" and the glazes as "dainty."[3]

In 1909 journalist Della McLeod reiterated the themes laid out in "A Biloxi Pottery," again paying more attention to Ohr's personality than to his work. She too saw him as a tourist attraction, urging visitors to complete their trip to Biloxi with a visit to the town's most eccentric citizen. But her descriptions of Ohr's character are more acerbic. To McLeod, Ohr is a "queer genius" and "freakish fool" who spews forth "philosophy and poetry" along with some "senseless twaddle." She did, however, mention his massive collection of more than six thousand pots.[4]

Authors of other early articles likewise found little beauty in Ohr's creations. Ethel Hutson, writing for the *Clay Worker*, branded his pots "ugly," "grotesque," and "bizarre." Ohr himself was described as "a little hysterical" and "controlled by occult forces" in a facetiously titled article, "High Art in Biloxi, Miss."[5]

Even reference books regarded Ohr and his work with a sarcastic edge. Though deemed significant enough to warrant an entry in William Percival Jervis's *The Encyclopedia of Ceramics* (1902), Ohr is glibly dismissed: "Did we but accept him at his own estimate he is not only the foremost potter in America, but the whole world. He says so and he ought to know."[6]

In each of the preceding examples, and many more not cited here, the authors' respective estimations are based on Ohr's eccentricity and disregard for accepted styles (either ceramic or literary). The authors appear personally offended by Ohr's lack of sophistication. Assessments of his wares are often afterthoughts, offered as little more than visual justification of Ohr's odd writing and disposition. Though many early reviews were negative, and even cruelly taunting, Ohr at least managed to stir up publicity and attention. Popular consensus seems to be that Ohr was not an artist, yet their collective reproach inadvertently establishes Ohr's gifts as a marketer and self- promoter.

AN "UNCULTIVATED GENIUS": POSITIVE CONTEMPORARY REVIEWS

Not all critics were dismissive of Ohr's wares; and some, refreshingly immune to Ohr's oddities, focused their attention on his pottery. L. M. Bensel, writer for *Art Interchange*, wrote a surprisingly judicious and analytical review of Ohr's work without allowing popular impression to interfere with his observations. Bensel noted Ohr's "experiments in metallic glazes" and his "penchant for a dull, soft green" as well as "the darker blues and dragon's blood" in "many of his finer pieces." He even went so far as to consider the type of clay Ohr used, dug from the banks of the Tchoutacabouffa River, and concluded that it allowed Ohr to produce "some of the softest and richest effects imaginable." Bensel provided the most accurate catalog of Ohr's forms in any literature up to that point: "With pitchers he is prone to bowl shapes, bent in trefoil pattern, as well as with cups and saucers. There are no 'trimmings' to Ohr's work." Though he felt that "the man is evidently an uncultivated genius, whose work runs to eccentricity rather than to individuality," Bensel determined that Ohr's work has "an art and a grace of its own that must be recognized."[7]

Edwin Atlee Barber, noted authority on pottery and author of the seminal *Pottery and Porcelain of the United States*, included Ohr in his 1902

edition, describing his style as "one of the most interesting in the United States." Barber observed the extreme thinness of the pieces and the great variety of forms, concluding that "the principal beauty of the ware consists in the richness of the glazes, which are wonderfully varied, the reds, greens and metallic luster effects being particularly good." Ohr, who claimed to emphasize form over finish, would have disagreed. Barber, however, captured the essence of Ohr's philosophy, stating that "no two pieces are precisely alike" and "all of [Ohr's] methods and processes are entirely original." Notably, Barber did not include an entry on Ohr in the two previous editions of his book, 1893 and 1901, suggesting that by 1902 Ohr was beginning to make a name for himself.[8]

History has celebrated Susan Frackelton's many accomplishments, including her hand-decorated porcelain, the establishment of her own porcelain company, the invention of the first portable gas-fired kiln, and her tenure as president of the Wisconsin School of Design. In the late 1890s she collaborated with Ohr on at least three pieces: a loving cup, 1899 (plate 7), a green bowl, 1899 (plate 8), and a bisque pitcher (plate 9). Frackelton even experimented with Ohr's practice of throwing the clay extremely thin. In 1900 she included Ohr in the Milwaukee Arts and Crafts Biennial, calling his work "remarkable for its eccentricities of form and brilliant glaze," though she seemed especially impressed by his "devotion, so heroic in sacrifices to its ideal of truth in art," in the face of "hampered," "cramped," and "unpropitious circumstances." Ohr and Frackelton were truly contemporaries, both learning to use clay within five years of each other and participating in many of the same expositions, including Atlanta's International Cotton Exposition, Chicago's World's Columbian Exposition, and the Pan American in Buffalo.[9]

WILLIAM KING, PUBLICIST AND ALLY

Despite Barber's reputation, William King is arguably the critic who did the most to further Ohr's career. King reported on Ohr's pottery making but, more importantly, provided a means by which to showcase his peculiar brand of writing and public image. Through a series of reviews and responses, Ohr and King played off each other like Abbott and Costello, a memorable and revealing routine staged in the pages of the *Illustrated Buffalo Express* and the *Crockery and Glass Journal*.

Professionally, King was a writer for the *Illustrated Buffalo Express* and business manager of the Catholic Union and Times. His interest in ceramics was purely recreational, though he did amass a collection of more than 350 objects from Asia, France, England, Germany, and Austria. His main focus, however, was on what he considered American pottery, including a wide range of ceramic production from Native American cultures, Rookwood, Chelsea, Trenton Belleek, and others, though none from Ohr. However amateur, he was recognized as a local expert and named to the Committee on Fine Arts of the Pan-American Exposition, held in Buffalo in 1901. In April 1900 King was made chairman of the annual pottery and glass exhibition of the Buffalo Society of Artists, which included works by Ohr. It is not known how King became aware of Ohr's work, though he was friends with both Edwin Atlee Barber and William Percival Jervis.[10]

King's first article on Ohr, "The Palissy of Biloxi," appeared in 1899 in the *Buffalo Express*. In it King retraced much of what had been reported previously. He offered a history and development of the Biloxi Pottery, including the 1894 fire that leveled everything Ohr had achieved. King, like the others, spot lit the boastful signs hanging around Ohr's newly built pagoda studio (plate 6), such as

UNEQUALED! UNRIVALED! UNDISPUTED!
GREATEST ART POTTER
IN THE WORLD!

George E. Ohr, Delieator [Delineator] in Art Pottery.[11]
Magnum Opos, nulli secundus, optimus cogito, ergo sum

[A sign over the door read:]
Erected in 1888, burned out and rebuilt in 1894
by the Unequaled Variety Potter, Crank, etc.

There is no record of King having visited Ohr's studio, so his observations regarding such rely heavily on other sources.

King's analysis of Ohr's wares was informative, describing the glazes as "fairly riotous in rich coloring. There are reds and greens, blues, browns and yellows—in fact every conceivable color is to be found. . . . His metallic glazes are veritable ceramic triumphs." More insightfully, "the shapes themselves are what will strike the 'rank outsider' with greatest force." King

concluded, "It may be inferred from all that is said above, that the Biloxi pottery has little or no claim to real artistic value, but, indeed, the inference would be an error. . . . Mr. Ohr is indeed a genius, an odd one, I grant, but well worthy of more space than I have given him. He would be a most attractive adjunct to our Pan-American Exposition." Most fairs, in their effort to underscore the cultural and technological sophistication of the United States, would have shied away from the odd backwater potter. Yet King, as Buffalo's local ceramics expert and committee member, used his status to illuminate Ohr's artistic and technical talents.[12]

To that end, King published "Ceramic Art at the Pan-American Exposition" in the *Crockery and Glass Journal* (1901), written from his position as Fine Arts Committee member. King was more or less stumping for the ceramic artists who would be featured when the exposition opened in May of that year. Rookwood, Grueby, Susan Frackelton, Volkmar, and Newcomb Pottery are all surveyed with King's predictions for success and assurances of the highest artistic degree.

Ohr occupies far more space within the article than any other potter, all the better to adequately illustrate his interesting personality. King's first statement on Ohr is enticing, "We will not only have an exhibit of Biloxi pottery, but we may have the Biloxi potter in person," and thus introduces Ohr to the American public not through his extraordinary ceramic pieces but through his peculiarities. Later in that section King devotes an entire column to the reproduction of a missive Ohr sent to Major A. M. Wheeler, prefacing it with "those who do not know of this quaint Southern product may get an inkling of his personality in this extract." An excerpt, quoting Ohr, reads:

> *I have ben to the Falls, and all over this U.S. A. of mine (and yours) and can write you a letter four miles long, one inch thick with 99 pounds pressure to the square inch, all pure unshrinking wool, without any crackage, breakage, all tonnage prepaid and no white feathers, and will try to make this short, stiff, business like and style to suit the occasion, as I am not in Fluer de lis [sic] fix to purchase sanding room for a clay baby (Pat) or myself, I'll proceed to talk (or write) $$$ acts . . . if I was the President of the Pan-American I would go to Paris or any country—one better—on an original art potter and make him (me) an exception, on a display of rarities that do exist and in a reality. Americans want every little and big object, article, machine, racers,*

etc., the greatest, and want it solid, pure, original and genuine America, and I can hold my end up till the cows come home on my specialty.[13]

As with his other statements, it takes close reading to construe his meaning. Ohr begins colorfully attesting to his diverse experiences and knowledge, which extend across the entire country. Rather than burden the reader with extensive detail, however, Ohr decides to get to the point ("short, stiff business like and style to suit the occasion"). He confesses that he did not have money to pay for a spot at the Pan-American Exposition and is not a "Fluer de lis," that is, some fancy French potter. Nonetheless, Ohr challenges Major Wheeler to find a more original potter ("go to Paris or any country . . . on an original art pottery and make him (me) an exception, on a display or rarities that do exist and in a reality"). Ohr suggests Wheeler would be smart to grant him a free spot since he is exactly the sort of American artist such fairs were created to showcase. Americans, Ohr insists, "want it solid, pure, original and genuine America," and thus, when placed in competition with the Europeans, "I can hold my end up till the cows come home."

Targeting Major Wheeler was an especially mindful strategy given the unfolding of recent events. Major Algar M. Wheeler was superintendent of the Department of Manufactures at the Buffalo Pan-American Exposition and was appointed to the position on 28 May 1900, only a few months before this article was published. A well-known Buffalo citizen, Wheeler had a distinguished record of service in the Civil War, served as assistant postmaster of Buffalo, was president of the Exhibitors' Club at the Atlanta, Nashville, and Omaha Expositions, and, during his tenure at the Pan-American, served as president of the National Association of Exhibitors.[14]

In November 1900 the *Buffalo Enquirer* announced that Wheeler had decided to devote display space to both "fine art" and "industrial products." Art industrial products he defined as "all work of an artistic character not included in fine arts." While today his two categories seem somewhat peculiar, Wheeler was, in essence, expanding the idea of creativity to include things, such as pottery, which were often left out in favor of the more popular painting and sculpture. His decision thus opened the door for Ohr to gain a major display of his work, and Ohr's letter was written with the goal of not only obtaining such as display, but doing so at no cost.[15]

King's attention garnered a lot of magazine space for the Biloxi potter and initiated the publication of a series of articles authored by Ohr. All three were published in the same journal in the same year (1901) and in this

way became a kind of miniseries, pitting the strange potter, George Ohr, against the art world.

Ohr's letter to Major Wheeler in "Ceramic Art at the Pan-American Exposition" is the first in the series. "Biloxi Heard From," a reprint of a letter Ohr sent to the editor of the *Crockery and Glass Journal*, follows. In it Ohr makes reference to two previous publications from the same journal as well as what seems to be King's first write-up of Ohr in the *Buffalo Express*. It is unclear which previous *Crockery and Glass* articles Ohr is referring to, as none have yet been discovered prior to 1901. Regardless, Ohr treats readers to the full palette of his eccentricity. From the outset he refers to himself as "one who is only and just a Potter" and extends an olive branch to the editor and King for a write-up he interpreted as less than complimentary. Ultimately, he concludes that their opinion of him is irrelevant as his pots speak for themselves: "I don't know if you are right or not on my pencil poking. But I know—and know it certain positively and sure—that the world of Pottery Lovers will never, never, and at no time know what I have and create untill some one gets or have what collection I have left of my lifes work in clay." Ohr correctly observes that this published letter "opens the way for more of [his] future sun shine and shadeing for publication," as later that year the *Crockery and Glass Journal* printed Ohr's first-person account, "Some Facts in the History of a Unique Personality," the final article in the series. Despite questions surrounding the authenticity of the events described therein, it remains a valuable document. Not only are examples of Ohr's writing few and far between, "Some Facts" is the only autobiographical statement that exists. Nor does it disappoint as it is infused with the same quirky language and grammar that audiences had become accustomed to.[16]

TO THE SMITHSONIAN: A SCATTERSHOT SAMPLE

Perhaps encouraged by the wave (or ripple) of publicity he had experienced in the last couple years, Ohr submitted a sample of eleven pots to the Smithsonian Institution in 1899, though they were not accessioned until 1986 (plate 10). While this might be seen as a rebuff, it was not unusual for the institution to be careless in its record keeping. It is notable that the pots were kept, rather than being returned or discarded. Unfortunately, no correspondence survives providing a record of the institution's reaction to

Ohr's unusual creations. Perhaps the most intriguing aspect of the episode is simply the nature of the work that Ohr sent to the Smithsonian, since he clearly intended this gift to serve as a summation of his life's work in clay.[17]

A good many of the pieces that Ohr sent are novelty wares: a puzzle mug, a log cabin, and a crumpled top hat. Ohr's choice to send such whimsical pieces to a national museum initially seems curious. Two motives can be proposed. One is that Ohr was proud to be associated with a form of pottery that had popular and rather low-class associations—in other words, he was proud of his working-class identity. The other is that he recognized this was a mode of work in which he had few rivals, and thus one that gave him a solid claim to be represented in the museum, even if in a low-class category.

In addition to his novelty wares, Ohr included five vases and three bowls that were very different in character. The first vase was glazed in an earthy color similar to the puzzle mug. While Ohr included some dimpling on the body, this piece was not subjected to any extreme gestures or motifs. Another is tall, slender, and classical, save the twisted neck and speckled, multicolor finish that put the pot closer to one of Ohr's more extreme wares. A third sample is also tall, but blood red with a deep twist in the body. While one does not sense that it is out of control, Ohr's formal choices make it one of the more enthralling works. The fourth is two intertwined necks stemming from a dimpled body, all overlaid with a metallic glaze. The simple coating smartly draws attention to Ohr's manipulations of the form. The final example is also blood red, but torn, pinched, battered, and asymmetrical.

The cohort of bowls likewise represents a variety of Ohr's talents. One undulates along the rim while the body is pinched and dimpled. The shape is fluid and loose, but the mottled red color makes the work resemble a bleeding, mangled limb or something similarly grotesque. Another, bearing a metallic glaze, has a thin ruffled rim that looks sharp enough to slice flesh. The final and perhaps most extravagant of the collection contrasts a round foot with a diamond-shaped mouth. The dilapidated form has a pulled rim that flops over the base and a ragged tear in the side.

Collectively, the works demonstrate a broad range of Ohr's techniques, from fairly humble, straightforward shapes to more unusual ones. Whether Ohr hoped they would remain as a prearranged group or was risking a scattershot sampling in the hopes that one would strike a curator's fancy is unknown.

More than a year later, in 1900, Ohr sent an umbrella stand, also now part of the Smithsonian's collection (plate 11). It is inscribed with the following:

Biloxi, Miss. Dec. 18, 1900. To the Smithsonian Wash. As kind words and deed never die, such words and deed are fire, water and water acid. And time proves when recorded on mother earth or clay. This is an empty jar just like the world solid in itself yet full on the surface. Deed and thoughts are but the instigation and shadows fade and disappear when the sun goes down. Mary had a little lamb Pot Ohr E George has had a little potter now where is the boy that stood on the burning deck. This pot is here and I am the potter who was. G.E. Ohr

This umbrella stand, sent more than a year after the original eleven samples, seems to signify a pessimism creeping into Ohr's outlook. He begins by declaring that kind words and deeds are never forgotten and for this reason are similar to fire, water, and acid, things that are elemental and difficult to destroy. He notes that such words and deeds are even more indestructible when burned into clay, which could also be understood as a variation on the vanitas theme of "life is short, art is long." At this point the statement shifts direction and a tone of bitterness slips in. He declares that the world, like this jar, is seemingly full, but is actually empty. Like shadows disappear with the sun, so too will thoughts and actions unless they leave some tangible trace. Clear meanings eventually dissipate into wordplay. Rather than signing himself "George Ohr," he becomes "Pot Ohr," that is, his name dissolves into his work as a potter. Ohr states, "Mary had a little lamb Pot Ohr E George has had a little potter," and questions, "now where is the boy that stood on the burning deck." The boy on the burning deck may allude to a sentimental poem of the time about a boy who perishes on a burning boat and at some level may refer to the child George Ohr, who has grown. However, the missing "little potter" and the "burning deck" more than likely refer to significant losses in Ohr's life. The first is the devastating 1894 fire. More tragically, by 1901 Ohr had lost two children: his first child, Asa, born in 1889, died in 1893; and Flo, born in 1897, died in 1900. He ends by expressing the desire that the pots will serve as a memorial to his life when he himself has passed away. At this time Ohr was nowhere near death, living for another eighteen years. What is more, he did not stop potting until around 1907. However, these final words reflect the discouragement that he

was beginning to feel. The common denominator of all these statements is their inquiry into the transient and the permanent. Ohr evidently hoped that his gift would earn him a lasting place in the national museum and would carry on his memory beyond his death.

From the beginning, articles constructed, and Ohr encouraged, an image based on his eccentricity, both in appearance and the written word. Meanwhile, his pots were treated as offshoots of his personality rather than objects deserving of critical attention in and of themselves. In person, Ohr was no different.

Chapter 2

MAKE A SPECTACLE OF YOURSELF

Ohr at World's Fairs and Expositions

IN THE MODERN ERA, MOST ARTISTS HAVE ACHIEVED A REPUTATION through art galleries and museums. Ohr, however, never showed his work in a gallery, and his attempts to place his work in institutional collections did little to advance his career. Instead, Ohr exhibited in a number of major fairs during his lifetime, including the following:

1884, World's Industrial and Cotton Centennial Exposition, New Orleans;
1893, World's Columbian Exposition, Chicago;
1895, Cotton States and International Exposition, Atlanta;
1900, National Arts Club, New York;
1900, Exposition Universelle, Paris;
1901, Pan-American Exposition, Buffalo;
1901, Providence Art Club of Rhode Island; and
1904, Louisiana Purchase Exposition, St. Louis.

Reveling in national achievement, world's fairs showcased the many ideologies and anxieties particular to the late nineteenth and early twentieth centuries. The diverse masses they attracted demanded sellers and participants to creatively and actively present and situate themselves within the bustling throngs. Steeped in the phenomena of these celebrations, Ohr applied the lessons he learned to his livelihood.

DIVERSITY AND THE ANGLO-SAXON PROGRAM

World's fairs had tremendous cultural influence across all classes of society in the late nineteenth and early twentieth century. Between 1876 and 1916, nearly 100 million people visited the international expositions held at Philadelphia, New Orleans, Chicago, Atlanta, Nashville, Omaha, Buffalo, St. Louis, Portland, Seattle, San Francisco, and San Diego. Each celebrated a particular instance of American bravery, scientific vision, natural resources, or economic achievement. New Orleans' World's Industrial and Cotton Centennial Exposition (1884–85) celebrated the 100th anniversary of the cotton industry, and Chicago's World's Columbian Exposition (1893) honored the 400th anniversary of Columbus's discovery of the New World. In 1896 Buffalo harnessed the power of Niagara Falls to provide low-cost electric power and boasted of it at their Pan-American Exposition (1901). And the Louisiana Purchase Exposition (1904) in St. Louis commemorated the centennial of the 1803 land purchase.[1]

The years in which world's fairs enjoyed the greatest popularity were filled with significant conflict. Industrialization, increasing class inequality, social reform movements, various financial depressions, and a growing consciousness of global diversity all contributed to the tension within this period. International expositions, however, placed all these developments within an optimistic framework. In effect they were "blueprints of future perfection." Through a program that linked progress and white supremacy, Americans' anxiety was alleviated and their national identity reaffirmed.[2]

A chief function of world's fairs was to herald the latest scientific, artistic, and cultural innovations. As a corollary to this, they were also commercial forums in which to showcase new products. Finally, they promoted both world trade and colonialism by serving as a meeting ground for the globe's diverse cultures. Consequently, the expositions in the United States often had an "educational" component aimed at introducing Americans to African, Asian, and Latin American customs.

Though claiming evenhanded cultural exchange, most displays promoted ethnic stereotypes and colonialist attitudes. For example, exhibits often portrayed Asian or African civilizations as "primitive" and traced an evolutionary progression that culminated with American white supremacy. The New Orleans exhibition in 1884–85, which Ohr attended, featured a fifty-foot giant globe that rose above the show floor. Its transparent crystal

sides were etched with outlines of continents. The interior was designed by Smithsonian ethnologists to feature the products of "heathen lands," such as "the exquisite handiwork of the semi-barbarian of the distant Orient." According to one account, the globe "was a perfect textbook of the habits, modes of life, social and political, of the countries over the seas."[3]

Along with promoting Anglo-Saxon supremacy, world's fairs championed more industrialized regions. America's North was therefore held in higher esteem than its South. Between 1881 and 1918 there were seven expositions held in six southern states, compared to eleven in nine northern states. While this ratio is not egregiously disproportionate, it is striking that nearly all of the exhibits at southern shows came from the North or from Europe, not from the South. The arts especially were subject to this incongruity since most southern folk arts were considered crude, old-fashioned, and unworthy of inclusion. At the Atlanta Cotton States and International Exposition of 1894, four-fifths of the art displays came from New York and Philadelphia, and the remainder from cities outside the cotton states. The breakdown of art exhibits is as follows: 426 in the Department of Fine Arts came from New York, 178 from Pennsylvania, 28 from France, 27 from Holland, 15 from Italy, and a solitary exhibit from a southern state, Georgia.[4]

To thwart the conception of the South as antiquated and largely irrelevant, certain business leaders promoted the notion of a "New South" dedicated to advancement and patriotism. Historian John Findling likens its fervor to the "Born Again Christian movement of our day." Supporters sought to purge southerners of timeworn divisive disputes and make them instead devote themselves to "commerce and industry—in a word, progress."[5]

This energizing new image was driven by men whom Findling describes as "New South zealots." They include F. C. Morehead, Vicksburg editor and president of the National Cotton Planter's Association; Edmund Richardson, largest cotton planter in the United States; and Major E. A. Burke (Bourbon-Redeemer Democrat), treasurer of the state of Louisiana and editor of the *New Orleans Times-Democrat*.

Their New South agenda emphasized the region's natural resources and importance to trade, citing its abundant plantation land and numerous ports. Aware that the "Negro Question" at times cast negative light on the South, displays in southern expositions attempted to demonstrate the vital role that African Americans played in the southern economy: "Where the directors of the Philadelphia and Chicago expositions had been ambivalent

toward black exhibits, if not adamantly opposed, the directors of the southern fairs established Negro departments to illustrate the compatibility of blacks and whites in the South." It was at Atlanta's 1895 Cotton States and International Exposition that Booker T. Washington delivered his famous Atlanta Compromise speech. Like five fingers of the same hand, blacks and whites should embrace their distinct but equally important roles within the same larger system.[6]

Fairs also exposed Ohr to a wide range of artistic trends, in addition to the frank Eurocentrism. The Centennial Exposition of 1876 in Philadelphia is often cited as the first instance in which Americans saw the full range of French and Asian styles of pottery, as well as new directions in painting, such as Impressionism or Symbolism. The Chicago World's Fair (1893), which Ohr participated in and attended, was notable for a particularly large group of stylistic examples, ranging from the academic work of William-Adolphe Bouguereau and Jean-Léon Gérôme to more innovative examples by James McNeill Whistler, Childe Hassam, William Merritt Chase, Elihu Vedder, and Mary Cassatt. Ohr's work was already unconventional, yet he was undoubtedly inspired by the many novel artistic styles.

The Eurocentric program of shows effectively evoked a division between the normal and the Other, the mainstream and the marginal. It was clear which group Ohr fell into. Later chapters will explore how Ohr cultivated his "otherness" for advertising means and also how his personal and spiritual philosophy, which embraced the outcast and lesser of society, was manifest in his pottery.

THE MIDWAY: SIDESHOW STAGE

While his work was sometimes exhibited in the central display area, Ohr devoted just as much, if not more, energy to the midway. At the Cotton States and International Exposition in Atlanta, Ohr positioned himself on both the midway (plate 12) and in the machinery building (plate 13). The former post was geared toward entertaining the public and selling his wares, the latter was intended to garner serious critical appreciation of his artistry and technique.

The midway was a standard feature of every major show: a sector set aside to provide visitors with carnival food, keepsakes, knickknacks,

musical performances, exotic dancers, ethnic villages, and other amusements. Crowds became lost among the banners and hawkers of this garish marketplace as salesmen, hucksters, and vulgar entertainers competed for their cash.

To a large degree this area was a business venture, a place for visitors to spend their money. The 1900 Universelle Exposition in Paris earned more than $700,000 in this section alone. But the midway was also intended to be educational, although in a less rigorous fashion. Here one would find a number of attractions that mixed ethnology and education with entertainment. On the Buffalo Pan-American midway, for example, the Esquimaux Village and Indian Congress exhibits competed with House Upside Down and Roltaire's Palace of Illusions. In Chicago, the midway was placed under the jurisdiction of the Department of Ethnology and Archaeology to lend it a degree of credibility.[7]

Fully embracing this carnivalesque pageantry, Ohr did not simply present his work: he used his booth to stage a performance. He adorned his space with large, boastful signs, a tactic similarly employed at his Biloxi studio (plate 6). From far off, visitors could make out a chaotic exhibit cluttered with bulky posters. Up close, these billboards declared Ohr's exquisite skills, inimitable creations, and challenges to prove him otherwise. His display at the Cotton States and International Exposition in Atlanta (plate 12) featured larger-than-life signage bearing such messages as:

<div align="center">

Biloxi
Mississippi
"Greatest" Art
Potter
On Earth
"You Prove the
Contrary"
GEO. E. Ohr

Biloxi Mississippi
Art and Novelty Pottery.
Geo. E. Ohr has challenged any
Potter on Earth in Variety Work.
Wonderfull Puzzling Trick cup
No Two Souvenirs on Earth Alike

</div>

Once in front of the booth, visitors were treated to a performance. Mustache tucked behind his ears, beard tied in a bow on top of his head, dark eyes flashing, Ohr would throw a lump of clay on the wheel and dazzle the audience with a myriad of forms: "First a flower pot, then a jar, next a jug with a cob stopper made of clay; form after form was brought out in rapid succession until finally it assumed the graceful outlines of a Greek urn."[8]

Most likely an idiosyncratic person even before his first exposition, Ohr clearly amplified his personality for the purposes of entertainment and attention. The competition of selling at such a demanding venue taught him to exploit the things that made him and his work different from everyone else's. Ohr fed off the festive atmosphere of the midways. His ability to transform a single piece of clay into shapes of varying sizes with different openings testifies to his profound throwing skills. He was tapping into the same amazement and disbelief that magicians and tightrope walkers depended on. His art pots display a similar daredevil thrill—thrown paper thin, twisted, crumpled, gravity defying, and alive.

While he exhibited scores of these fanciful vessels, Ohr had another line of clay goods that targeted the fair-going audience; they were most likely not interested in his more ambitious creations. The forms were often whimsical and vulgar—even obscene. They included coin banks (plate 14), log cabins (plate 15), creamers with sculpted feces at the bottom (plate 16), puzzle mugs (plate 17), cardholders (plate 18), brothel coins (plate 19), and other fanciful items. Ohr considered much of his handiwork to be more valuable than gold and was often reluctant to let it leave his studio. He had no qualms about parting with these knickknacks, however. Unfortunately, we have no records of what Ohr sold, or to whom. But since thousands of his art pots remained in his possession at his death, we can assume that he did not sell such pieces very often. Most of his artistically significant objects can be traced back to the family trove that Carpenter acquired. By contrast, his much cheaper trinket wares appear to have sold readily, and while many were probably broken or thrown away, they still frequently turn up at auctions and in local antique stores. That they are so common implies Ohr made them in vast quantities. His brothel tokens, coin banks, inkwells, and mugs are regularly available on ebay at prices much less than his one-of-a-kind wares.

Amid the hustle and bustle, haggling, lights, and noise sat George Ohr, performing amazing feats on his wheel while large signs proclaimed his superiority. By locating himself on the midway he was not only directly within

the flow of money, but also aptly situated among the other oddities. Rather than being part of the fine arts building, he was a sideshow gimmick, outside the ethnographic program and accepted norm. Ohr was keenly aware that his success depended on his difference from other potters.

VISUAL DISPLAY: AROUSING CUPIDITY

Ohr's visits to world's fairs and large cities like Chicago also taught him the importance of visual display. His second, pagoda-like studio (plate 5) reveals his obvious intent to astonish, especially when compared to his first studio (plate 20). An observer commented on its anarchic blend of architectural styles:

> *Architecturally, it is chaotic, having some of the characteristics of every well-known type of building except that which it might most readily be expected to have—the low pillared, balconied, Colonial house in which the South abounds. The ground floor suggests a log cabin, the upper ones a cross between a Chinese pagoda and a Russian country house, the whole the dream palace of a freakish brain. Needless to say, Mr. Ohr built it himself. And he's proud of it.[9]*

To make certain the building would not be missed, Ohr painted "Biloxi Art Pottery" across the front.

Also included in Ohr's new studio were multiple windows and doors on the ground level of the structure, perhaps informed by the latest trends in window display and merchandise design. Prior to 1880 department stores did not exist and shoppers relied on smaller or more specialized outlets for their needs. This would all change by the 1890s as cities brimmed with large, multi-floored, multi-windowed buildings, such as John Wannamaker's franchises in New York and Philadelphia. The appeal of these glass-sheathed edifices and the material desire they implanted were not limited to large northern cities; Wannamaker's ad, "Wannamaker on Advertising," appeared in the *Biloxi Daily Herald* in 1888.

Central to the proliferation of glass and display windows was "the desire to show goods off day and night through all possible means" and to intermingle "the application of color, glass, and light to create an extensive

public environment of desire." One is reminded of the intricate and impressive Christmas window decorations that have so infiltrated the American psyche that they are now a long-standing tradition. More than showcases of specific commodities, they are portholes to a fantasy world of snowflakes, goodwill, and abundant treasures that appeal to consumers' innermost longings. They create (and deign to sell) an image of contentment, success, leisure, and the American Dream.[10]

In the late nineteenth century two prominent journals were dedicated to the study and guidance of window and interior merchandise presentation: *The Dry Goods Economist* and Frank Baum's *The Show Window*. Baum would achieve greater fame for his later effort, *The Wizard of Oz*. Ohr's favored *Crockery and Glass Journal*, described as being "designed as much or more for the retailer as for the manufacturer," would have also discussed strategies for the visual display of merchandise. The culmination of Baum's expertise was his book *The Art of Decorating Dry Goods Windows and Interiors* (1900). Baum declared that the unique function of store windows is not to illuminate inner recesses, but to sell goods. A successful design was therefore unusual, distinctive, and capable of capturing the consumer's attention. Baum cautioned that merely crowding a space with articles was not nearly as effective as a "simple artistic arrangement of a few attractive goods." A "simple arrangement" could entail color theory, drapery, constructed backgrounds, mechanical operations, and dazzling light effects. He even recommended using the "Framed Form" to simulate a life-size picture. The ultimate goal was, of course, to embellish and enhance commodities. Though the illustrations of theories often appeared crowded with numerous components, his principle of design was still apparent—the individual objects are subordinate to an overall harmony. Baum insisted, "there must be positive knowledge as to what constitutes an attractive exhibit, and what will arouse in the observer cupidity and longing to possess the goods you offer for sale."[11]

Though Ohr's studio did not have show windows per se, the ground level was encircled by an inviting covered porch that sheltered numerous windows and large doorways, ultimately creating the same effect. Ohr provided visual accessibility to the interior of his workspace, where he employed many of Baum's recommended techniques. At first glance the interior may have appeared chaotic—vessels hung from the ceiling, lined the walls, and were even stacked on the floor (plate 6). However, this configuration was

purposeful, boasting the sheer variety and quantity of forms. Each occupied its own space, organized by size and/or type. There was no imbalance or fragility in the assembly; each piece was securely and solidly positioned.

It would have been easy for chaos to overcome the scene, but this was not the case. Harmony was achieved by the insertion of larger vessels at various locations that broke up the repetition of his customary four- to twelve-inch wares. Existing photographs of his workspace are in black and white, so his practice of color theory is hard to discern. Even so, knowing the array of unique glazes that constitute his oeuvre, it is not hard to imagine a room enlivened with vibrant colors. Baum's suggestion of using a frame to create a "life-size" picture was not ignored either. Instead of a gilded frame, however, Ohr employed two horizontally elongated signs—one at the ceiling and one at the floor. As a potential customer entered the room, he was overcome by a sea of pots "framed" by declarations of their greatness and uniqueness.

Though Ohr applied emerging visual design guidelines, he implemented elements that further distinguished his studio from the large glass casements of northern department stores. Show windows were meant to create a desire in potential consumers and also to advertise the glamour, beauty, and selection of products. Certainly, the configuration of Ohr's display embraced this principle. Yet it was of the utmost significance that the interior scene was not a model of a studio with mass-produced fabrications. Visitors observed the genuine workspace, the many one-of-a-kind objects, and, with Ohr's presence, the actual process of creation. Northern display windows did not offer what Ohr's pagoda gave people—the witness of authorship and the promise that these items actually delivered the preciousness that department stores could only fabricate.

Ohr's design was not complete until the mad potter himself sat among the crazy forms. An observer recorded the impression:

Entering the house that Ohr built, you find, bending over his wheel or patting into shape—more probably out of it—his latest creation, the potter himself. His eyes hold you first—wonderful eyes, big, bright, brown, wild like those of a startled animal. And then your gaze gets tangled in the meshes of his mustache and so lost for awhile. For it is impossible to tear your fascinated eyes away until they have followed all the twists and turn of that hirsute ornament and discovered its ends as they curl for the third time about his ears.[12]

The interior of the pottery studio "tells a tale of tireless work, a happy workman, few sales, unappreciative townspeople and infrequent visitors." Ohr was selling more than an object; he was selling an image—an image that was contrived, but one that offered a viable alternative to the mass production so rampant in the Gilded Age.[13]

ARCHITECTURE: CLASSIC VERSUS EXOTIC

The idea of the Other was also manifest in the architectural agenda of expositions. The Chicago World's Fair is a case in point. The main pavilions, while designed by disparate architects, were all in the classical style, following guidelines laid down by the master planner, Daniel Burnham. Indeed, what was most striking about the effect was its insistence on visual unity. Within the main grounds, only Louis Sullivan's transportation building departed from a classical template, and even that followed the general color scheme and system of proportions observed in the other buildings. Sullivan did, however, enliven the format with the addition of delicate reds, oranges, and yellows. As many writers have noted, this program carried an imperial message. The whiteness symbolized both cleanliness and supremacy, which, as Stanley Appelbaum notes in *The Chicago's World's Fair of 1893: A Photographic Record*, suited "the temper of the country, which was actively turning from the conquest of its own territory to imperial conquests overseas."[14]

As one moved away from the central area, building styles grew more exotic. Like other nineteenth-century expositions, it featured "many separate, freely imaginative pavilions, pagodas and kiosks supplied by the individual exhibitors, whether foreign nations, states of the Union, private firms or other organizations." The fair's most unusual building was the Japanese Ho-o-den (Phoenix Temple), constructed as a traditional edifice with sloping roofs and pagoda-esque design (plate 21). According to Japanese historian Judith Snodgrass, the Ho-o-den's placement on the Wooded Island assured that it was literally and figuratively marginalized in keeping with the program of Western dominance.[15]

Nonetheless, the Ho-o-den had enormous architectural and cultural influence, inspiring the likes of Frank Lloyd Wright and even triggering a national interest in Buddhism. It is striking that when Ohr's studio burned down just a year after he had attended the Chicago event, he built his new studio in the spirit of exoticism that he had witnessed there. The apparent

reference to the Japanese pavilion is intriguing. Clearly, Ohr consciously chose to picture himself as unusual and outside normative American cultural traditions.

Chapter 3

TWIXT GENIUS AND HUMBUG

Ohr, Mass Media, and Self-Promotion

OHR RECOGNIZED HOW IMPORTANT IT WAS FOR BOTH HIS WORK AND persona to stand out from the crowd, even if it meant being regarded as annoying, crazy, or tasteless. After all, any publicity was good publicity and better than being unnoticed. The tactics Ohr employed at his studio and world's fairs attest to his self-advertising skills. His expertise was not limited to these venues.

Several contemporaneous writers noted that his methods of self-promotion were not truly crazy or unconsidered but reflected a deliberate strategy of gaining attention. In 1905 Ethel Hutson, a southern critic, Newcomb College graduate, and colleague of Ellsworth Woodward, wrote:

> *It is said that the most unfailingly effective way to attract the attention of the public is to slap it in the face. . . . James McNeill Whistler was the cleverest of such self-advertisers. . . . The notorious "Fra Elbertus" of East Aurora has practiced similar advertising methods. . . . Mr. George E. Ohr, of Biloxi, has adopted similar methods of self-advertisement; and though he can not be said to display the genius of a Whistler, neither can he be accused of exhibiting the humbuggery of a Hubbard.*[1]

Hutson's significant observation links Ohr to painter James McNeill Whistler and to Elbert Hubbard, founder of Roycroft. Both men were pivotal to the developing consumer culture of the late nineteenth century. Whistler

helped create a distinctive persona for the creative "genius," and Hubbard showed that art and craft could benefit from skillful use of promotional techniques. Ohr's unusual style of self-promotion employed the ideas of these two men. By combining commercial marketing and the popular notion that creative geniuses were inherently eccentric, Ohr simultaneously boosted the virtues of his wares while authenticating their status as art. The full implications of Hutson's statement are explored below. But first, a brief discussion of developments in mass media is necessary to appreciate the fundamental transformation of advertising practices in the second half of the nineteenth century.

Advertising has always played a role in business. However, the notion that it was a business in its own right, one on which industry success depended, was something that came to the fore in Ohr's lifetime. Historian Joel Shrock observes that during the first half of the nineteenth century, when America was still largely agrarian, reading matter was relatively scarce. Yet, after 1850 the expansion of railroads, postal subscriptions, mail-order catalogs, and other systems of distribution provided all Americans, urban or rural, with the opportunity to obtain printed material. Consequently, published documents increased exponentially. The number of books grew by 300 percent between 1880 and 1900; newspaper dispersion experienced a 700 percent increase during this same period. Magazines diversified from 3,300 titles in 1885 to more than 5,500 in 1900, by which time periodical circulation had reached 65 million, providing three magazines for every four people in the country.[2]

Gilded Age Americans were barraged by information and an astounding, if eclectic, diversity of material. The Montgomery Ward catalog, for example, offered a selection of atlases, dictionaries, encyclopedias, Louisa May Alcott's works, Ralph Waldo Emerson's *Essays*, Mark Twain's complete writings, Dante's *Inferno*, and the works of the ancient Jewish historian Josephus, among other things.[3]

The swift proliferation and thus availability of information made it necessary to market in ways that had not been previously explored. Retailers could now identify and tailor their campaigns to different client bases based on reading and consumption interests. More genteel publications, such as *Harper's, Scribner's,* and *Atlantic Monthly,* sold for twenty-five to thirty-five cents a copy and were aimed at the moneyed and well-educated classes. But it was the low-cost periodicals that most effectively developed the mass

market. The more economical *Ladies Home Journal, Munsey's, Cosmopolitan*, and *McClure's* asked only ten cents and less for a copy while retaining excellence and good illustration. To remain competitive, editors of upper-class magazines "locked up their ivory towers and came down into the market place."[4]

Advertising in the Gilded Age was also a principal determinant of social trends and ideologies. This was a time of desire and consumerism. The Industrial Revolution had created a middle class with time and money to spend. And people sought ways to spend, whether on household items, fashion, vacations, or art. It was the responsibility of each individual, corporation, or manufacturer to create a yearning for their wares, whatever they may be.

Artists were not exempt from these changes in how business was conducted. Their livelihood depended on popular desire for their product. The creation of an artist persona was an especially perceptive method by which desire was cultivated. Art historian Sara Burns, in examining this modern phenomenon, explains it as a personality and character designed to include artists in society while simultaneously setting them apart from the general populace as "creative geniuses."[5]

JAMES MCNEILL WHISTLER AND THE COMMODIFIED SELF

The guise of the eccentric artist-genius in late nineteenth-century America was developed principally by painter James McNeill Whistler. Whistler lived from 1834 to 1903, overlapping Ohr's life by forty-seven years. During the mid-1880s to mid-1890s, when Ohr was growing professionally, Whistler had already established himself as an artist with a distinct manner and appearance.

According to Burns, "the career of Whistler marked the point where artist and image became interdependent, where the commodified self became a vital marketing tool. . . . Not every artist thirsted after publicity, and exploited it, as insistently as he did, but his actions must be seen as forming an exemplary pattern of great significance for artists in the twentieth century." Ohr would have realized the importance of Whistler's commodified artist image long before Hutson's remark associated the two. Perhaps he even identified with him on a personal level. Both men had created works

that were popularly and critically unappreciated, insulted, and rejected. And both believed their artistic efforts to be substantial. The various tactics Whistler employed to gain attention are comparable to Ohr's.[6]

While a remarkable painter whose *Nocturnes* and *Arrangements* startled the audience of their time, Whistler's fame was derived in large part from his eccentric appearance and public spats with critics. The widely publicized lawsuit against John Ruskin, whom he sued for libel after Ruskin accused him of "throwing a pot of paint" in the public's face is an apt example of his relationship with the press. Whistler knowingly shaped and manipulated his image, "using the newspaper and the periodical establishment to popularize and immortalize himself and his work."[7]

One of Whistler's most effective self-promotional techniques was to publicly confront critics with whose reviews he did not agree. A good example of this is his exchange with P. G. Hammerton, who, in 1867, criticized Whistler's *Symphony in White No. III*. Hammerton observed that despite Whistler's descriptive title, this painting, featuring a girl in a white dress, actually contained colors other than white—such as her blue ribbon, red fan, and reddish hair. He also noted that her complexion was not a pure white, but more flesh colored. Whistler then replied:

> How pleasing that such profound prattle should inevitably find its place in print! "Not precisely a symphony in white . . . for there is a yellowish dress . . . brown hair, etc. . . . another with reddish hair . . . and of course there is the flesh colour of the complexion."
>
> Bon Dieu! Did this wise person expect white hair and chalked faces? And does he then, in his astounding consequence, believe that a symphony in F contains no other note, but shall be a continued repetition of F, F, F? . . . Fool![8]

In essence, Whistler made disputes about his work a form of entertainment. Though time and again berating and abusing critics for their artistic ignorance, he kept a scrapbook of every remark made about him or his work throughout his entire career. His book *The Gentle Art of Making Enemies* opened with a long series of negative reviews that he faithfully reprinted. He understood that the content of the article was not nearly as important as the fact that he was still considered newsworthy.

Along with his temperament, Whistler's cane, white tuft of hair, monocle, and long dark coat became identifying trademarks often deemed by critics to be more noteworthy than his works. Such an assessment is apparent in the article "Whistler, Painter and Comedian," from *McClure's Magazine* (1896): "He wears a very long black overcoat . . . and a French top hat with the brim standing straight out. In his hand he carries a kind of wand of bamboo about four feet long and very thin. His gloves and boots are very carefully selected, and of irreproachable fit." All that is missing to complete this description is mention of his infamous monocle and white tuft of hair at the front of his head (plate 22). A glance at any portrait, caricature, or cartoon will reinforce the importance of these attributes.[9]

Like Whistler, Ohr used both his strange appearance and dialogues with critics as a way of gaining attention. His long handlebar mustache became his distinguishing attribute (plate 23). When pictured, his exaggerated whiskers were readily apparent, and he often used them as a sight gag:

He is a man of interesting conversation, with restless, flashing eyes. . . . We also begged a photograph of the potter himself, though we like him best in his potter's garb, at which time his flowing mustaches are wound up and about his ears with two or three turns.[10]

To see him bending over his wheel, his long mustache plaited and tucked behind his ears, his sleeve rolled up to his shoulder, patting the white clay into shape to the tune of some familiar lullaby, carries out still further his comparison about the child of his fingers.[11]

Ohr's facial hair was certainly not a rarity in the Victorian period, as most photographs from this time feature men with overstated mustaches. That he maintained it until his death in 1918, long after it had gone out of style, reveals his motive.

Ohr, too, delighted in stirring up controversy in the press. Recall the distinctive letter Ohr wrote to Major A. M. Wheeler in an effort to secure display space at Buffalo's Pan-American Exposition (discussed in chapter 1). Though Ohr's prose was not as caustic as Whistler's, it was equally memorable because of his bizarre misspellings and peculiar wordplay. So strange, in fact, that he was able to get it published in a widely circulated magazine

simply to provide amusement to readers, an accomplishment Whistler might have envied.

In addition to making use of magazines and journals, Ohr also printed up promotional statements on his own. In a letter to a friend dated 16 May 1898, Ohr boasts:

> *How you like my rather warm circular? I got a cheap job making a 1000 souvenirs for a Chicago [sic] coal dealer and will put one of these THINS—with every flower pot—etc. that I sent—it will shake some of the Rookward lovers on art. I am not making salt just now—BUT Im making a lot of fuss as U'C. If you get in town, show this to that Rooward dealer and ask him to invest $500 on a sample = he wont hit you =.[12]*

Though not making much money ("salt") right then, Ohr is excited by his handbill strategy and confident enough to challenge "Rooward" (that is, Rookwood), one of the big names in pottery production. References have been made to numerous handbills of this sort, but only one has been found, published by Eugene Hecht in 1992. An excerpt reads:

> *when U get some ORIGINAL article of thing, U get the 1st 1 & only 1, & there is no more inch 2 that than there is in purchasing a valuable parrot, painting, dog, horse or book, by the inch. ART and animals have a NAME, & when you hear of creatures that have been proven "masters," you know their worth by their signature—not by inches. U pay for the cognomen that goes to identify the article—that's what I call high art. . . . Beautiful things produced by hired help, or servants . . . is the larger the article, the more U pay, & the greater the amount you purchase, the cheaper it's sold.[13]*

Though conceived of as a promotional gimmick, Ohr's statement confronts enduring aesthetic issues, namely, the definition of art. High art, to Ohr, is an original object created by a proven "master." Art is not simply something that is beautiful, since beautiful objects can be produced by factory workers, or "servants," in bulk. The one-of-a-kind vessels Ohr creates are therefore art, and their value can't be determined by size, labor, or material. Never specific about the monetary value of his pots, Ohr did perceive a

clear link between pecuniary worth and artistic merit. An original artwork commands more money because it is the only one in existence. That same artwork reproduced is a fraction of the cost because it is no longer genuine. For those wishing to spend their hard-earned money on artistic wares, Ohr makes a case that is hard to dispute.

One of the most interesting aspects of Ohr's marketing and self-promotion is that it forced him to define the distinguishing qualities of his work and himself: he was a proven master who produced original wares, not an assembly-line hand making lovely copies. Designing an advertising circular to pinpoint the special qualities of his work prodded Ohr's artistic creativity.

Unquestionably, Whistler and Ohr constructed opposing characters (which will be discussed more thoroughly in the next chapter). The former consistently portrayed himself as a sophisticated dandy, while the latter played the role of a half-educated buffoon. But though the two differed in their roles and attendant costume, the strategy was similar: to develop and control their own public personas.

HEART-THROBS OF THE HUMAN SOUL: OHR, ELBERT HUBBARD, AND MASS MEDIA

While Whistler may have established the strategy of behaving eccentrically to market his art, Ohr was probably more directly influenced by a model closer to home, Elbert Hubbard. Evidently admiring of Hubbard's success, Ohr once placed an advertisement in his magazine the *Philistine*, which will be discussed below. The intrigue was reciprocated. An obituary for Ohr states that Hubbard had "learned of his [Ohr's] genius" and "became interested in the man and his work."[14]

Born in 1856 (he died on the *Lusitania* in 1915), Hubbard founded the Roycroft community and was a pioneer of modern advertising. Until the age of thirty-six, he worked as a salesman for the Larkin soap company, initiating such promotions as gift premiums for regular purchases. But Hubbard yearned for much more. In 1895 he sold his share of the company to create an Arts and Crafts commune in Aurora, New York, based on the ideas of William Morris. The name Roycroft pays homage to the accomplishments of Samuel and Thomas Roycroft, seventeenth-century English bookbinders. Initially, he focused on publishing, after the model of

Morris's Kelmscott Press. Hubbard's first and most successful publication was a monthly journal, the *Philistine*, which ran for twenty years, until his death. He also produced a great range of other profitable magazines and periodicals, including the *Fra* and *Little Journeys*. Eventually, the community manufactured a myriad of other products, including pottery, rugs, baskets, furniture, stained glass, and candy, all of which were marketed under the Roycroft name.[15]

The pages of the *Philistine* were filled with Hubbard's prose and poetry. Most of his writings provided guidelines for living, and were titled like sermons, such as "Heart to Heart Talks with Philistines by the Pastor of His Flock." Hubbard referred to himself as "Pastor" and "Fra" though never ordained or recognized by any church or religious organization. He used these designations to reflect the new Gilded Age faith centered on secular life in nineteenth-century America, rather than on an omnipresent God. Hubbard's distinctive spirituality struck a cord as his readership grew dramatically from 2,500 in 1895 to 20,000 by the third year and 52,000 by 1900. In comparison, a contemporary elitist journal, the *Chap-Book*, had a circulation that never rose above 16,500.[16]

Hubbard, like Ohr, held many views that were extremely moderate for the time. He fought for greater marital freedom, liberal divorce laws, and socialism. Plate 24 shows the ad Ohr placed in the December 1901 issue of the *Philistine*. Ohr identified himself as "Rev. George E. Ohr," reverend of his own business, to poke fun at Hubbard's unauthorized and self-appointed title of pastor. Perhaps he was also a bit fascinated by and resentful of Hubbard's success as a proselytizer. Like Hubbard's, Ohr's claim to be a preacher had no official status, but referred to the fact that "He does his work as well as he can, and Minds his own Business." He insinuated divine powers of creation by comparing himself with Setebos—the god in Shakespeare's *Tempest* who created the moon and the sun. The Renaissance he boasts of originating comes from the "Bug-house," or insane asylum, and there is nothing fancy about his working process; he simply "Makes things out of mud." He again reiterates his position of superiority over rival potteries like Rookwood, Van Briggle, and even Roycroft, who use industrial methods to produce identical or near-identical objects.[17]

Though inspired by William Morris's ideals, Hubbard's processes, like many Arts and Crafts endeavors, increasingly adopted mass-production factory techniques that reduced the individual's mark on a finished product,

something Morris would not have advocated. No doubt Ohr was taking something of a dig at Hubbard when he stated that his own pots were "never duplicated." Likewise, while Hubbard was inspired by idealism, in practice his approach limited individual freedom. Hubbard's employees were not only expected to work in the Roycroft shop, but to live in the community and partake of its activities. Hubbard strove to create a utopian existence; however, many workers complained of excessively long work hours, mandatory involvement in company recreations, and inadequate wages.

Advertising was the field in which Hubbard truly excelled. For him, promotion was not just an appendage to business but a way of life. He strongly believed that one should advertise every day and there was never a wrong time for it. As he wrote,

> The author [Hubbard] advertises men, times, places, deeds, events and things. His appeal is to the universal human soul. If he does not know the heart-throbs of men and women, their hopes, joys, ambitions, tastes, needs and desires, his work will interest no one but himself and his admiring friends. Advertising is fast becoming a fine art.[18]

Hubbard believed that promotion was far beyond mere persuasion. His true understanding of the human soul and its desires were the source of his success. Consumers were not interested in retail goods in and of themselves, but rather what they represented. Later chapters will explore how Ohr tapped into this same philosophy—his pottery was an experience, a solid memory, or a tangible expression of faith.

Hubbard's methods of endorsement were often ingenious. A typical issue of the *Philistine* contained approximately seventy-two pages—about forty of which were ads. Hubbard designed his communications to take advantage of his loyal readership, who hung on his every word. Many ads began as stories, and the reader only discovered their commercial intentions several pages later. The November 1906 issue of the *Philistine* featured a lengthy promotion for Macy's, beginning with the sentence "George Washington did his shopping by mail." Hubbard then went on to discuss the shift from London to New York as the center of the fashion world, the importance of trusting the merchandiser, the evils of buying on credit, and the need for women to be financially independent. Finally, four pages later, when Hubbard began to extol the virtues of Macy's, the reader

discovered he had been tricked into spending much time and concentration on an advertisement, not an article about George Washington. This essay also illustrates Hubbard's use of deeper psychological lures. Washington's common-sense leadership and New York's success over Europe in the art world are sources of pride and identity for Americans. By criticizing the use of credit Hubbard underscores the importance of self-control in one's expenditures. He thereby links ideas of patriotism and moral fiber to Macy's, which is also an American enterprise. Rather than merely providing information, here Hubbard shows that he understands the "heart throbs" and desires of his readership and plays upon that understanding to create loyalty to Macy's.

The ad Ohr placed in the *Philistine* was certainly an effort to capitalize on Hubbard's notoriety and marketing savvy. But it also enforced Ohr's authenticity as a hard-working, self-sufficient product of American innovation. Ohr was also engaging the inner desires of Americans.

Like Whistler, Hubbard was aware that an "artistic look" could be helpful in promoting his ventures. A former coworker observed that "as his public career grew—with its dependence on self-advertising—his appearance became a sort of trademark." He began to wear a cape overcoat, large Buster Brown cravat, flannel shirts, baggy pants, and heavy shoes (plate 25). He also allowed his curly hair to grow. In essence, he combined the bohemian air of Oscar Wilde and the rugged craftsman look of William Morris. That Hubbard so skillfully used his distinctive look as a marketing tool very likely encouraged Ohr to do the same.[19]

Hubbard frequently included his likeness in the *Philistine*, and he arranged to be photographed with important people—playing golf with John D. Rockefeller, dancing with Eva Tanguay, and talking to Thomas Edison. Ohr also had a large group of striking photographs taken of him. Several of these were reproduced in early articles about his work. One image is a very proper quarter length portrait prominently featuring Ohr's long mustache and a bow tie (plate 26). In a second, less formal visage he wears scruffier clothes and crosses his arms to accentuate his muscles/masculinity (plate 27). Another shows Ohr inside his studio, surrounded by thousands of his wares (plate 6). And finally, a very small Ohr is pictured standing proudly in front of his towering pagoda-like construction (plate 5).

Ohr repeatedly used one particular rendering throughout his career (plate 23). In this countenance his hair has been arranged into three parts—two sides sticking straight out from his head and the third pointed down

over his forehead in the shape of a triangle. His twisted, waxed moustache extends at least five inches beyond his checks while his beard curls beneath his chin. To exaggerate his incongruity he assumed bizarre expressions—his mouth stretched in an "O" of mock surprise or fear and his eyes frantic and wide. Such constructions made him look mentally unbalanced and reinforced his "Mad Potter" identity.

HUMBUGGERS OHR AND BARNUM

In the aforementioned quote, Hutson situates Ohr between "the genius of a Whistler" and "the humbuggery of Hubbard," thus providing another significant cultural cue to which Ohr was likely responding. As used here, the term "humbug," links Ohr, Whistler, and Hubbard to the most extravagant showman of the nineteenth century, P. T. Barnum, the man who turned humbuggery into an art form.

P. T. Barnum was the founder of the Barnum and Bailey Circus, but it was at his American Museum that he seduced the masses by turning extravagant, ridiculous, and untruthful claims into a form of entertainment. He popularized the "humbug"—the game of pulling one over on the public—and the term has since been culturally associated with him. His first such stunt involved an elderly black woman, Joice Heth, whom he claimed was 160 years old and had once been the slave of George Washington. When interest in Heth appeared to be waning, Barnum wrote an anonymous letter to the local newspaper suggesting that she was not really an aged woman but instead an automaton. Not only did this attract new visitors, but it also brought back repeat viewers who wanted to figure out how they had been duped. According to historian Neil Harris,

> it was during Joice Heth's tour that Barnum first realized that an exhibitor did not have to guarantee truthfulness; all he had to do was possess probability and invite doubt. The public would be more excited by controversy than by conclusiveness. The only requirement was to keep the issue alive and in print.[20]

Rather than seeking to conceal his deceptions, in his 1869 autobiography, *Struggles and Triumphs*, Barnum boasted of his ability to fool the public through ingenious ruses.

While Barnum's rise to fame occurred before Ohr was born, he was still a vital presence when Ohr was beginning his career. The showman published almost annual editions of his book, and in 1883 produced a third version, which he revised yearly until 1889. By the late 1880s Barnum was boasting that more than a million copies of *Struggles and Triumphs* had been sold, making it one of the best-known autobiographies in nineteenth-century America. Barnum's book doesn't offer an examination of his psychological makeup, instead he presents himself as a stereotype of the New England Yankee: clever, keen, eager to strike a bargain. In this way it is not merely a narration of his life, "but a text on the social functions of illusion and the role of the deceiver in an egalitarian society."[21]

Like Barnum's museum, Ohr's pottery demonstrations were not intended to be educational. They were a form of entertainment—and also a kind of freak show that provoked feelings of curiosity, disbelief, disgust, amusement, and excitement. Also like Barnum, Ohr exploited a regional stereotype, although it was that of the "dumb southerner" or southern eccentric, rather than the clever, deceitful New England Yankee.

Interestingly, while Ohr's persona was ostensibly southern, his boastful self-advertising belonged to a northern tradition. It is often assumed that the innovations of the Gilded Age were experienced by the nation as a whole. However, northern states were the predominant beneficiaries of new methods of production, consumption, and advertising; and it was largely their promotional strategies that transformed the business world. In fact, after Reconstruction and in the wake of economic collapse, residents of the South "rationalized their commercial failures by taking refuge in the notion that they were too refined and civilized to compete successfully against the vulgar money grubbers of the North." It was a point of pride that they did not resort to northern advertising "tricks" or gimmicks in order to dupe their customers.[22]

Barnum's hoaxes were never popular in the South because they presupposed a climate of interest in science, the latest technology, and new discoveries. Paradoxically, this made northerners more apt to believe outlandish reports as long as they were dressed up in impressive jargon. Yankees were "easy targets for pseudoscientific explanations, for detailed descriptions of fictional machinery, for any fantasy that was couched in the bland neutrality of a technological vocabulary. . . . The coming of steam, of railroads, of telegraphs indicated the futility of declaring anything impossible or

incredible." In this atmosphere of continual forward progress, it was often difficult to distinguish truth from falsehood, and deception became a form of entertainment. Ohr's "humbuggery" was aimed toward his northern visitors who *liked* to be fooled.[23]

Whistler, Hubbard, and Barnum together capture the essence of what marketing had become in the Gilded Age and constitute an effective template against which to compare Ohr. Ohr's ad in Hubbard's *Philistine* and Hutson's quote are contemporary sources that establish his awareness of these leaders in modern advertising. Far from primitive and simplified, the persona Ohr presented to the public was just as sophisticated and studied as the promotional strategies employed by Whistler, Hubbard, and Barnum. The following chapter will explore how, like these men, Ohr strategically appealed to the desires and "heartthrobs" of his distinct consumer base.

Chapter 4

"SMART ALECK, DAMPHOOL POTTER"

Ohr as a Southern Character

NOT ONLY HAD OHR TAPPED NEW DEVELOPMENTS IN MODERN ADVERTISING when he crafted an eccentric persona, but he also tailored it to his particular client base. A general outline of the region's commerce is helpful in understanding Ohr's marketing savvy.

Biloxi had an economy quite different from the rest of Mississippi. Aside from oyster and seafood canning, tourism was the main trade for Biloxi and the Gulf Coast. The completion of the Louisville and Nashville Railroad (L&N) in the early 1880s connected the main ports of New Orleans and Mobile, Alabama, and provided easy access to all of the coastal towns in between, including Bay St. Louis, Pass Christian, Biloxi, Ocean Springs, and Pascagoula, among others. While the rest of the South was struggling with flawed Reconstruction efforts, Ohr's coastal town was perfectly situated to receive affluent northern tourists.

According to the *Biloxi Herald* the L&N ran four daily trains through Biloxi to eastern and western cities and a coast train morning and evening. The L&N was frequent, accessible, and facilitated easy travel for those from northern and Midwestern states who wished to winter in warmer regions. Coastal towns were thereby granted a second season. "As more and more of these 'snowbirds' flocked to the 'American Riviera,' the hotels remained open all year."[1]

The tourist trade was so prominent in Biloxi that one 1890 article from the *Biloxi Herald* reported that for two weeks in February "Biloxi hotels

[had] been tared to their utmost capacity to provide accommodations for the great number of Northern visitors . . . [and] on several occasions guests [had] been turned away." This article reinforces the importance of tourism in Biloxi, but, more significantly, qualifies its visitors as northern.[2]

"Along the Gulf: An Entertaining Story" (1894) is a whimsical booklet narrated by Charles Lawrence Dyer, an L&N rider on holiday with a large party of northern ladies and gentlemen. He praises the shores that edge the state of Mississippi, saying:

> *here . . . during the summer months, congregate the cream of Southern Society . . . the flower of Southern manhood and the blossoms of Southern womanhood: while in the Winter months, people from all over the country come to these places, seeking in the balmy climate of this section, the health which the rigors of a northern winter deny them.*

Each chapter in the booklet is a review of one of the L&N's coastal stops, but Biloxi is given the most attention and celebrated as "a thriving, energetic little business city." Notably, Dyer singles out Ohr, describing him as "the artistic potter whose quaint and indescribable shapes in clay have made him famous all over the United States." Ohr's studio is "one of the show places of the town," and Dyer recommends that "visitors to Biloxi make it a point to visit it during their stay."[3]

BILOXI'S NORTH-SOUTH TENSIONS: RELIANCE AND EXPECTATION

Citizens of Biloxi were quite aware of how important their northern tourists were. Each issue of the *Biloxi Herald* contained a standard section listing the "visitors of the North" and at which hotels they were staying. They even published a letter from a northern veteran who was expressing his views on whether or not a Federal Soldiers' Home should be established in Biloxi. It was of no consequence that he was not a resident—his northern status was qualification enough.[4]

Despite the symbiotic relationship, there existed a tension between Biloxians and their "very Northern" visitors. The South resented its reliance on the Yankee dollar. Exacerbating southerners' indignation were the northern visitors who consistently reminded their hosts exactly who was facilitating

their economic success, and that the North was still considered the more progressive and educated region of the country.

In his introduction to *Facts about the Gulf Coast*, a tourist-oriented booklet from 1905, W. A. Cox praises the warm and sunny attributes of this ideal coastal community. An included essay entitled "A Northerner's Opinion," by Ethelyn Colcord from Le Mars, Iowa, begins with a backhanded compliment:

> *We Northerners . . . seem to have acquired a mistaken idea of our sister states. Those who have not taken the trouble to investigate the matter are led to consider the Southerner an indolent, lazy, unenergetic, unenterprising body, lacking all ambition. This, of course has been so in the past, and is at present true to a certain extent.*

She then praises the wonderful advancements the Gulf Coast has made, including its lumber output, power house, street car line, two large banks, and attractive wide streets, among other things. Lest she appear too proud of the South, she then tempers her acclaim with the statement, "It cannot be truthfully said that this change is due wholly to 'Northern enterprise,' although, it must be admitted, that the Northerner is in some degree the instrument of it."[5]

The strong northern presence in Biloxi, the city's dependence on their dollar, and the tensions that created strongly directed Ohr's advertising strategies. But the North's progressive means of self-promotion and pursuit of consumer desire made as much of an impact. In particular, Ohr's client base made him sensitive to northern attitudes regarding southern arts.

Northern artists were sophisticated, their work refined and erudite. Those of the South were quaint craftsmen or artisans capable of producing delightful but primitive folk wares. Their creations could not be held to the same standards as those of the North. The work of a southern potter, then, had no hope of garnering aesthetic or critical respect from these northern visitors. For the people of Biloxi, and Ohr in particular, these mindsets vividly illustrated how the southern "artist" was perceived by northern visitors—charming, but outmoded and unrefined.

If the North, which directed the nation's advancement and set its trends and standards, was considered the model, then the post–Civil War South had become the aberrant of the mean, the Other. The idea of the southern eccentric is an offshoot of this concept of South as the Other. While the

origins are not well defined, there has long been a specifically southern type capable of existing only within states below the Mason-Dixon Line. Many well-known southern writers such as Mark Twain, William Faulkner, and Eudora Welty focus on offbeat and peculiar personalities who also have distinctly southern speech patterns and social characteristics. Even modern depictions of southerners maintain the same behaviors. The outrageous antics of Ellen Bernstein's circle of friends in *The Divine Secrets of the Ya Ya Sisterhood* are nothing out of the ordinary in southern society, or so we are to believe. Even kidnapping her soon-to-be married daughter is par for the course. John Berendt's book *Midnight in the Garden of Good and Evil* (1994), which was based on real life events from the 1980s, stressed the voodoo qualities of the midnight hour. Kevin Spacey played the mercurial homosexual millionaire art dealer Jim Williams in the later film of the same name and perfectly captured the decadence of New Orleans.

These fictional characters differ greatly from one author to the next, but they have important commonalities. They exhibit a disregard for societal norms whether out of ignorance or lack of concern. Additionally, in their regional isolation, they are the embodiment of a particular kind of people who lack the cosmopolitanism often associated with people from the industrial Northeast.

Ohr's version of southern whimsicality was not a product of regional or cultural isolation. Rather it was a response to the modern ethos of advertising and consumption that pervaded his consciousness via expositions, New Orleans culture, and the scores of northern visitors in Biloxi and in his studio. He designed a persona that played to the narratives northerners imposed on southerners. Just as one buys a Caribbean souvenir more for its representation of a specific time and place than for artistic qualities, Ohr was selling Biloxi's local flavor in the form of pottery. His flamboyant, even clichéd southern self-presentation mirrored the distinct myths projected on the culture of the South by those who controlled the nation's economy—the northerners.

The North's perspective on the South was and, some would argue, remains oversimplified and caricatured, casting the entire South as culturally homogeneous. Even though Biloxi did not fit the profile of the typical southern town, Ohr's image, as projected both by the media and in person, portrayed just the kind of southerner the North had come to expect—the dumb-yet-good-natured illiterate popularized through characters such as Sut Lovingood and Huckleberry Finn.

TRADITIONS OF SOUTHERN HUMOR AND BILOXI'S MAD POTTER

Henry Watterson's *Oddities in Southern Life and Character* (1882) is perhaps the first book to acknowledge a uniquely southern brand of humor and recognize its importance: "Many of the best American antebellum comic writers came from southern states, but until Watterson their achievements were not deemed to be a source of regional pride." This anthology, therefore, is not simply a collection of humorous stories but employs comic material to "represent a culture."[6]

Watterson drew on a number of well-known antebellum writers and characters to illustrate that such humor was not just the product of a talented individual but represented the region. Included in this list was one of the nineteenth century's most popular authors, George Washington Harris, creator of the much-loved Sut Lovingood, featured in *Sut Lovingood's Yarns* (1867). Sut is the archetype of the early East Tennessee mountaineer:

> *I'se hearn in the mountins a fust rate fourth proof smash ove thunder cum onespected, an' shake the yeath, bringin along a string ove litenin es long es a quarter track, an' es bright es a weldin heat, a-racin down a big pine tree, tarin hit intu broom-splits, an' toof pickers, an' raisin a cloud ove dus', an' bark, an' a army ove lim's wif a smell sorter like the devil wer about, an' the long darnin needil leaves fallin roun wif a tif-tif—quiet sorter soun, an' then a-quiverin on the yeath es littil snakes die; an' I felt quar in my in'ards, sorter ha'f cumfurt, wif a littil glad an' rite smart ove sorry mis'd wif hit.[7]*

Sut's backward and loutish language comically and vividly contrasts with more formal manners of speech associated with the privileged and educated. His crude vernacular, therefore, was emblematic of a dislike of untrustworthy Yankees, "sheriffs, most preachers, learned men who use big words or flowery language, tavern keepers who serve bad food, and reformers." Sut represented the non-elite class of America and those men who physically cultivated and settled the land, rather than those who threw money at it from their safe and comfortable mansions. What's more, Sut's descriptions of his home in the Smoky Mountains were warped and hyperbolized to emphasize the comedy and not the reality of his squalor. His humor made his life appear very jolly.[8]

An interesting revelation about the way Sut's language was expressed is put forth by Carol Boykin in her essay "Sut's Speech: The Dialect of a 'Nat'ral Borned' Mountaineer" (1965). She observes that Harris's warping of Sut's language was not an attempt to phonetically capture the East Tennessee dialect for greater authenticity. In fact, she notes that at times Harris misspelled Sut's words for no good reason; the phonetic pronunciation had not been changed or directed. For example, the words "wun," "cum," and "trubbil," are spelled differently, but the pronunciation has not changed; "one," "come," and "trouble" still sound the same. Additionally, the reduction of syllables, such as "want" for "wasn't," "natral" for "natural," "speck" for "expect," or "pendence" for "dependence," highlighted Sut's sloppy diction but did nothing to indicate his regional dialect. Boykin suggests that Harris's intentions for the misspellings were to "deliberately overstate the ignorance and illiteracy of his characters" and to "clutter the page."[9]

If Sut's distorted speech, deliberate misspellings, and deformed words signify a "dumb" southern type, the southern region, and its general disdain for the northern Yankee/fast talker/elitist, then the words of Ohr can be read in a similar fashion:

Now then, my Dear, Good Readers, and all the rest of yease . . . let me radiate & while U R reading, don't think between D lines, 'Smart Aleck, damphool potter,' etc. A duck doesn't knead his brains 2 float as he is built 2 hold water, B in it & stay dry & I don't need any 2 mash mud or push a pencil, Because I'm built that way.[10]

Boykin's observations about Sut's parlance also hold true for Ohr's. As seen in this passage, he uses "damphool" for "damn fool" and "knead" for "need," even though neither misspelling actually changes the pronunciation of the word. In fact, he spells "need" correctly later in the same sentence. Further, the only function served by his consistent use of numbers and letters for words, as in "2 B" for "to be," "U R" for "you are," and "D" for "the," is to confuse and dramatize the paragraph visually, not to aid in pronunciation. Ohr's inimitable phrases, such as "mash mud" (make pottery) or "push a pencil" (write) are not reflective of his regional dialect, only of his own distinctive way of writing or talking. Of course, at times Ohr's phonetic spelling may have been due to actual ignorance, but he exaggerates this quality to dramatize his southern persona.

It bears mentioning that Ohr and Sut represented two different cultural and geographical regions, Mississippi's coast and the Tennessee Mountains, respectively. However, the types set forth in southern cartoons were not overly topographically specific:

> *Longstreet's Georgia [Augustus Baldwin Longstreet's* Georgia Scenes *(c. 1840)] is intended to represent the sparsely settled, raw, and morally unenlightened counties west of Augusta and Savannah; Baldwin's Alabama and Mississippi [Joseph G. Baldwin's* The Flush Times of Alabama and Mississippi *(1853)] are geographically interchangeable; and Cob's Mississippi could be any of those states below the Ohio and north of Louisiana.[11]*

It is important to realize that familiarity and enjoyment of these characters was not limited to the South. The northern perspective is often what gave them their edge—those who lived in the South would have dismissed such outlandish caricatures. The North, aware or not that such descriptions were overstated, used them to rationalize its superiority, an insinuation especially pertinent in the existing antebellum and Reconstruction climate. Many of the authors and fictional personalities Watterson featured, including Harris and Sut, were first printed in the New York journal *Spirit of the Times*, which became their principal medium of publication. The success of this magazine prompted others to follow suit, and many of these authors were picked up by other regional papers like the *New Orleans Picayune*, the *St. Louis Reveille*, and the *Cincinnati News*. Further, most of these same writers had northern publishers; Harper printed Longstreet and Appleton released Baldwin, for example. This was, of course, due largely to the fact that northern cities had cornered the book industry, but it also indicated the preferences of a crucial portion of their dominant readership.[12]

Southern humor also looked to the wildly overstated behaviors, words, and tall tales of frontiersmen. An example from Mike Fink reads:

> *I can hit like fourth-proof lightnin' an' every lick I make in the woods lets in an acre o' sunshine. I can out-run, out-jump, out-shoot, out-brat, out-drink, an' out-fight, rough-an'-tumble, no holts barred, ary man on both sides the river from Pittsburgh to New Orleans an' back ag'in to St.*

Louiee. Come on you flatters, you bargers, you milk-white mechanics, an' see how tough I am to chaw! I ain't had a fight for two days an' I'm spilein' for exercise. Cock-a-doodle-doo![13]

The passage from Mark Twain's *Life on the Mississippi*, in which we first encounter the soon-to-be famous Huckleberry Finn, also features southern crowing of this sort:

Whoo-oop! I'm the old original iron-jawed, brass-mounted, copper-bellied corpse-maker from the wilds of Arkansaw!—Look at me! I'm the man they call Sudden Death and General Desolation! Sired by a hurricane, dam'd by an earthquake, half-brother to the cholera, nearly related to the small-pox on the mother's side! Look at me! I take nineteen alligators and a bar'l of whiskey for breakfast when I'm in robust health, and a bushel of rattlesnakes and a dead body when I'm ailing! I split the everlasting rocks with my glance, and I squench the thunder when I speak! Whoo-oop![14]

In the preceding passage a young Huck has swum up to the side of a raft and is eavesdropping on two rowdy frontiersmen exchanging warnings and gearing up for a fight. Perhaps this man is hoping his far-fetched bravado will be enough to discourage a first punch.

Similarly, much of Ohr's singularity was illustrated in his farcical embellishments. The sign hanging from his studio is one example, as is a flier of sayings Ohr distributed, some of which include the following:

My challenge to the whole world of wealth and potters, too make fac-simile of my twist or crinkled SHAPES or for creating new designs on potter's wheel still holds good. Please shut me up.

American born, free and patriotic, blowing my own bugle, and will tackle the greatest of all great potters in the world, creating shapes on ceramic wheel.[15]

While the amplifications of Mike Fink and Twain's riverboat men were meant to emphasize their strength and toughness, Ohr's words boast of the exceptionality of his pottery and his great skill on the pottery wheel.

The Civil War radically changed the southern way of life and erased many of the conventions necessary for the kind of humor discussed in these pages. Ohr's vernacular, therefore, recollects characters and southern humorists who originated prior to 1860. However, the writing "was a bridge that linked the past and the present, oral tradition and the written word, and a regional culture with the national culture.... The times changed and so did the mode of comedy, but Old Southwestern humor did not entirely disappear." Mark Twain is again an apt example. Though his career flourished after the war and he was a contemporary of Ohr, his humor often exhibited the illiteracy and aggrandizement of pre–Civil War humorists.[16]

It is worth recalling that Ohr was an inspiration for Giacamo Barse, the fictional potter in Mary Tracy Earle's *The Wonderful Wheel*, because he was sufficiently flamboyant and entertaining to essentially carry a fictional novel. In other words, Ohr's persona perfectly fit the expectations of northern customers and readers.

SOUTHERN CHARACTERS IN NORTHERN PERIODICALS

The magazines with which Ohr was involved suggest that he deliberately courted a northern audience. As one might expect, Ohr was featured in regional southern periodicals such as the *Biloxi Daily Herald*, the *Commercial Appeal*, and *Southern Quarterly*, but he reached far beyond these geographic boundaries. *Brick*, which published the first known article on Ohr, was based in Chicago, and the *Clay Worker*, which printed the Hutson article "Quaint Biloxi Pottery," was based in Indianapolis. King's important first article, "Palissy of Biloxi" (1899), was published in the *Buffalo Express*. The *Crockery and Glass Journal*, in which Ohr idiosyncratically aired his grievances with William King and Major Wheeler, was a New York trade paper. Ohr even managed to infiltrate elitist New York art magazines such as *Harper's Monthly* and *Art Interchange*, albeit rarely. *Harper's* only included a photograph of the pottery and a short caption that read "The Pottery of Biloxi" in its May 1895 issue, while *Art Interchange* provided a very respectful review of Ohr's work by L. M. Bensel in 1901.[17]

As previously discussed, King's "Palissy of Biloxi" was one of the most comprehensive articles on Ohr. One angle of this article not yet touched on is the specific appeal the *Buffalo Express* held for Ohr because of its

proximity to New York, the cultural center of the United States, and to Elbert Hubbard's Roycroft community in East Aurora. King's write-up highlighted Ohr's individuality, prominently featuring his usual misspellings, strange punctuation, awkward and illogical sentence arrangements, photographs of himself, and interior and exterior shots of his new pagoda-like studio. His Biloxi origins, conspicuously featured in the title, coupled with the crazy words and images, encouraged northern readers to view Ohr as a typical oddball southerner.

In March of 1896 Joe Jefferson, the actor known for playing homely American characters, in particular, *Rip Van Winkle* (1859), made a stop at Ohr's studio. Jefferson's visit was in part leisure and perhaps to satisfy his curiosity about the mad Biloxi potter. It is also likely that Jefferson was studying Ohr's humorous mannerisms in an attempt to authenticate the characters he often played. Ohr's character, part real and part constructed, was a sincere and effective representation of the South. It was also a revelation about Ohr the businessman.

Well aware that consumer culture, advertising, and self-promotion were becoming increasingly important to late nineteenth-century America, Ohr used his Biloxian context to hone his advertising skill. Drawing upon the desires of northern visitors, he crafted a persona that would deliver the presumptions of southern residents that they expected. Ohr's "dumb southerner" image did not disappoint and played to the sophistication and progressive attitudes they prided themselves on. The quaint and outmoded Biloxi potter skillfully subverted northern strategies and deluded America's "superior" citizens, who were blinded by their own prejudice.

DURANCE VILE: OHR IN BILOXI

Though the residents of Biloxi constituted a portion of Ohr's clientele, his relationship with this group could be described as more honest. Biloxians conducted business with Ohr on a practical level; their needs were along the lines of flower pots and chimney pipes, not dysfunctional, oddly shaped works of art. Likewise, Ohr's "show" would not have impressed his neighbors for the same reasons that residents of Inverness, Scotland, are not impressed by tales of Nessie; it is difficult to project an exaggerated image of a region to someone who already lives there. It is worth outlining the

complicated and contentious relationship between Ohr and the residents of Biloxi.

On the surface, Biloxians embraced Ohr's strange behaviors and clay oddities, especially when it became clear that his business was a tourist draw. However, Ohr always had the underlying feeling of being an outcast or crank who never fit in and whose work was never appreciated. In later years his view became more extreme, as he considered himself a misunderstood martyr subject to the town's persecution.

Within his own family he believed himself to be the lone "duck" among roosters and hens. He butted heads with his father, who wanted him to continue in the blacksmith trade, finally escaping the household into various odd jobs that never lasted. This situation came to a head after his father and mother died in 1904 and 1905, respectively. Ohr's siblings wanted to sell family property that had been jointly willed to them. The terms of the will stipulated that the property was not to be sold for ten years and that George and his family would be offered a chance to buy it before it was sold off. Ohr's siblings wanted to sell the property quickly, so they attempted to have him declared insane in order to remove him from the proceedings. The jury found him sane.[18]

On 7 September 1909 the conflict landed the family in court. At the hearing Ohr presented a document that he alleged had been signed by a court clerk stating that his parents' property could not be sold for ten years. F. S. Hewes, the court clerk in the case, refused to accept it, saying the paper had nothing to do with the trial, and proceeded with the sale of the property. At this point "the defendant [Ohr] struck him with his hand and seizing his [Ohr's] wife's hand, struck him with it." Ohr was fined ten dollars.[19]

Ohr published his impression of the hearing in the *Biloxi Daily Herald*: "It took me 53 years to go to jail, and lawbreakers broke the law TO DO IT." He concluded his op-ed with a less rational postscript that reads, "Oh! Well! Let 'er go Galliger, and er er. Yes, take an eat up (lock) all dis chill lasses and bred, then call him nigger, crazy, etc." Here he accuses the powers that be (it is unclear whether he means his siblings, Biloxi's public officials, or others) of taking all that matters to him and then wanting to lock him up and declare him insane ("then call him nigger, crazy, etc."). These are the words and thoughts of a man convinced that his family and community have long been against him, conspiring for fifty-three years to put him behind bars.[20]

The situation ended when in October 1910 Ohr was jailed for not paying the ten dollar fine and for trespassing on the property that had formerly belonged to his parents (the siblings had succeeded in selling the property out from under him). From jail Ohr wrote a letter to the *Biloxi Daily Herald* regarding the unsanitary conditions of the prison, which was published in the article "Geo. E. Ohr Released from Durance Vile" (1910). He wrote:

> *I, Geo. E. Ohr, a law-abiding citizen, an innocent man, a victim of misconstrued ideas and culprit of misdirected energy, am now incarcerated in a filthy pen—a dirty bricked walled jail where a nauseating unsanitary dirt receptacle—a dirty and rotten excelsior torn straw mattress is strewn on a floor that never gets a scrubbing . . . I . . . had my dear sweet wife to bring me a blanket and a sheet so I would have a clean resting place on the boxes.[21]*

He plays to the sympathies of his readership, but his hyperbole becomes ridiculous when one realizes that he spent only a few hours in jail. More significant is his impression of the situation. He sees himself as a just, innocent, yet misunderstood man who has been targeted by an unsympathetic community backed by the law. His "durance vile" represents his lot in life, a place of punishment for those who chose not to fit in and go against the grain. His only comfort in jail and in life is his wife, the one who understands, tolerates, and supports him.

Chapter 5

REAL HEAD-HEART-HAND-AND-SOUL ART

Ohr, Socialism, and Individual Purpose

BECAUSE OF ITS RELIANCE ON SEAFOOD CANNING AND TOURISM, BILOXI was freed from the strictures and ideologies of the plantation system that pervaded most of the South's economy. "This industry [oyster and shrimp canning and shipping] is by far the biggest industry of the coast," asserted prominent citizen W. A. Cox in his 1905 essay, "Biloxi Old and New." The five large oyster and shrimp canning factories in the city ran eight months out of the year and were staffed mostly by hundreds of "bohemians . . . brought here from Baltimore, the chief northern oyster center." The men lived in Biloxi from September to May, helping the factories produce 2,500 barrels of oysters a day for canning purposes. One of the largest shippers in Biloxi was Mr. U. Desporte, who dispatched seventy thousand raw oysters every day, more than the other oyster dealers combined. Cox declared, "The supply never grows less though the demand steadily increases. It makes our part of the country a cash country." Cox's report not only describes the magnitude of the seafood industry but also reveals the importance of the "bohemian" worker and the outsider to Biloxi's financial success.[1]

Inhabiting a prosperous, diverse, and tolerant city, Biloxians were aware that their culture set them apart from the surrounding southern region. Personal accounts from citizens of Harrison County (in which Biloxi is located) who experienced Reconstruction in the late nineteenth-century South further illuminate Biloxi's sense of ownership and pride:

> *Our County of Harrison had no large cotton plantations, and no large slave owners, hence there was not the sharp feeling among our people because of class and caste. Harrison County had been settled largely by men and women from other lands, Germany, France, Denmark, Sweden, England, Italy, Sicily, Slavonia, Poland, Scotland, and they were not so imbued with the feeling of class distinctions as were their countries, and too, Harrison County was thinly settled, and the settlements had been built by men who had come from far countries to get away from Caste, war, taxation, too much government, and especially from too much meddling with the individual. They had come here to be free, to be let alone, to be given a chance to make a living.[2]*

The region's distinct character made it fertile ground for the socialist movement that swept the nation in the hopes of reforming America's corrupt capitalist system. While it was never a politically dominant movement, socialism was stronger around Biloxi than in any other area of the state. Mississippi was and is predominantly a one-party state, voting non-Democratic only twice out of the thirty-two presidential campaigns between 1836 and 1960, and choosing a non-Democratic governor in only four elections out of forty-four. However, in response to growing dissatisfaction with government efforts to reconstruct the South after the Civil War, Mississippi experienced an upsurge of locally grown political movements. These opposition movements, including the Republican, Greenback, Gold Democrat, and Prohibition Parties, as well as a variety of independent political groups, had some degree of success but by 1885 were mostly finished. By 1889 Farmer's Alliance leaders were in the process of forming another political bloc—the Populist Party. Along with other Deep South states such as South Carolina, Georgia, and Alabama, Mississippi gave very few votes to socialist presidential candidates. Indeed, each state gave 3 percent of the vote or less to socialist contender Eugene Debs in his attempts for the presidency.[3]

However, on a regional level, socialism gained a significant following, achieving the most popularity in the sixth (southeast, including Harrison County) and fifth (east central) districts of Mississippi. Historian Stephen Cresswell suggests several reasons for this. Most farms in these areas were traditional, small, family-owned, family-operated ventures. The majority, 60 to 66 percent, of the population was white, defusing the threat that their livelihood would be in danger without Democratic control. And, finally,

their economies were not farm based but varied, including transportation, manufacture, commerce, and tourism. The southeast and east central districts of Mississippi, which were located on the coast and maintained important train depots, were anomalies because, unlike most places in the South, they did not have to base their economy on agriculture.[4]

Even though the Socialists and any oppositional factions fell short of blocking Democratic dominance, "during the years from 1904 to 1922, the Socialists in Mississippi were the most important opposition party in the state. . . . The Socialists ran candidates at all levels, published newspapers, had prospering local chapters, and even won a couple of offices—rare for non-Democrats in the deep south."[5] Socialists from Biloxi in the year 1912 had slightly higher property values than Biloxi Democrats. Most owned their own homes and most were married with three or more children. The professions of many leaders of Mississippi socialism, according to the 1910 census, break down as follows:

twenty-two were farmers,
twenty were skilled craftsmen or industrial laborers,
eleven owned small businesses,
four were professionals (physician, two lawyers, optometrist),
four were salesmen or store employees, and
two were fishermen on the Gulf Coast.

Typically, Socialist Party leaders in Mississippi were born there or elsewhere in the South. Most, almost half, were fifty or older. Greatly outnumbering small merchants and professionals were those who worked with their hands, such as farmers and skilled craftsmen. Their personal wealth surpassed that of typical citizens within the community.[6]

These men were not at the bottom of the economic system, meaning their interest in socialism was not fueled by despair and poverty. Rather, they viewed it as a means through which they could safeguard what they had earned. "Like the earlier Populists, they sought protection from monopolies, unjust advantages of the very rich, and unfair practices by the railroads."[7]

If we take Cresswell's profile as a standard, Ohr's position within the community was similar to that of many Mississippi Socialists. Ohr owned his own property, was married, had ten children, was born and raised in

Biloxi, worked as a craftsman, and was in his mid fifties by the time socialism was experiencing its heyday in Mississippi. He was not a wealthy man, but when the fire of 1894 destroyed his business, he had the funds to rebuild within the year, whereas many businesses were not able to do so. Ohr would have also been keenly interested in protecting his trademark pottery and business from larger ceramic producers. Rookwood, Teco, and Van Briggle, for example, could advertise more widely and set their prices lower than could the individual craftsman. Finally, Ohr was also, through his mother, of German descent, as were the majority of American followers of socialism. There is no conclusive proof that Ohr was a member of the Socialist Party. However, compelling evidence suggests that he was at least a strong supporter and sympathizer.

SUMNER ROSE: FRIEND AND COMRADE

Approximately three years after Ohr's death, Biloxi's socialist leader Sumner Rose submitted a letter to the *Biloxi Herald* stating that he "happened to know him [Ohr] intimately." Aware of Ohr's struggles and conflicts, Rose presents a posthumous defense of his friend. Describing Ohr as "the potter artist . . . an artist in every degree," Rose urges that every school in the Gulf Coast, perhaps Mississippi entire, own a pot by Ohr in order to show their appreciation for him. He counters the popular impression of Ohr as an oddball, stating, "Eccentric he was, it is true, but there are few artists who are not. I . . . knew there was a second and very serious side to George Ohr. . . . To his friends he showed a depth of thought none would ever believe he had who remember only his Eccentricities."[8]

As publisher for the first socialist paper in Mississippi, *The Grander Age*, Rose was central to the movement within the state. Originally a Populist paper, *Grander Age* shifted its allegiance in 1896 when Rose refused to support the Democratic runner and endorsed the socialist presidential candidate instead. Publication of *The Grander Age* ceased for a time, but in 1903 it was resurrected in Biloxi, where it was printed weekly for a subscription cost of fifty cents a year.[9] Rose used the paper to strengthen the Socialist Party of America in Mississippi and across the South, but "the paper had its greatest impact . . . in its city of publication. Biloxi, a center of fishing, seafood canning, and tourism, soon was home to a strong and growing Socialist local."[10]

As with most other socialist publications in the United States, the paper devoted little attention to economic theories. The maxims Rose printed in *Grander Age* are closer to homespun humanist philosophy than a political platform:

> To be a Socialist is to espouse the cause of humanity.
> Instead of "making money" under Socialism, we will produce a living, and a splendid one it will be.
> Thoughts are living things—frequently they influence, frequently they propagate.
> Socialism is the doctrine of love, and those who teach it, should avoid teaching hate.[11]

Ohr's own signs and one-liners bear resemblance to these sayings in format as well as content, suggesting that he may have been inspired by Rose's example:

> No Preacher, no Doctor, no Lawyer can carry your cross.[12]
> Shapes come to the Potter as verses come to the poet.
> Clay follows the fingers and the fingers follow the mind.[13]

In addition to editing *The Grander Age*, Rose was heavily involved in socialist activities and politics. In 1911 Rose was elected alderman for Biloxi's first ward with nearly 60 percent of the vote. He also won the socialist nomination for mayor of Biloxi in 1912 but did not win the election (Biloxi also gave 20 percent of the vote to socialist mayoral candidate Jens Neilsen in 1910). Party gatherings were often held at Rose's place of work. Local advertisements listed him as the manager of the Gulf Coast Musical Headquarters, "located at 210 E. Howard Ave, near City Hall," the same address given for local socialist meetings.[14]

While Ohr's close association with Rose is not proof that Ohr himself was socialist, he did champion his friend's political endeavors. The picture published with his 1901 autobiography shows a large banner hanging from his studio that reads "Welcome Miss S.P.A."—Mississippi Socialist Party of America (plate 28). That Ohr would display such a banner is evidence of his support, but most intriguing is that he chose to publish this particular image with his autobiography.

In the early to mid 1890s Rose began a cooperative colony along the Gulf Coast called Co-Opolis Clay. It consisted mainly of Populists and supporters of farmers' and workers' collectives, primarily from the northern states. The group "built homes, a store, a print shop, and planned to farm, raise fruit and engage in light manufacturing."[15]

While Ohr did not join the colony, he endorsed their product. The *Biloxi Daily Herald* article "Geo. E. Ohr on Co-opolis Clay" stated that Ohr had been experimenting with clay from Co-opolis, where the Biloxi Brick company would locate its plant. He speaks favorably of the organization, encouraging locals to use the clay for almost any project from pottery to roofing tiling or "anything in that line, except china." Ohr continues, "The brick made from this clay be of superior quality."[16]

"MERITORIOUS SERVICE IN THE CAUSE OF SOCIALISM": OHR, WAYLAND, AND THE *APPEAL TO REASON*

If Rose's *Grander Age* aspired to organize the Magnolia State, the *Appeal to Reason* was a nationwide endeavor. Published by Julius A. Wayland, it was the most influential and widely read socialist publication of the period in the United States. Wayland's first career was in real estate but came to an abrupt end upon his first introduction to socialist tenets. He immediately closed his business in order to devote all of his time to spreading the message to friends and neighbors. Having faith in the party's teachings, Wayland believed the United States would soon be experiencing another economic crisis, so he sold all his property and assets, insisting on payment in the form of gold and government bonds. After the panic of 1893 he found himself with $80,000 that he used to begin his first paper, the *Coming Nation*.[17]

In 1894 Wayland founded the Ruskin Commonwealth Association, a utopian socialist colony near Tennessee City, Tennessee. The *Coming Nation* was the colony's main means of financial stability. However, conflict over the paper's business practices forced Wayland to leave in 1897. Later that same year "American Socialism found its most indigenous voice" when he established the *Appeal to Reason* in Girard, Kansas. Using simple, straightforward language, the *Appeal* was accessible to almost anyone who read it. With a subscription rate of twenty-five cents a year and circulation of between 300,000 and 500,000, this journal became the most prolific and

successful means by which the socialist message was spread throughout the United States.[18]

Ohr lent his considerable talents to the *Appeal*, promising a vase that would be the "only one of its kind in existence," whose "plan will be destroyed as soon as it is finished." The one-foot high vase would go to the member who collected the greatest amount of subscribers for the month of May 1899 and would be inscribed "Presented to ___ by the Appeal to Reason for meritorious service in the cause of Socialism" (plate 29). Due to its great success, the contest was repeated for the months of June, July, and August of 1899.[19]

A. or H. Ramsay was the May winner, and J. T. Van Rensselaer claimed the June vase (plate 30), securing 504 subscriptions. A graduate of Yale, Van Rensselaer was an active party member, publishing an essay in 1899 entitled "What Is Socialism?" and serving as the point person in Los Angeles for Eugene Debs's lecture engagements.[20]

Winners of the July and August vases were never announced, perhaps because they were never awarded. A change in circulation manager was not seamless and many contests were left incomplete. Another reason may be due to the anger and dissatisfaction felt by "losers." Like the sole winner, they had also contributed a significant amount of publicity work for the *Appeal*, but their efforts were not recognized. Prolonging promotional contests was thus a way to avoid negative feelings. Van Rensselaer's vase (plate 31), however, lived up to its promise. Recently uncovered by his great grandson, the pot is a strange hybrid of Victorian elegance, muddled green and brown glazes, and Ohr's trademark neck twist. Clusters of molded leaves form wing-like handles that accent the central body, engraved with the words: "Presented to j.t. vanrensslear los angeles calif by the appeal to reason giard Kansas for meritorious service in the cause of socialism." According to the paper, "When you get an *Appeal* vase you have a prize worth having. No other paper on earth has ever given vases especially made from original designs. . . . If you secure one of them you have the only one of its kind on the globe, with a standing offer by the maker, Geo.E. Ohr, of $1000 to any one who can duplicate it."[21]

Though key to spreading socialist ideals throughout the country, the *Appeal* received much criticism from other members and papers. Some of this hostility sprang from their lesser success, but Wayland's *Appeal* "was also criticized for its lack of publicity of the Socialist Party, its 'ultra capitalist business methods,' its use of the party to build the *Appeal* instead of vice

versa, its reformist approach to socialism, and its employment of salesmen who brought the socialist movement into disrepute." In 1906, the *Appeal* had an income of $10,000 a month thanks to its copious advertising. Perhaps most damning was Wayland's determination to "singlehandedly . . . 'Yankeefy' the American Socialist movement." Contests such as the one Ohr was involved with certainly perpetuated the idea that the *Appeal* was too focused on monetary support.[22]

AMERICAN SOCIALISM: A VARIED THEORY

Ohr supported socialism on some level, but what about this philosophy attracted Ohr? To investigate this point it is necessary to understand the nature of the party in America. Socialism in the United States was rarely a pure Marxist vision. Karl Marx and Friedrich Engels urged the installation of a classless society through a proletarian revolution. Land, factories, mills, and all other means of production and services would then be owned and controlled by the people via a Socialist Industrial Union Government. Equality would be achieved by eliminating money and therefore social classes.

Despite Marx's planning, many ardent Socialists were unable to grasp his turgid arguments. In fact, Wayland's widely read *Coming Nation* failed to print anything by Marx and Engels out of fear that the material was too difficult for most American readers and would turn people off to the cause. Instead, Wayland published such works as Edward Bellamy's *Looking Backward* (1888), Victor Hugo's *Address to the Rich and Poor*, and essays by John Ruskin and Thomas Carlyle that were more accessible to ordinary readers.[23]

As a result, socialism in the United States was often an odd mixture of different intellectual strands:

> *Henry George's "single tax" campaigners, Edward Bellamy's "nationalist" clubs, Christian socialists, cooperative unions, and many elements of the Populist movement each combined in its own unique way a hostility to industrialism, a limited vision of state socialism, and a devotion to political liberty.*[24]

Within this varied collection of beliefs were many opposing positions, making it difficult for American Socialists to remain unified. Those leaning rightward wanted to maintain a class system but with better cooperation

and mutual respect. An improved relationship between the classes would be achieved through a gradual step-by-step process rather than a single revolution as called for by Marx and Engels. Left-wing radicals wanted a classless cooperative commonwealth that would be accomplished through a violent working-class revolution. Some wanted to eliminate religion in favor of science, while the Christian Socialist movement believed that socialism was in keeping with "the fatherhood of God and the brotherhood of man, in the spirit and according to the teachings of Jesus Christ."[25]

During the last years of the nineteenth century, some forty utopian socialist novels urged a cooperative American society that would provide a fair and balanced life. The two most influential being Edward Bellamy's *Looking Backward* (1888) and William Morris's retort, *News from Nowhere* (1890). These two novels frame the major contradictions and issues surrounding socialism in the United States at the time.

Bellamy's *Looking Backward* resonated for Americans. It tells the story of Julian West, a typical nineteenth-century middle-class gentleman who falls under hypnosis in the year 1887 and awakens in the year 2000 to find the world much changed. All manufacturing has been consolidated under the government and all citizens work within this universal industrial service beginning at age twenty-one and retiring at forty-five. Each citizen has a distinct purpose determined by his wishes and aptitudes. Because every job is integral to a functioning socialist society, all are valued equally, eliminating hierarchy created by occupation. In Bellamy's view, money allowed the rich to prey upon the poor and was the root cause of the unjust and horrible conditions suffered by the lower class during the latter part of the nineteenth century. Bellamy's system was therefore moneyless, providing equal wealth to all just for being citizens.

Bellamy's blueprint was a popular one, and by 1900 there were four thousand Bellamy Clubs in the United States and hundreds in Holland, Denmark, and Sweden. Politically, Bellamy's vision united his Nationalist Party supporters with the Populists and amassed numbers large enough to scare the Democrats and Republicans who dominated politics in the United States.[26]

The other major socialist novel of the period, William Morris's *News from Nowhere*, was a direct response to Bellamy's *Looking Backward*. In Morris's novel, the main character, socialist employee William Guest, falls asleep and dreams of a utopian society. Unlike Bellamy's Julian West, who ultimately

remained in the future, Guest awakens and realizes that his dream will never be achieved during his lifetime, regardless of his efforts. Herein lie the key differences between Morris's and Bellamy's utopia. Morris's is much more pragmatic. His citizens are individuals who speak different languages and reflect the very realistic dissent, grumbling, and obstinate refusal that would accompany such a massive shift in hegemony. Bellamy pictures the transition to socialism as something as easy as falling asleep and waking up in a different time. For Morris, equality was attainable, but not without intense effort along the lines of the revolution Marx foresaw.[27]

Bellamy's and Morris's visions inspired a flourish of utopian communes in the United States. A diversity of programs was reflected, ranging from "absolutism to anarchy, spiritualism to atheism, speculative land development to collective industry." However, all the reformers believed that a single ideal community could serve as a prototype on which the entire country could be modeled.[28]

MORRIS, SOCIALISM, AND THE TRANSCENDENT VALUE OF LABOR

William Morris, founder of the Arts and Crafts movement, believed that the combination of worker satisfaction and consumer appreciation of handmade wares was the key to balancing society and effecting social change. Through time, Morris began to suspect that a more systematic approach was necessary to rehabilitate modern civilization, so he became a staunch and vocal member of the Socialist Party. However, his two passions were closely allied. Stirred by John Ruskin's philosophies, Morris argued that the Industrial Revolution and overuse of machinery had debased humanity and that social justice could only be achieved when all men could take pleasure in their physical efforts. Morris also believed manual labor was the one undertaking that instilled within man a true sense of purpose: "[a] man at work, making something which he feels will exist because he is working at it and will it, is exercising the energies of his mind and soul as well as his body. . . . Not only his own thoughts, but the thoughts of past ages guide his hand, and as part of the human race, he creates."[29]

Though Morris never visited America, his and Ruskin's message was carried to the United States through crafts exhibits; salesrooms; catalogs; and various Arts and Crafts, socialist, and labor magazines. The last years of the

nineteenth century and the opening years of the twentieth saw the largest following of the Arts and Crafts movement in the United States. Thousands of organized groups formed a craft network across the country between 1896 and 1915.[30]

Ohr's friend and business associate Elbert Hubbard was Morris's most vocal advocate in the United States. Hubbard constantly reiterated Morris's theme of the importance of virtuous exertions. Thus, for example, he wrote:

> *To be healthy and sane and well and happy, you must do real work with your hands as well as with your head. The cure for grief is motion. The recipe for strength is action. Love for love's sake creates a current so hot that it blows out the fuse. But love that finds form in music, sculpture, painting, poetry and work is divine and beneficent [emphasis added].*[31]

Despite his proclamations of the transcendent value of real labor, Hubbard was also a modern businessman and, like many of his ilk, was dubious of the relationship between financial value and spiritual value. In one published anecdote Hubbard described asking an artist to fix a price on his wares, beginning by inquiring what the cost of the material and production had been. The potter responded, "Do not ask me anything about the cost of material. I make a beautiful vase, that is enough." Hubbard then inquired as to the amount of time it might take, receiving the petulant response, "Time! How can you ask me the time it takes to make a beautiful thing? You certainly do not understand art. An artist knows nothing about time nor expense. He creates. That is enough." Hubbard then mockingly observed that this same artist had a work of art that, in an unguarded moment, he offered to part with if I would "pay a price which seemed to me beyond that of rubies." As Ohr often asked improbable sums for his wares, one wonders if this story does not refer to him.[32]

Ohr himself addressed the financial and spiritual value of handicraft in a remarkable letter of 1915 in which he condemned mass production for destroying creative individuality:

> *G. E. Ohr Will and can Make any of the high Priced Payers—of Rookwood Teco—Vanbriggle or Capitalized companies Servents Work—"show their HAND—As to where is the Potter—that can" "Father the Art Produced—The outcome would "BE" that Five—or*

Fifteen Did the "JOB on Pot While in Sculptertng—Carving—of Paintings it dont Take a Doz' to Accomplish Art Pottery—(Originality does not Emenate from A Company of regiment ((Cromos and Photos Are "PICTURES"—But sutch dont command Fabulous Prices As "Real—head-heart-hand-and Soul" "ART."[33]

This statement is significant for several reasons. First, it establishes Ohr's attentiveness to the competition between himself and other popular potteries such as Rookwood, Teco, and Van Briggle. Second, Ohr simultaneously condemns their methods of mass production while distinguishing his own approach of making each object entirely with his own hands. The value of art pottery, he implies, is not in the high prices or the number of people who do the carving and "sculptertng" but in the degree of originality that cannot be manufactured. He also points out that this system, which relies on "high priced payers" of "capitalized companies," perpetuates the servitude of artists on the assembly line. Not only is their product commercialized, but they cannot see their own hand or prove that they fathered the object. Finally, his invocation of the phrase "Real head-heart-hand-and Soul art," especially when used in conjunction with remarks on mass production, bears a remarkable resemblance to Ruskin's words regarding the spirituality inherent in the production of art: "'Fine Art' is that in which the hand, the head, and the heart of man go together."[34]

While at odds with Hubbard, who mocks the value of intangible components, Ohr embraces Morris's valuation of spiritual, intellectual, and physical effort inherent in a handmade object. To deliver an original creation to the world, one that exists because your individual will made it so, is the heart of Morris's Arts and Crafts ideal. That the conceptions and constructions of people within society are distinct and irreplaceable is also central to socialist thought. Money and material goods are poor substitutes for human insight and productivity. Even the *Appeal to Reason*, to which Ohr donated vases and which came under heavy criticism for its materialist slant, never offered monetary prizes to its contest winners. Rewards—a vase, a drawing, or acres of land—underscore the value of physical labor.

It is probable that Ohr's peculiar and inconsistent selling habits are products of his socialist beliefs. Ohr would ask exorbitant prices for his wares, refuse to sell to those willing to pay, and then turn around and offer the piece for a trifle to someone he deemed "worthy." This seems to be counter

to Ruskin's and Morris's standards, which urge art to be accessible to all. However, barring the realization of a truly egalitarian society, this may have been Ohr's way of equalizing the classes. He would deny the rich something and grant it to someone more deserving, awarding it democratically and based on merit instead of to the highest bidder.

The conception of labor as a sacred form of expression had links with an indigenous tradition of American thought, that of the New England transcendentalists. In his lecture "The Transcendentalist," for example, Ralph Waldo Emerson insisted that work should be endowed with dignity and spiritual purpose, in terms strikingly similar to the writings of William Morris:

> *Much of our reading, much of our labor, seems mere waiting; it was not that we were born for. Any other could do it as well or better. So little skill enters into these works, so little do they mix with the divine life, that it really signifies little what we do, whether we turn a grindstone, or ride, or run, or make fortunes, or govern the state.*[35]

In his well-known essay "Self Reliance" (1841) Emerson further reinforced his belief in labor with purpose:

> *There is a time in every man's education when he arrives at the conviction that envy is ignorance; that imitation is suicide; that he must take himself for better or for worse, as his portion; that though the wide universe if full of good, no kernel of nourishing corn can come to him but through his toil bestowed on that plot of ground which is given to him to till. The power which resides in him is new in nature, and none but he knows what that is which he can do, nor does he know until he has tried.*[36]

Henry David Thoreau was another popular figure who decried the loss of spirituality in a modern world. His book *Walden* (1854) detailed the two years he spent living on Emerson's land around Walden Pond in Massachusetts. His purpose in removing himself from society was to gain a more objective understanding of it. Addressing many issues, such as economy, reading, solitude, and higher laws, Thoreau concluded that consumerism and modern life had allowed humanity to neglect reality and perhaps

people their true selves. Thoughts from the conclusion of his book seem to resonate the most with readers: "Only that day dawns to which we are awake. There is more day to dawn. The sun is but a morning star," and "If a man does not keep pace with his companions, perhaps it is because he hears the beat of a different drummer." For Thoreau, personal accountability dictates individual fate, which should always be valued and embraced.[37]

The thoughts of Emerson and Thoreau were widely read and reached a large audience of people. The philosophies of these two men encompassed the individual as part of a whole, emphasizing a need to critically question modern society, spirituality, and, ultimately, one's purpose and place within it.

Ohr's pots ostentatiously declare that they are handmade, even crude. Through the rough clay, strange glazes, and irregular shapes, they are more closely aligned with the work of humble artisans in the folk tradition than with the factory mode of northern industrialists. These artistic qualities had a deeper social significance for Ohr, for we know that he was a political radical, a socialist supporter, and advocate of the rights of the common man.

While American socialism was a varying hybrid of thoughts ranging from utopian cooperation to a moneyless association, Ohr was never vocal about the theory's economics. Rather, it was the humanitarian component that most attracted Ohr: "I thought and thought, and wondered if I was a Republican carpetbagger or a middle of the road Democrat, or vice versa. But in the morning I solved it—I was a going potter. Eat or no eat, money or no money, sweetheart dead or not born, it was all the same to me."[38]

Ohr's forms, "no two alike," "unequaled," and "unrivaled," are his politics, religion, divine purpose, and reason for living. He considered his pots to be true extensions of himself, going so far as to call them his "mudbabies." They exist because he exists. In opposition to the assembly-line technique of contemporary mass-production potteries, Ohr is not an interchangeable cog in a machine and his vessels are not normalized replicas. Each is a distinct and necessary component with a specific place within his oeuvre. This notion mirrors the value of humans within a socialist arrangement.

Chapter 6

BEAUTY OF THE GROTESQUE
The Malformed, Marginalized, and Mudbabies

THE VARYING TENETS AND FIGURES OF AMERICAN SOCIALISM, AS WITH ALL political and spiritual movements of the time, were, at base, searching for an answer to the same question: What is the purpose of humanity? To Ohr, and perhaps many others, socialism was a way to organize society so that all human effort and existence mattered. In contrast to capitalism, which legitimized the few getting wealthy off the backs of the many, socialism valued each member and contribution within society. Though not through overtly dogmatic or traditional means, society was striving for a solution to its current spiritual crisis. Through his actions and creations Ohr also probed the questions of purpose, value, and truth that plagued humanity.

THE RUBÁIYÁT, OHRMER KHAYYÁM, AND THE MEANING OF LIFE

Ohr adorned his studio with a sign declaring himself "BILOXIES OHRMER KHAYAM," referring to Omar Khayyám, the Persian mathematician and astronomer of the late eleventh and early twelfth centuries (plate 32). Khayyám's mid-nineteenth-century fame stems from the appearance of a collection of his quatrains, *The Rubáiyát of Omar Khayyám*, translated and published in 1859 by the English poet Edward Fitzgerald. Three more editions followed in 1868, 1872, and 1879, respectively, and Khayyám began to develop a cult-like following. By the late nineteenth century, numerous illustrated editions had

begun to appear, including a famous one by the American visionary painter Elihu Vedder with images that foreshadow both Symbolism and art nouveau.

In 101 stanzas, the *Rubáiyát* describes the certainty of death and explores man's struggle to find his purpose in life. Fitzgerald's verses only loosely followed the original Persian source. In practice, Fitzgerald had produced a new statement of his own: an iconoclastic rejection of traditional religion, morality, and notions of rectitude and duty. While he would have been censored for making such assertions on his own, these statements became acceptable, or at least marginally so, because Fitzgerald's publication was allegedly a "translation" of an ancient source.[1]

Even when presented under said guise, the book was widely condemned as decadent and blasphemous. William McIntoch's spoof, published in *The Philistine*, characterizes popular attitudes toward the *Rubáiyát's* perceived nihilism:

> Wake! for the bearded goat devours the door!
> And now the family pig forbears to snore,
> And from his trough sets up the Persian's cry—
> "Eat! drink! To-morrow we shall be no more!"
>
> And is this all? Shall skies no longer shine,
> Or stars lure on to themes that seem divine?
> Ah, Maker of the Tents! Is this thy hope—
> To feed and grovel and to die like swine?[2]

McIntoch deemed the poem immoral because it questioned widely held religious and spiritual ideals.

Of great interest to Ohr were the verses of the *Rubáiyát* that repeatedly refer to a potter and his pots as metaphors for God (the maker) and individual persons, respectively. For example, stanzas eighty-two through ninety describe a conversation among pots overheard by the author while standing in the potter's house:

> As under cover of departing Day
> Slunk hunger-stricken Ramazán away,
> Once more within the Potter's house alone
> I stood, surrounded by the Shapes of Clay.

Shapes of all Sorts and Sizes, great and small,
That stood along the floor and by the wall;
 And some loquacious Vessels were; and some
Listen'd perhaps, but never talk'd at all.

It is as if the author is describing Ohr's studio exactly—wares of all shapes and sizes stacked on shelves, piled on the floor, hung from walls, and along doorframes. Talkative or attentive, these pots, like Ohr's, are anthropomorphized. The poem continues:

Said one among them—"Surely not in vain
My substance of the common Earth was ta'en
 And to this Figure moulded, to be broke,
Or trampled back to shapeless Earth again."

Then said a Second—"Ne'er a peevish Boy
"Would break the Bowl from which he drank in joy:
 "And He that with his hand the Vessel made
"Will surely not in after Wrath destroy."

After a momentary silence spake
Some Vessel of a more ungainly Make:
 "They sneer at me for leaning all awry;
"What! Did the Hand then of the Potter shake?"

Whereat some one of the loquacious Lot—
I think a Súfi pipkin—waxing hot—
 "All this of Pot and Potter—Tell me then,
"Who is the Potter, pray, and who the Pot?"

"Why," said another, "Some there are who tell
"Of one who threatens he will toss to Hell
 "The luckless Pots he marr'd in making—Pish!
"He's a Good Fellow, and 't will all be well."

"Well," murmur'd one, "Let whoso make or buy,
"My Clay with long Oblivion is gone dry:

"But fill me with the old familiar Juice,
"Methinks I might recover by and by."

So while the Vessels one by one were speaking,
The little Moon look'd in that all were seeking:
 And then they jogg'd each other, "Brother! Brother!
"Now for the Porter's shoulder-knot a-creaking!"[3]

Khayyám's language is decadent in its skepticism of God's presence and human purpose. It also celebrates and values a diversity of forms in much the same way that Ohr revered his "mudbabies." Indeed, Ohr's earthen and biological offspring shared a spiritual connection; both existed as a direct result of his actions and were molded according to his thoughts and beliefs. This bond was strengthened in 1894, by which time he had lost two children (the first of many) and his life's work in a studio fire. The pots charred in the devastating fire were his "killed" or "burned babies," who occupied a place of honor in his new studio. When asked why he kept useless wares, Ohr answered, "Did you ever hear of a mother so inhuman that she would cast off her deformed child?"[4]

Perhaps this was Ohr's way of answering the questions Khayyám proposes—would God create someone only to have him or her waste away in a purposeless life? What of the pots/people that are "ungainly" and "leaning all awry" (plate 1)? Are they nothing more than mistakes? For Ohr, broken and misshapen forms were just as capable of beauty. In this they are reflections of humankind itself, which consists of the "well-made" as well as the "broken." People or pots that appeared useless still had an inherent destiny or function. One's reason for being can be recovered/discovered by simply filling the vessel with water—that is, letting it perform the action for which it was created. Likewise, a person's importance and, thus, destiny is revealed by simply doing what he or she is able to do. Such was Ohr's response to the nineteenth century's anxiety about the pointlessness of life.

Khayyám addresses another issue that was important to Ohr—the parallel between the potter and God. Ohr saw himself as a Creator, akin to God because both created out of nothing but mere mud. In his tender treatment of his mudbabies, Ohr addressed the niggling voice, symbolized by Khayyám's Sufi pipkin, that inquires, "Who is God?" God is a "good fellow"

and kind, manifest in both the creator and the created. Ohr's value was granted by God, and he, in turn, imparts purpose to his mud creations.

As a related but peripheral issue, it is interesting to note the similar visual formats employed by Ohr and Khayyám. The following is a typical example of the kind of language Ohr used:

> *Soposen a pretty 'a beautiful'—a raving handsome and sweet darling steen years of lovlyness—were 2 tell U—right at Y-R mustach—that u was the sweetest man on Earth and was going 2 love U 4 Y-R life— heart & soul; wouldent you shout very loud, and nervously, the word— WHAT.*[5]

A sample of Khayyám's writing follows:

And if the Wine you drink, the Lip you press,
End in what All begins and ends in—Yes;
 Think then you are TO-Day what yesterday
You were—TO-MORROW you shall not be less.[6]

Both Ohr and Khayyám have distorted punctuation, random and sporadic use of capitalization, and illogically ordered sentences. Undoubtedly, Khayyám's balanced quatrains were far more organized than Ohr's text, yet both writers relied on a visually dramatic composition to further enhance their words. Whether or not Ohr was deliberately emulating Khayyám is an ultimately unverifiable but interesting thought, strengthened by the importance Ohr placed upon Khayyám's words.

OHR'S MUDBABIES: SUFFERING, DISFIGURED, AND BEAUTIFUL

Critics contemporary to Ohr often described his pottery as disfigured, twisted, and ugly:

> *His work, indeed, suffers from his efforts to make it original at any cost of beauty and aesthetic charm. . . . [I]t is the lack of good proportion, of grace and of dignity, that makes it fail to produce on the spectator the effect a work of art should produce. At once I am reminded of those*

grotesque and rugged poems of Robert Browning's, which even his most
ardent admirers can not defend.[7]

Hutson's remarks border on cruel. She asserts that spectators fail to love Ohr's pots because they exhibit a "lack of good proportion, of grace and of dignity." His mudbabies "suffer" from their physical imperfections, congenital deformations, and general deviant abnormalities. In other words, they are misfits too ugly and weird to be loved.

One may wonder why, since Ohr thought of his clay creations as children, he rendered them crippled and repulsive, committing them to a life of ridicule and exile. Ohr believed in the value of each individual, especially those whose worth was not readily apparent: the lower class, the common worker, the underprivileged, the ineffective and feeble. Perhaps because he was one, he strongly identified with the outcasts that society dismissed. Ohr intuitively combined his implicit sense of social compassion with another major theme of nineteenth-century thought, that ugliness can be beautiful if seen in the right light.

Popular philosophers Emerson and Thoreau challenged readers to find beauty in ugliness. Emerson wrote that man should embrace "the dignity of the life which throbs around him, in chemistry, and tree, and animal, and in the involuntary functions of his own body." Similarly, Thoreau argued that man should learn "to eat, drink, cohabit, void excrement and urine" in a spiritual way. Thoreau used the process of creation itself to show that body and soul were interchangeable, as they originated from the same place. While at Walden he observed winter giving way to spring, buds becoming flowers, grubs metamorphosing into butterflies, decayed animals becoming fertile soil. The hawk, symbolic of the soaring spirit, was also a vulture surviving on decomposition. Life was death and death was life, the earth became spirit and spirit returned to the earth. Thoreau insisted this realization "should at once cheer and disgust us."[8]

Richard Mohr, author of *Pottery, Politics, Art: George Ohr and the Brothers Kirkpatrick*, has proposed that Ohr's vessels confront still more fundamental issues—the realities of the body:

[Ohr's] rending and splattering . . . suggest a deeper signification in these
works and in Ohr generally. The theme is that of abjection. . . . Abjection's
blurring of interior and exterior specifically explains reactions of disgust

to body excretions—matter expelled from the body's inside: blood, pus, sweat, excrement, urine, vomit, menstrual fluid, plus the smells, sounds, images, and other psychic reminders of these excretions.[9]

The genital likenesses Ohr at times employed were simply the gateways between the inner and outer realms of the body (plate 33). His ceramics did not match up to "received templates of urn and baluster" and instead adhered more closely to clay's "shit-like," half-living and half-rotted qualities, which produced "liminal" and "formless" forms.[10]

Ohr appreciated that things that disgust us are also a necessary part of nature and vital to our survival. Though she was not contemporary to Ohr, literary critic and psychoanalyst Julia Kristeva's postmodernist theories help illuminate the connection between Ohr's disfigured pottery, society's abject, and individual purpose. Rather than forcing Ohr into a determined framework, her ideas provide the language needed to explore and define the paradox that Ohr intuitively understood.

When we witness something we understand to be a physical component of our bodies and ourselves—blood, pus, excrement, and such—we are horrified because it is no longer a part of us. The sight of blood in and of itself is not death; the absence of it is what we fear. Abjection, then, is the process of letting go. Kristeva asserts:

A wound with blood and pus, or the sickly, acrid smell of sweat, of decay, does not signify *death. In the presence of signified death—a flat encephalograph, for instance—I would understand, react, or accept. No, as in true theater, without makeup or masks, refuse and corpses show me* what I permanently thrust aside in order to live. These body fluids, this defilement, this shit are what life withstands, hardly and with difficulty, on the part of death.[11]

In this way, the body's baser functions are not reminders of death but of the distasteful processes necessary for life.

The utmost manifestation of abjection is the human corpse because it crosses the boundaries of death to infect life. It is something rejected, from which we cannot separate. Abasement is not caused by filth or sickness but is rather "what disturbs identity, system, order. What does not respect borders, positions, rules." In this way, "the traitor, the liar, the criminal with a

good conscience, the shameless rapist, the killer who claims he is a savior . . . Any crime, because it draws attention to the fragility of the law, is abject." Marginalized groups such as prostitutes, convicts, and disabled persons likewise confront the precariousness of the social order.[12]

If blood, sweat, pus, and other excretions are signs of life, vulgar though they may be, displaced and malformed people are also integral components of our communal structure. They are no less valid simply because society has deemed them unpleasant. In fact, to Ohr they are more authentic than the morally upstanding, wealthy industrialist, the incorruptible government official, or the physically perfect socialite.

Ohr offended people with his collapsing, limping, and crooked forms (plate 2). Their surfaces are festering, leprotic, intestinal, bloody, and algal (plates 34, 35, 36). But to Ohr this is not abstracted gratuity or shock. It is a truthful representation of nature. Emerson's and Thoreau's concern with finding splendor and spirituality in the vulgar realities of daily life permeated nineteenth-century culture. But the bizarre, often grotesque, at times obscene aspect of Ohr's work goes beyond American transcendentalism into a fascination with the decadent and misshapen. The writings of Oscar Wilde and his French counterpart, novelist J. K. Huysmans, and some of the extreme expressions of the aesthetic movement explore such preoccupations. These writers challenged conventional morality and traditional ideals of beauty.

OSCAR WILDE'S PERVERSION

Oscar Wilde's extravagant persona and tantalizing activities made him familiar to Americans at all social levels and brought ideas of decadence to the attention of a broad public as no one had before. Millionaires, aesthetes, and even coal miners packed in to hear his pronouncements and epigrams during his widely publicized 1882 lecture tour of the United States. After his stop in New Orleans, Wilde toured to Vicksburg and eventually visited Jefferson and Varina Davis at Beauvoir in Biloxi. Ohr may have been on his two-year sojourn at this time but was most certainly aware of the provocative visitor's stay in his hometown. Given Wilde's ubiquity and Ohr's voracious curiosity for all things ceramic, it is not unreasonable to suggest that the former informed the latter in ideas of beauty and propriety.

Wilde's writings, persona, and mode of dress challenged Victorian standards. Like other artists of the time (Whistler, for example) he embraced a persona with many feminine qualities: he wore his hair long and dressed in extravagant clothing with ladylike features such as ruffles and silky fabrics. While Victorians generally shrank from the word "homosexual," they clearly recognized from the first that Wilde was interested in a world that was sexually perverse.

These issues burst into public scandal in 1895 when Wilde unwisely brought a libel suit against John Shalto Douglas, the ninth Marquess of Queensberry and father of Lord Alfred Douglas, the beautiful young man with whom Wilde was infatuated at the time. During the London trial the defense brought out numerous witnesses who testified to Wilde's homosexual escapades. Sensing the tide turn against him, Wilde dropped the suit only to be charged with gross indecency. He was convicted and sentenced to two years of hard labor. After his 1897 release he lived a penniless and hermitlike existence until his death in 1900. To many, Wilde's incarceration and subsequent death represented a triumph of virtue. To others it was an act of martyrdom. Regardless, prior to his arrest, gay culture had no public identity and homosexuality did not exist in popular discourse. Afterward, it entered the collective consciousness.

Wilde's deviance introduced a new sensibility that defied normal conceptions of beauty and propriety. In his *Picture of Dorian Gray*, for example, he celebrates Dorian's youthful good looks but is likewise enchanted by the increasingly visible decay in his portrait. Dorian's many immoral and selfish acts, catalyzed by "the poisonous French novel," widely believed to have been Huysman's *À Rebours*, register on the face of the portrait, while Dorian himself never ages:

> Hour by hour and week by week, the thing upon the canvas was growing old. It might escape the hideousness of sin, but the hideousness of age was in store for it. The cheeks would become hollow or flaccid. Yellow crow's feet would creep round the fading eyes and make them horrible. The hair would lose its brightness, the mouth would gape or droop, would be foolish or gross, as the mouths of old men are. There would be the wrinkled throat, the cold, blue-veined hands, the twisted body, that he remembered in the grandfather who had been so stern to him in his boyhood. The picture had to be concealed. There was no help for it.[13]

To Wilde, the aging process is shockingly grotesque and brutal. One does not merely grow old. Instead, bodies "fail," their senses "rot," they become "hideous" and "haunted." Aging is a natural process of life; however, Wilde refuses to come to terms with it peacefully. Even his grandfather is described as being "twisted," "wrinkled," and "blue-veined." He resists idealizing the inevitable or idyllically yielding to an unstoppable process. Instead, he embraces the abject truth, taking the position that humanity is not exempt from decay, death, or failure. Our carcasses are not above rotting in the woods like the body of a dead deer.

In a remarkable passage of the novel, Wilde celebrates not only physical decay, but moral and mental deformity as well. As he cynically declares,

> *There is a fatality about all physical and intellectual distinction, the sort of fatality that seems to dog through history the faltering steps of kings. It is better not to be different from one's fellows. The ugly and the stupid have the best of it in this world. . . . If they know nothing of victory, they are at least spared the knowledge of defeat. They live as we all should live, undisturbed, indifferent, and without disquiet. . . . Your rank and wealth, Harry; my brains, such as they are—my art, whatever it may be worth; Dorian Gray's good looks—we shall all suffer for what the gods have given us, suffer terribly.[14]*

Because of their exceptionalism, it is actually the beautiful, wealthy, and intelligent of society who are disfigured. Paradoxically, Wilde envies the poor, stupid, and ugly masses because expectations of them are much lower. Like Huysmans, he sees people as decaying, reveling in their own ignorance and celebrating the very accomplishments that cause their collective decomposition. Only a select few (the wealthy, smart, and beautiful) can see the real truth, and for this they suffer.

In a general way, there are parallels between Ohr and Wilde. Each emphasized, even celebrated, the reality of physical deformity and decay. The spirit was not enough to stop inevitable processes at work on the body, yet this harsh truth offered its own type of salvation. So, too, did both men delight in playing a self-consciously exaggerated artistic role. Ohr, with his bristling mustache and clay-covered hands, was aggressively masculine rather than "feminized." But both men stressed sexual roles to the point of parody. Ohr simply pushed the approach in a slightly different direction.

J. K. HUYSMANS'S MONSTROUS LIFE

If Wilde popularized decadence, French novelist J. K. Huysmans was largely responsible for introducing its allure. Indeed, Wilde was an early enthusiast of Huysmans and readily admitted to borrowing his prose and ideas.

Though it cannot be firmly established that Ohr was aware of Huysmans writings, the circumstantial evidence is compelling. Huysmans reputation began to take root in England and the United States around 1895. The first translation of his work in the United States in 1890 was prefaced by popular novelist and critic William Dean Howells. Both Wilde and Whistler declared their appreciation of his writing. Huysmans's 1886 review of Edgar Degas is evidence of his art world presence. Given this particular circle of public figures as well as Ohr's interest in the abject and grotesque, it is not unreasonable or outlandish to speculate that Ohr would have known about Huysmans's ideas or even that he had read him. Regardless, perhaps it is best at this point to allow the following discussion of Huysmans to act as a characterization of the age, rather than a direct study of his influence on Ohr. Either perspective is illuminating and suggestive.[15]

Huysmans's best-known book, *Against the Grain* (1884), tells the story of wealthy Duc Jean des Esseintes, only surviving member of a once-powerful family that has succumbed to inbreeding and degeneracy. Weary of the hypocrisy of Parisian life, des Esseintes retreats to the country and adopts a self-indulgent lifestyle. Sleeping all day and awake all night, he immerses himself in solitude, books (Stéphane Mallarmé, Charles Baudelaire, Edmond de Goncourt), art (Gustav Moreau and Odilon Redon are his favorites), and his own thoughts, which, not surprisingly, ruminate on the brutal, ugly, and spurious modern world. Incessant scrutiny of spirituality and purpose trigger within him a sickness that is equal parts physical and psychological. Ironically, in the end des Esseintes is only able to save his life by returning to the culture of pretense that he fled.

While Huysmans's pessimism targets human folly—in particular, he laments the hypocrisy of the church, spiritual decay through capitalism and commerce, and the corrosive trend of individualism—his meditations revolve around their predictability and tendency toward destruction:

> *Des Esseintes dreamed of . . . the picture of a London, fog-bound, co-lossal, enormous, smelling of hot iron and soot. . . . All this activity he*

could see in full swing on the riverbanks and in gigantic warehouses bathed by the foul, black entanglements of beams piercing the wan clouds of the lowering firmament, while trains raced by, some tearing full steam across the sky, others rolling along in the sewers, shrieking out horrid screams, vomiting floods of smoke through the gaping mouths of wells, while along every avenue and every street, buried in an eternal twilight and disfigured by the monstrous, gaudy infamies of advertising, streams of vehicles rolled by between marching columns of men, all silent, all intent on business, eyes bent straight ahead, elbows pressed to the sides.[16]

For Huysmans, modern life is a destructive, unstoppable monster and humanity is its captive. Far from God's divine invention, people are simply organisms lacking agency. Nature too is a grotesquerie:

The men brought other and fresh varieties [of Caladiums], in this case presenting the appearance of a fictitious skin marked by an imitation network of veins. Most of them, as if disfigured by syphilis or leprosy, displayed livid patches of flesh, reddened by measles, roughened by eruptions; others showed the bright pink of a half-closed wound or the red brown of the crusts that form over a scar; others were as if scorched with cauteries blistered with burns; others again offered hairy surfaces eaten into holes by ulcers and excavated by chancres. . . . Thus assembled all together, these strange blossoms struck Des Esseintes as more monstrous yet than when he had first seen them ranged side by side with others, like patients in a hospital ward, down the long conservatories.[17]

The colors and shapes of the flowers fail to charm des Esseintes, who views them as images of disfigurement and sickness. Here Huysmans identifies the oft-denied dualism of reality; nature is both beautiful and ugly.

If the writings of Emerson and Thoreau embraced individuality and optimistically suggested a more general but more pervasive presence of God, the *Rubáiyát* proposed a spirituality that was separate from the popularly accepted, organized religions of the day. It confronted the question that nagged at everyone's subconscious: What if the human race had no special divine purpose? What would distinguish humanity from every other living

organism if there were no God, heaven, or hell to guide its conscience or reward their faithfulness? Huysmans and Wilde offer a gloomier response to the spiritual crisis of the Gilded Age. Humanity and even our own bodies are subject to forces of nature even darker, more brutal, yet more truthful than considered. Though harsh, there is something comforting in the equality that inevitable decay affords. These men offered a new starting point that forsook wealth and social placement as indicators of spiritual worth and replaced it with an uncaring but impartial system of existence.

Ohr's deformed, bizarre, and grotesque designs were not eccentric merely for the sake of eccentricity, as many contemporary critics insisted. Rather, like the writings of Khayyam, Wilde, and Huysmans, Ohr's creations defy revered ideas of nature and represent deeper messages about the human condition, perpetual struggle with life's meaning, and modern perceptions of individual value.

PART II
OHR THE POTTER

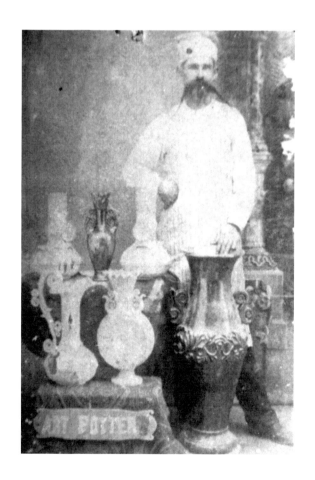

Chapter 7

GEORGE OHR, ART POTTER

OHR BEGAN HIS CAREER AS A COMMON LABORER, SPECIALIZING IN MANY trades. Even as a professional potter, many of his wares were simple forms intending to fill a need. During the 1880s and early 1890s Ohr ran classifieds in the *Biloxi Daily Herald* like this:

POTTERY!
GEO. E. OHR,
Manufacturer of
Flower Pots, Drain Tiles. Stove Flues,
Water Jugs, Vases and Artistic Ware[1]

One 1889 ad, placed seven years after Ohr learned to pot, announced his sign-painting services. He seems to have been willing to perform almost any job for which he would be paid.

Eventually, Ohr's ambition shifted. In the early 1890s he was photographed amidst a group of large pottery vessels and a sign reading "Art Potter" (plate 37). No longer did he wish to be known as the local journeyman: he now considered himself an artist. Notably, the vases standing beside him, while well crafted, are not particularly original. For the most part they follow standard high Victorian fashion. However, some ruffling around the lip of the vase in the middle and the fanciful, scrolled handles featured on the other forms hint at the radical designs for which he would become known within the next decade.

What caused this transformation in Ohr's thinking? There is no specific event or ordeal than can be singled out. What follows, however, is an exploration of the ceramic world Ohr navigated, the people who populated it, and the factors that contributed to his new self-perception.

THREE CERAMIC TRADITIONS OF THE NINETEENTH CENTURY

With Ohr's use of the specific term "Art Potter," he was firmly placing himself within the pottery practices of the day: northern manufacturing, folk pottery, and art pottery.

By the late nineteenth century industrialization had touched almost every aspect of life, and pottery production was no exception. Mass-produced ceramics were predominant in the North, where industry was king. Rather than originality or craftsmanship, the large quantities of ceramic ware were made with the intent of profit making. Such enterprises relied heavily on premixed, powdered clays and glazes and usually organized workers in assembly-line fashion. Molds were used to churn out replicated forms, which were finished in large electric or gas kilns whose temperatures and firing patterns were standardized to fit their formulaic glazes. Gates Pottery near Chicago and Grueby near Boston are well-known examples.

In contrast, folk pottery, found in small agrarian communities in the South, Ohio, and Illinois, was created under smaller, more intimate conditions and was often a family endeavor passed down through generations and tied inextricably to the needs of locals and available natural resources. Clay was dug from local pits, glazes were mixed from local minerals, and kilns were built by hand and fueled using logs cut by the potters. The lack of formal or academic training preserved the phenomenon of early handicraft types, which were simple functional forms. Jars for food storage and serving ware were the primary products.

Ohr's working practices and some of his wares suggest a close relationship to the folk pottery tradition. He dug his own clay from the banks of the local Tchoutacabouffa River, mixed his own glazes, and felled his own trees for wood firing. Ohr's pottery education was informal and arguably a family heritage as mentor Joseph Meyer was a close friend of the Ohrs. Ohr even produced "monkey jugs" and wares reminiscent of "ugly jugs," two iconic folk pottery forms. However, there are some important differences.

Folk pottery was rarely a fulltime business. In most instances it was a seasonal activity, one that dovetailed neatly with the natural cycle of planting and harvesting. Ohr, in contrast, was a fulltime potter, making or selling pots throughout the year. He had no farm or other business that would detract from his time at the wheel or, conversely, supplement his income when his pots were not selling. Ohr's interest in clay was a fervent vocation, not a hobby.

Art pottery was the third major ceramic category of the nineteenth century and the one Ohr identified with. It is linked with the emergence of the Arts and Crafts movement, which strove to beautify all aspects of ordinary life while rejecting the impersonality of mass production. This idea was not something unique to Ohr, as Van Briggle, Chelsea Keramic, Teco, and Newcomb all described their wares as art pottery. The distinguishing difference between Ohr's pots and these potteries was individual workmanship and the degree to which each form was truly unique. Even Rookwood Pottery, celebrated for adhering to the Arts and Crafts ideal, could not mask the emphasis it placed on production. Forms and designs proven successful with consumers were replicated in mass amounts and using methods perilously close to an assembly-line scheme. Nancy Owen, author of *Rookwood and the Industry of Art*, concludes, "Although management and contemporary observers agreed that Rookwood was not operated according to the prevailing factory system of regularized production and division of labor, when the circumstances of production are probed they do not always match the claims."[2]

While fine art was often thought of as elite, expensive, and inherently useless in a practical sense, art pottery and the Arts and Crafts movement attempted to dismantle artistic hierarchies and instill functional everyday ware with the same kind of beauty and value found in high art. Quality utilitarian ware was intended to be less expensive and more accessible to the everyday person, while maintaining the individuality and one-of-a-kindness of fine art.

ZIGS, ZAGS, AND DABS: OHR'S EDUCATION, INSPIRATION, AND MOTIVATION

From his autobiography we know that Ohr learned the potting trade from family friend Joseph Meyer in 1879 or 1880 but did not stay long with him. From 1881 to 1883 Ohr began cultivating his voracious appetite for all things ceramic:

> After knowing how to boss a little piece of clay into a gallon jug I pulled out of New Orleans and took a zigzag trip for 2 years, and got as far as Dubuque, Milwaukee, Albany, down the Hudson, and zigzag back home. . . . I sized up every potter and pottery in 16 States, and never missed a show window, illustration or literary dab on ceramics since that time, 1881.

Unfortunately, very little information survives about this sojourn, which was undoubtedly vital to Ohr's artistic development. His description provides only vague suggestions of regions—let alone individuals—he may have called on. Even if he visited every working potter in the United States, there is no guarantee that a record was made of the meeting. Compounding these problems is that very few of the studios that existed during his trip are still in business today. Regardless, we do know of a few contemporary potters with whom Ohr interacted.[3]

Ohr had a close affiliation with the Kirkpatrick brothers pottery in Anna, Illinois, and his collaborations with Susan Frackelton have been previously discussed in chapter 1. Additionally, Hecht has discovered that Ohr spent time at the Pison Pottery in Madison County, Tennessee, where a clay stamper inscribed with "Geo Ohr" and the following poem were found:

> If you want to Shit with ease
> Put your Elbows on your knees.
> If you Shit to fast just shove
> Your Nose up my Arse
> *Sheakspear*

From a purely visual basis Robert Ellison has linked Ohr to numerous potters, ranging from Thomas Haig in Philadelphia to Anthony Baecher of

Winchester, Virginia, and even English designer Christopher Dresser while he was at Linthorpe Pottery. Vases inspired by the Chinese Sung and T'ang dynasties (plate 34) and even the ancient Greeks (plate 38) were likewise part of Ohr's education.[4]

Though not of the period, the sixteenth-century French potter Bernard Palissy is one specific master to whom Ohr can be linked definitively. Ohr christened himself the "second Palissy," a moniker taken up by both Susan Frackelton and William King. Ohr and Palissy share some formal similarities, for instance, the use of bright colors and animal forms such as snakes and lizards (Ohr only occasionally). However, Palissy's decorations were actual molds of flora and fauna (plate 39), while Ohr distorted the vessel shape itself in a way that is more abstract and embodies a universal grotesqueness.

Perhaps of greater interest to Ohr were the legends surrounding Palissy, establishing him as an innovator and artistic rebel. Palissy was known for his obsessive search for Nuremburg faience enamel—a search so compulsive that, according to his biography, *Palissy, the Huguenot Potter* (1860), he purportedly burned all his furniture as well as some of the supporting woodwork in his home to pursue his quest. Most people around him, including his wife and family, thought his behavior insane. When he finally achieved his goal, he became famous and was patronized by the likes of Catherine de Medici, but his period of success was relatively brief. Because of his Protestant faith, he was thrown in the Bastille, where he died at about the age of eighty.

Ohr sympathized with the eccentric and outcast Palissy, who, like himself, never did get the recognition he felt he deserved. While Ohr did not burn his home or furniture, he was a controversial figure and considered himself a social misfit. Ohr embraced Palissy as a kindred spirit, stating, "When I'm gone (like Palissy) my work will be prized, honored and cherished."[5]

Ohr drew freely from the abundant visual vocabulary provided by contemporary and antiquated sources yet still created radically different forms. His relationship to his fellow potters establishes the framework he was working both within and against. Ohr was engaged in some kind of dialogue, even if only on a visual level, with potters all over the United States and throughout history.

THE NEW ORLEANS ART POTTERY: A CONDUIT

Even after he returned from his pottery sojourn and began his own business in Biloxi, Ohr supplemented his earnings by working at the New Orleans Art Pottery (NOAP) with Meyer. He spent so much time there that the 1889 New Orleans city directory has him listed as a resident for at least that year. The NOAP was a small enterprise located on Barrone Street in the French Quarter. Though only in business for a short time, 1885-1890, it left an indelible mark on Ohr and the pottery trade in New Orleans.[6]

Not much is known for certain about the NOAP, and key sources of information about the pottery often conflict. Nonetheless, it is true the NOAP was a direct forerunner to Newcomb Pottery. The NOAP consisted of members of Tulane's Decorative Art League who hoped to turn their hobby into a professional form of income. When the NOAP eventually failed, William Woodward, an instructor at Tulane who had worked closely with the pottery, approached the president of the newly formed Newcomb College about adding industrial arts courses to the school's curriculum. Once agreed that pottery would be the form of art pursued, the president himself traveled to Cincinnati to hire Mary Given Sheerer, marking the official start of Newcomb Pottery in 1894.[7]

Other than local lore, there is no evidence that Ohr worked with Newcomb Pottery, though this is not to suggest that he wasn't affected by the company as perhaps his most personal competitor. It was during his tenure at the NOAP, however, that Ohr worked closely with Joseph Meyer, a respected Gulf Coast potter, and William and Ellsworth Woodward, driving forces in the new industrial arts field. William Woodward's 1889 painting captures the atmosphere of the NOAP (plate 40). In the foreground Ohr throws a large vessel, while behind, Meyer concentrates on decoration. The painting provides a record of the interlocking relationships between the Woodward brothers, Ohr, and Meyer and reflects the significant role these men played in Ohr's life during this time.

JOSEPH MEYER, GULF COAST GURU

Paul Cox, historian, critic, and fellow potter at Newcomb College, wrote in 1935, "Joseph Fortuné Meyer is the impressive and outstanding figure in the story of the Gulf Coast potteries. . . . [He] is the foundation for all that

has been done in fine ceramics along the entire Gulf Coast." Nine years his senior, Meyer had no children and acted as father figure and role model to Ohr, willingly imparting the wisdom he had gained through his years of experience.[8]

Meyer's pots, nothing like Ohr's trademark style, were unsophisticated, imbued with subtle gracefulness, neutral glaze tones, and functionality. His surfaces were more conducive to decoration, which is most likely a key reason that Meyer worked at Newcomb from 1896 to 1927, the longest of any employee.[9]

Many of Ohr's early works resembled Meyer's folk style. However Meyer's stylistic precedence was not nearly as imperative to Ohr's development as was the image of an intelligent, learned, spiritually liberal mentor that Meyer projected. Meyer was not educated, though he exhibited a peculiar wisdom and shrewdness that prompted Cox to compare him to Voltaire, Clemenceau, and even Rabelais. Cox further describes Meyer as "an incessant reader" and "agnostic as to faith," though he was married in the Catholic Church. His agnosticism must have been a novelty to the Episcopalian Ohr.

Socialist leader Sumner Rose has provided valuable insight to Ohr: "What did he [Ohr] read—foolishness? No, but such literature as 'Dawn,' 'Mirty,' 'The Christian,' 'Nantilus,' 'The Philistine,' Etc. He clipped much of poetry. . . . To his friends he showed a depth of thought none would ever believe he had who remember only his Eccentricities." Recollections of Meyer and Ohr fixate on their wisdom, learnedness, and sophisticated wit. The older, wiser, and worldlier Meyer was most likely Ohr's introduction into this world, far from small-town Biloxi.[10]

THE WOODWARD BROTHERS: HARBINGERS OF PRACTICAL BEAUTY

William Woodward and his younger brother Ellsworth were prominent figures in New Orleans cultural life, members of Tulane's faculty, and designers of the artistic vision for the NOAP and then Newcomb Pottery. The brothers embraced the growing trend of industrial arts in the United States that was spurred by Europe's superior decorative arts showing at the 1876 Philadelphia Centennial Exposition. In part, the industrial arts movement promoted an art among American citizens that utilized manufacturing and mass production. In order to better compete with European manufacturers, the Massachusetts Normal Art School (now the Massachusetts College of

Art) opened in 1873 and was the first institution of its kind to emphasize art culture in American producers.

William and Ellsworth Woodward were native New Englanders and proponents of the Normal Art School's mission to unite art and technical labor so as to integrate art more fully into everyday life. The curriculum emphasized that "artistic, moral and 'civilized' values were all intertwined." Not only would this "raise man above the level of savagery," but it would allow America to compete in other markets. Through "the development of skill, the improvement of popular taste, and the enhancement of general well being," the school intended to benefit the industrial field and, in general, "deepen the river of life."[11]

By 1878 the Normal Art School was boasting that it was not only "rearing teachers of industrial art for the state's schools, but sending teachers to many of the remoter states of the Union." Gertrude Roberts Smith, who joined the faculty at Newcomb in 1887, was trained at the Massachusetts Normal Art School. Likewise, New Orleans' amateur potters were inspired to form the Women's Club, forerunner of the NOAP, upon viewing the school's educational exhibit at the city's Cotton Exposition in 1884 and 1885.[12]

Their efforts in educating the women at Newcomb College on ceramic decoration far exceeded a mere extracurricular purpose. The pottery classes were social experiments performed in the petri dish of the agricultural South. Aware that vocational opportunities available in New England were absent in the still-recovering post–Civil War region, the brothers wondered how anyone, women in particular, could earn a living from his or her artistic training—especially when considering that "the most unfavorable conditions under which an art school can maintain an existence are beyond doubt experienced in those cities remote from manufacturing and publishing centers" such as New Orleans. Thus, Newcomb became a kind of model for the real-world applications of artistic training.[13]

Like William Morris in England, Ellsworth Woodward strove for a simple, sensible, and practical form of beauty available to all that would counteract the debasing materialism rampant in America's industrial age. This was a civilizing factor that every human craved, Ellsworth insisted: "It is therefore no light matter this gospel of the holiness of beauty." He declared: "Art begins at home. We are learning that the museum and the picture gallery are not the natural and exclusive home of art, but that civilized life demands it in its daily routine."[14]

It was on the evil inherent in industry that Ellsworth and Morris diverged. Both men viewed the cheapness and offense of industrialization as a threat to nature, beauty, and the human spirit, but Ellsworth thought, given the right guidance, its force could be useful. To Ellsworth, business was the foundation for any great art center in the modern world. He reasoned that, as with most consumer products, competition forced higher quality, and in the case of art, a higher artistic value. Logically, a desire for quality art and artists would demand the creation of schools to train aspiring artists while also educating the general public about art appreciation. Museums and galleries would be established and "beauty would flourish within the heart of the industrial beast." A community immersed in loveliness would therefore be spiritually uplifted. With craftsman and industrialists allied, the influx of ugly and shoddy wares into the marketplace would cease and the barrier between higher and lesser, fine art and craft would be overcome.[15]

ELLSWORTH'S BRAND AND OHR'S ONE OF A KIND

The choice to develop the pottery medium in particular was logical. It also gave Ellsworth Woodward an opportunity to advance his other key philosophies: to emphasize the identity of the region and to create distinct and freshly inspired forms so that no two were alike. Though Ohr most likely never worked at Newcomb Pottery, Ellsworth's ideals are best represented through its products. It is therefore appropriate to discuss Ohr's wares in comparison to those of Newcomb as a means to illustrate the ways in which Ohr embraced and rejected Ellsworth's teachings.

Under Ellsworth's directive, the look of Newcomb Pottery became precise, a trademark style drawn from common floral shapes found along the Gulf Coast and Louisiana swamps. Designs repeatedly references local wildflowers such as blue flag, yellow jasmine, and tiger lily along with the forests of pine, magnolia, and cypress, all typically cast in a range of blues and greens. The region boasted "an infinite variety of plant life to be observed year round," which was "adapted for the designs of the artist who decorated the pottery. The trees and flowers found on Newcomb Pottery provide a miniature guide to the flora and fauna of Louisiana." Such ideals were in keeping with those of John Ruskin and later critics who wanted to get away from the imitation of historical forms in favor of finding a distinct

style for the modern age. The elaborate design and regional characteristics also connect these works to art nouveau, popular during this time.[16]

Ohr was in some ways a disciple of the Woodwards and espoused many of their Arts and Crafts philosophies, perhaps none more so that the doctrine of "no two alike." The Woodwards were also responsible for the formation of many of Ohr's ideas about the nature of art and pottery as well as the purpose of art in the world. Ohr's creations and those of Newcomb at times appeared to be two peas within the same distinct pod, especially when set against other developing contemporary potteries such as Rookwood, Grueby, and Dedham. In its early years Newcomb had a simplified system of production, consisting mainly of three steps: throwing, decorating, then firing the form. Larger potteries that relied on a division of labor system involved several craftsmen in the creation of a single pot, effectively removing the individual artist from the process. Ohr, of course, threw and decorated his own wares. Likewise, the Woodwards' belief that the industrial arts would beautify all levels of society reveals a democratic and egalitarian impulse similar to Ohr's.

However, Ohr does not fit neatly with Arts and Crafts ideals or those of the Woodwards. Ellsworth intended to elevate Newcomb's clay medium by applying the philosophies on industrial art he learned at the Massachusetts Normal Art School. He wanted Newcomb pots to combine appeal and function and in so doing facilitate a coordinated yet useful and practical home environment. The harmonizing beauty to which Ellsworth aspired was manifest in the decorative elements of the pottery. Because the finished pot was realized by at least two different people (men would throw the forms and women would decorate them), the no-two-alike ideal that Ellsworth insisted on was rooted in the surface design rather than structure. In fact, formal originality was discouraged:

> *A wide variety of shapes were employed through the years [at Newcomb]. However, from the beginning there was no special effort to create new shapes, nor to make the shapes a distinguishing mark of the pottery as was, especially a little later, to be true of Grueby and of Van Briggle wares. . . . Such forms . . . would have been chiefly the work of the potter. If a basic aim was to show the role of artistic training—in design, drawing, painting, even sculpture—and to employ the talents of young women so trained, then the character of the decoration could best be set off by traditional forms, unobtrusive in themselves.[17]*

Ohr's pots exemplified the no-two-alike philosophy to an extreme. However, for him, the true beauty of a pot was not in the surface decoration, be it hand-painted or glazed en masse. Form and surface design were inseparable, together comprising his truly unique wares. Each pot was its own statement, seemingly without consistent regard for function or an overall harmonizing beauty.

Newcomb continued to develop along the ideals that its pottery be individual works of art, but maintained a characteristic formula that readily identified them as Newcomb, ultimately forcing its pots into conformity. The designers were so restricted by the popularity of the trademark Newcomb design that Sadie Irvine, a lead decorator at Newcomb, said, "I was accused of doing the first oak tree decoration, also the first moon. I have surely lived to regret it. . . . And oh, how boring it was to use the same motif over and over though each one was a fresh drawing" (plate 41).[18]

Eventually, the demand for their affordable, functional, and unique wares necessitated an increase in production that could only be met by abandoning handmade procedures in favor of the mass manufacturing against which they had been reacting—the fate of many Arts and Crafts ventures. Not only did this process remove the hand of the artist, but it drove up prices, effectively reversing the very ideals they had espoused.

Ohr's wares, which were often impractical and rarely beautiful in the Victorian sense, managed to escape the repetitiveness into which so many art potteries, Newcomb included, had fallen. Perhaps fortunately, there was never a craze for Ohr's pottery as there was for Newcomb pots. As a result, he never needed to meet a high demand and therefore relied largely on his own labor. Ohr's consistent originality and his lack of relative success precluded any potential need to choose between originality and mass production.[19]

THE CROSSROADS OF THE SOUTH: NEW ORLEANS

Tulane University and Newcomb College profoundly influenced the intellectual life of New Orleans. Grace King, nationally recognized New Orleans writer, made the following comment in 1896 about the effect Tulane had on its host city:

Within the decade . . . since the University began its active work in the community, the whole framework of intellectual expression in society

. . . has received a new and healthy impetus. Scientific, literary, and art circles have sprung into being where before existed only desultory efforts, or, more accurately speaking, longings: old, neglected libraries have been rehabilitated . . . extension lectures have been given, free drawing classes maintained.[20]

In this period, New Orleans was one of the most prosperous and vital cities in the South. Between 1850 and 1950 it was the busiest southern seaport, the chief route through which cotton was exported, and the gateway to the Upper Mississippi River Valley before the rise of Chicago. The city had more European immigrants and more native-born free people of color than any other southern city.[21]

The endless flux and flow of diverse people and foreign goods made New Orleans a major artistic and cultural hub, one that drew artists from other parts of the United States as well as from Europe. A healthy economy likewise promoted a strong circle of patronage. Populous, cosmopolitan, home to a thriving art market, it was the South's artistic center.

As centers of art and culture for southern and northern society, New Orleans and New York, are analogous. Yet within the art world the two cities remained distant:

Southeasterners created visual art in the nineteenth century, but the region was far from the national centers of opinion and publishing, and its art got little attention from northeastern critics. American art came to mean northeastern art; everything else was relegated to merely "regional" status.[22]

Thematic and compositional choices of southern artists also contributed to their regional status. The South, in its desire to be identified as separate from the North, incorporated motifs from its own provinces, such as landscapes, flora, and fauna. As a result:

Nonrepresentational art came relatively late to the South, and unlike impressionism, abstract expressionism never became widespread in the region. Representational and narrative art, on the other hand, endured in the South, and they continue to thrive today, finding new interpreters and interpretations.[23]

As previously noted, Ellsworth Woodward strongly encouraged students to stick with local subjects, borrowing British writer Violet Piaget's concept of "genius loci," defined as "a substance of the heart and mind, a spiritual reality." Woodward's philosophies on which subjects were appropriate for southern designers at Newcomb Pottery reflected the general perception of what southern art should be as well.

The self-imposed segregation of northern and southern art markets, and Ellsworth's insistence on southern locality, did not preclude artistic dialogue between the two sections of the country, however. If the North paid little attention to southern art, nothing stopped northern artists from visiting the South or southern artists from relocating to the North.

Randolph Delehanty's study *Art in the American South* (1996), one of only a few books to relate a history and survey of southern art, illustrates New Orleans' syncretism. Of the 199 southern artists of the early nineteenth to late twentieth century that Delehanty includes in his study, 115 lived or worked in the Crescent City at some point. Most had relocated from some other region, and 98 were associated with northern cities. Ohr is, of course, part of this mixture.

A specific case in point is painter Arthur Wesley Dow. Enmeshed in the New York art world and instructor at Pratt, Columbia University, and the Art Students League of New York, Dow was aware of and impressed by southern artistic efforts in general and Newcomb Pottery specifically:

All who have at heart the development of art industries, who recognize the value of beauty in its relation to every day life, will be interested in the Newcomb pottery. It is a serious effort in the direction of uniting art and handicraft. The examples I have seen were beautiful in form and color, simple in design, and of excellent workmanship.[24]

The primary documents discussed at the opening of this chapter continue to best express the impact that New Orleans, and the events and figures associated with it, had on Ohr. It is true that Ohr was working in his extreme trademark style before coming under the influence of the Crescent City. However, the ads he placed in the *Biloxi Daily Herald*, combined with the 1892 photograph in which he identifies himself as an art potter, illustrate that his conception of self was changing. The individuals and associations

described in this chapter, though having an impact on his physical wares, trace most specifically Ohr's internal shift from craftsman to artist.

Ellsworth Woodward's philosophy of "no two alike" became the hook upon which Ohr hung his reputation, while Newcomb's success provided artistic substantiation to the clay medium. Thus, Ohr was freed from the constraints of traditional folk art. Yet Ohr declined many of Ellsworth's other limiting dictums, instead turning to the mélange of New Orleans' art culture. Here he found broader expressions of beauty and truth that countered the specificity of southern regionalist art. Ohr's art pottery therefore embodies the unique brew that was late nineteenth-century New Orleans.

Chapter 8

RUFFLING, CRUMPLING, AND TWISTING

Ohr's Visual Vocabulary

PREVIOUS CHAPTERS HAVE EXPLORED AND OUTLINED THE CONTEMPORA-neous philosophies, movements, people, and places that had an impact on Ohr and his creativity. This second half of the book applies that insight to his body of work. His buckled and distorted pieces, at times malformed, anomalous, and event deviant, tossed aside the traditional functionality of clay work. Despite prevalent influences from his own time and throughout history, Ohr's pottery was radical and unique. This chapter examines the methodologies, processes, and categories of Ohr's output to further illuminate the choices that made him distinct within his time and among his colleagues. As always, the context illuminates the intent of all his choices.

In order to understand and investigate his working methods and formal constructions, it is necessary to impose some loose categorizations on his large and diverse output. Ohr's oeuvre can be subdivided into four categories: early traditional and derivative; functional wares such as pitchers, chimney pipes, and flower pots; trinkets, primarily small, cheap novelties such as puzzle mugs, coin banks, log cabins, inkwells, and prank creamers; and art pottery, consisting of his famous twisted and misshapen works.

EARLY/DERIVATIVE FORMS

Like any other artist or craftsman, Ohr had to start somewhere. An art student's first forays into drawing are awkward and unsuccessful, so too must

have been Ohr's early exertions. Aside from the pig flasks inspired by the Kirkpatrick brothers and the stamper from Pison pottery there are virtually no examples from his extreme early stage. This, of course, begs the question of whether or not he kept them and whether or not these first attempts were also his "clay babies." What does exist are unassuming efforts, largely based on fundamental shapes that are utilitarian and technically successful but exhibit few, if any, of his trademark manipulations (plate 42).

Interestingly, scholars often conclude that creations in obvious imitation of other potters (and even glass- and silverware) occurred early on in his development, reasoning that Ohr was just accumulating visual data and skill upon which he would later build. Ohr did at times do this, but derivative is not synonymous with early. He borrowed motifs and employed Victorian and traditional adornment throughout his career. It becomes clear early on why it is difficult to create a chronology based on form alone.

FUNCTIONAL WARES

If Ohr's art pottery did not appeal to the average consumer, then his practical wares and trinkets were designed to do just that. Despite the fact that he never sold a lot of his art pots, Ohr remained in business for many years, owned his home and studio, and supported a wife and ten children. He was, of course, able to do this by providing the community with its ceramic needs: "If it were not for the housewives of Biloxi who have constant need of his flower pots, water coolers and flues, the family of Ohr would often go hungry." His purely serviceable specimens, lacking his artistic originality, are not given much scholarly attention. Most are not even glazed (plate 43).[1]

Ohr's functional wares cannot be assigned a late or early designation as he made them throughout his career. Objects from this category are valuable for the origin and context of their surface decorations, if any. For instance, Ohr created a mold of President Grover Cleveland's face in an effort to appeal to public awareness of his two terms as president, 1885–89 and 1893–97.

TRINKETS

Most likely Ohr's trinkets were also responsible for a healthy portion of his income, the main market being tourists whom Ohr encountered at fairs and in his studio/store. In both environments Ohr's charge was to attract passersby, which he did through the use of loud, boastful signs, his strange appearance, and his acrobatics on the wheel. Some pots have been recovered with random names on the bottom, suggesting yet another one of Ohr's ingenious marketing strategies. As a visitor strolled past, Ohr would lure her in, perhaps by inquiring of her name or simply through his ceramic talents. Before she knew what was happening, she became captivated by Ohr's spins and swirls that caressed the clay into an impossible variety of shapes, completely entertained by his magic show. At the end he carved her name into the metamorphosed clay, thus personalizing a souvenir from the crazy Biloxi potter while applying a touch of pressure to purchase the piece. Attracting attention was merely the first step. Making a sale required just as much, perhaps more, finesse.

His most popular baubles included three-handle loving mugs, puzzle mugs, log cabins, card holders, personalized pots, coin banks, brothel tokens, and creamers bearing sculpted feces (plates 14 through 19). The mugs, log cabins, card holders, and personalized pots are amusing, fun, and innocent, similar to impulse items positioned at the checkout line. Of this group, the puzzle mug with its complex construction could be relatively pricey, about one dollar. To drink from it the user must cover the correct combination of holes. Knickknacks were undoubtedly less expensive, as many, the log cabins and inkwells, for example, were made from molds. Likewise, the loving mugs and personalized pots were simple shapes that Ohr made hundreds of times each day. Playful and fun, these trinkets appealed to adults and children alike.

The final three types—coin banks, brothel tokens, and feces creamers—express a much more mature sense of humor and aptly represent Ohr's own brand of naughty and off-color wit. Coin banks often took the shape of droopy and indefinite forms, resembling feces or, at the very least, suggestive organic/anatomical shapes. One bank was modeled after a vagina, complete with pubic hair scratched into the surface and a slit down the middle where coins were to be deposited. The brothel tokens are flat ceramic exonumia, cast from molds. There are six known variations, each with an

imprint on both sides, providing a total of twelve racy phrases constructed mostly of letters and pictures. Listed below are the deciphered messages, front and back, of the coins pictured in plate 19. From left to right they read:

You have a fine pair of balls
Leaf [ve] me feel your cock
You made my ass tired
Good for one screw
I love you dear
Give me some
A Screwing Match
You have a hairy pussy
Let's go to bed
Put it inside
You have a big ass
Can I screw you

New Orleans was home to Storyville, the United States' first experiment in legalized prostitution, beginning in 1898. Within this district specially designed tokens could be purchased and redeemed for "services." Upon delivery of said services, the customer would leave the girl a token and any appropriate gratuity, ensuring that the madam got her cut and the girl could keep her tips. Though termed "brothel tokens," Ohr's coins were not used as official currency within these establishments but were intended to take advantage of the unique tourist trade that this culturally and historically significant destination attracted.[2]

Ohr's feces creamer was a devilish prank. Imagine a small, unassuming bowl set out with coffee and tea. As guests consumed the contents a small pile of excrement (sculpted of clay, of course) emerged, the hook being that the scat was not discovered until the majority of cream had been consumed.

In recent years, Ohr's trinkets have begun to enjoy a deserved elevation of status in value and scholarship, while their significance is debated. Critic and scholar Garth Clark has linked their off-color, irreverent, and risqué sense of humor to the fetishistic subconscious of Funk and Dada movements. Richard Mohr blurs the distinction between these trinkets and Ohr's art pottery wares, reading them both as cultural texts representing a truly American vernacular, a rarity among U.S. potters at the time. Undoubtedly,

as these authors argue, such baubles hold cultural and historical significance, but this does not exclude a more pragmatic purpose of making money. Akin to pens with figures that strip when clicked or decks of cards bearing nude pictures, Ohr's trinkets are responses to popular culture. He so often had his thumb on the pulse of consumer desire that these wares seek to be read primarily as extensions of this.

ART POTTERY

Though each of these categories shares areas of overlap, Ohr's art pottery is arguably the most recognized. Originating as traditional shapes—vases, mugs, teapots, bowls, and cups—pots in this category exhibit the extreme colors, twists, and contortions for which he has become famous (plates 1–4). The most frequent shapes were the vases, bowls, and pitchers that provided the ideal foundations for his manipulations. Such simple forms lent themselves to the larger output and variety on which he staked his reputation and the oft-repeated no-two-alike philosophy. These imaginative forms are a fantastic language of shapes and motifs that are Ohr's distinct and masterful responses to new cultural and social phenomena, as outlined in previous chapters.

It is challenging to try to describe the difference between Ohr's art pots and his other wares, especially in light of modern scholarship, which has interpreted much of his oeuvre from an artistic perspective. How does one define the "artness" of his deliberate art pots, especially when at times the lines between his categories are blurred. The issue is complicated further because Ohr seemed to consider anything that was not a trinket or functional piece to be art, while critics and collectors today have different criteria for categorization. Ohr's writings suggest that the mere creation of these wares by the potter himself was justification enough to call them art pottery. His main qualifiers seemed to be their one-of-a-kindness and the degree to which they expressed his "head, heart, hand, and soul." Though some pots may forever remain in limbo, it is possible to outline definite motifs that pervade much of the output considered to be Ohr's true art pottery.

As discussed earlier, at first glance Ohr's art pottery is neatly aligned with the ideals of that movement: he emphasized one-of-a-kind individuality, worked in the traditionally utilitarian medium of clay, and vehemently rejected concepts of repetition and mass production. He is further situated

within this context by the extent to which he borrowed from contemporaries, such as basic ceramic forms, some crumpling and ruffling techniques, and the intermittent use of earthy-colored glazes. However, much of Ohr's work ceases to be like art pottery of the late nineteenth century.

Many scholars agree that Ohr's creations have entered a high-art paradigm, but they rarely agree on why. Some insist it is because of his sculptural use of clay, while others dispute this, saying his forms did not take advantage of any traits inherent to three-dimensional sculpture. Critics link his manipulations and contortions to the abstract expressionism of Jackson Pollock, while some challenge the notion that these objects were self-expressive, claiming they were more formalistic than emotional. To an extent, we will never know the answer to these theories because that would require access to Ohr's own thoughts.[3]

Discussing all the ramifications of what distinguishes art from craft would be an exhausting process. Like many such disputes, it is essentially a matter of definitions, and both the terms, "art" or "craft," can be defined in innumerable, almost limitless ways. It does seem worthwhile, however, to examine this question from the nineteenth-century standpoint, since in the nineteenth century this issue was often discussed and debated. Ohr was surely familiar with the terms of this argument, which defined "art" and "craft" largely by their functionality.

If craft is inherently useful and art's purpose lies in its aestheticism, then Ohr's choice to use traditionally functional forms that he then rendered completely dysfunctional was extremely avant-garde for his time. Consider pitchers too small to hold much liquid (plate 44); bowls riddled with pock marks, discouraging any kind of use for fear of the contents becoming trapped (especially food, which would rot) (plate 3); vases so visually harmonized that adding flowers would ruin their appeal (plate 45); and many thrown too thin, and thus made too fragile to survive the typical wear and tear of a serviceable ceramic piece. Ohr's pots are the physical manifestation of his belief, as outlined in chapters 5 and 6, that function does not equal worth and purpose, either for people or for wares.

This was a period when accepted academic norms were being challenged to reveal deeper emotional or psychological truths. "Finished" paintings by popular artists like Kenyon Cox, William-Adolphe Bouguereau, or Jean-Léon Gérôme were being challenged by the sketch-like styles of such figures as James McNeill Whistler or the French Impressionists. Academic

beauty was being contested by various modes of realism, or symbolism, that explored unusual visual and emotional conditions.

Ohr's distorted and impractical pots also defied existing norms. Pitchers that looked like pitchers, but could not perform as such, deformed bowls that were not practical—not one could do what was traditionally expected of it. Their distorted shapes seem to provoke existing canons of beauty and purpose, while at the same time creating a strange new allure of their own.

His teapots provide an ideal example of how difficult it is to define and characterize the degree to which his pottery challenged conventional notions of utility. Although they comprise only a small proportion of his oeuvre, the teapots are some of his most fascinating objects, displaying fantastic designs, colors, and techniques. For example, he applied two separate chambers and spouts to a teapot—one side for tea, the other for hot water. Or he utilized a traditional cadogan design, which required the user, through an intricate system of interior channels, to pour the liquid in from the bottom because the lid has been fused to the body. At times he glazed two sides of the same teapot in a radically different way, so that a simple rotation of the wrist would provide a completely new object.

Without a doubt his teapots are original and creative but, because they are still usable, straddle the line between art and craft in a way his more definite art forms do not. If, as described above, we can define the "artness" of Ohr's pots as founded in the play of a functional object rendered dysfunctional, then where do his teapots fall? They still use his characteristic radical glazes, but very few, if any, appear structurally deformed (plate 46). To be clear, his skill and talent are not what is being questioned. Rather, these teapots test the definitions of Ohr's "art" pottery.[4]

The artness of Ohr's wares is not always present, even in forms he would have considered to be art. It would be extremely cumbersome and ultimately fruitless to speculate, piece by piece, whether or not Ohr strove to cross from craft to art and what qualifiers he used for this. It is doubtful his knowledge was that specific. Most relevant, however, is that his behavior emulated that of artists whose creations were recognized as art, thus revealing his conviction in the artness of his pots.

There are five distinct decorative motifs that are consistently associated with Ohr's art pieces, at times with early forms and rarely, if ever, with trinkets and functional wares. Used either separately or combined, they are crumpling, ruffling, twisting, tubing/lobing, and surface snakes.

Crumpling

Crumples are often asymmetrical and lopsided, creating the effect that the form is falling, sagging, or melting (plate 2). There is no obvious sense of control. Yet because these vessels have kept their shape (never tore or fell apart as a result of their slumping), it is apparent that the chaos was controlled. Ohr had perhaps encouraged a vigorous slump and allowed it to dictate the shape, but he also prevented the pot from becoming a mere pile on the floor.

Ohr's working methods are not clear, but a possible approach is that, unlike other effects, crumpling was done while the clay was still wet, before it had reached its leather state. It is most often seen on open-form, unlidded vessels such as bowls, pitchers, cups, and some vases, because the uneven nature of the crumpling made it difficult to fit a lid securely.[5]

Ruffling

Ruffling is a flair-like embellishment that typically occurs at the lip or base (plate 47). It is a superficial feature that is not involved with the object's structure, though it does imply movement. Ruffles add an element of suppressed personality and mischievousness, as though the pot was capable of twirling itself. Ohr often used ruffling in conjunction with a smooth, nondeformed surface, setting the whimsical undulations against the fixed silhouette. Like a little boy in a tuxedo, ruffling is reminiscent of a struggle to free oneself of restrictions and discomfort.

Ohr's ruffles can be quite graceful, like flower petals or rippling drapery. Or, in contrast, they can assume a tattered, thin look. In the former, the soft curves suggest a process in which Ohr first stretched the clay and then gently rubbed his finger over it to create a circular dip; the latter process indicates that Ohr pulled the clay thin and then pinched it together with his fingers.

Twisting

Twisting occurs within the body of the pot and is evidence of Ohr's ability to throw the clay extraordinarily thin (plate 48). Clay that twists on the wheel indicates that there is a discrepancy in the thrower's technique, creating an

inconsistent wall thickness. Because the thinner part cannot support the thicker, the shape will undoubtedly collapse upon itself. In order to twist the form, Ohr threw the vessel with extremely thin walls and kept that thinness uniform throughout. Twisting was most likely executed while the clay was still very wet, as semi-dry clay would rip and break.[6]

Twisting, like crumpling, jeopardizes the structure's integrity, yet Ohr's torques are tidy and controlled, not chaotic or lopsided. Twisting was most often used in taller objects such as vases because they are narrow and easier to manipulate in this manner. It was not confined to such forms, however, revealing Ohr's remarkable technical skill.

Tubing/Lobing

Tubing, almost exclusive to bowls and vases, symmetrically separates the design into three or four lobes, resulting in an organic shape (plate 49). Perhaps because it was more time consuming, this effect is not used as frequently as ruffling or twisting. Ohr would have needed to throw the original shape, allow it to reach a leather state, and then cut and shape the body into curved tubes that would then be reattached to one another. Because this process is more involved, tubed pots lose that sense of spontaneity and emotional gesture found with other motifs. For someone as skilled as Ohr, tubing probably would not have taken that long, but the process was more complex. Though interesting, tubing is not nearly as electrifying as his other adornments.

Snakes

Ornamental snakes are by far the least common of his decorations, yet they have opened a significant dialogue among Ohr scholars. The only other animal images he used were coin banks in the shape of farm animals and pig flasks, all of which were made from molds. Ohr's implementation of the snake form was infrequent and stylistically unlike his other embellishments, indicating that he borrowed the motif from other clay workers. Susan Frackelton and the Kirpatrick brothers both incorporated snakes in their decorations. However, compared to the Kirkpatrick brothers' snakes, in which distinct species can be discerned, Ohr's are not very realistic (plate 50). Neither do they intertwine or create a nest over the entire surface of the

pot, as the Kirkpatricks' snakes do, but simply encircle the neck once or rest atop a contour. The long, thin handles Ohr used on vases and teapots were snakelike simplifications, only lacking a face or reptilian details, suggesting that he was merely attempting to develop the motif further.[7]

TYPES OF GLAZES

> My creations have an intrinsic value; in shape. . . . Can't read nothing in color R quality in his DESIGNINGS—you paint the house any color you like and you DON'T change his designs. I claim NOTHING in COLOR R QUALITY—only originally in designs—a shape creator and maker.
>
> —GEORGE OHR

Ohr insisted that the true virtue of his pots lay in the form rather than the finish, as his quote above affirms.[8] Perhaps this declaration stemmed from the accidental nature of the firing process—he preferred to gain attention from something he did purposely rather than from something out of his control. Numerous factors influence the success or failure of a glaze, such as consistent quantities and qualities of its ingredients, the thickness of the application, the age of the mixture, and even the type of clay. Glazes applied too thickly or that have a tendency to run will drip onto the shelf below, ruining pots that may otherwise be perfect—a common occurrence. An Ohr vase owned by the Philadelphia Museum of Art shows just this simple error in judgment. His thickly applied glaze ran off the pot during firing, forever fusing its base to the kiln stilts on which it sat.

The success of the firing itself is just as variable. Clay not completely dry can crack or possibly explode if too thick. Environmental phenomena that effect humidity and moisture, for instance, can prevent proper oxidation and reduction within the kiln, thus affecting the ultimate color of certain glazes. Prolonged periods of oxidation or reduction will likewise alter the outcome. Even wares made of exactly the same kind of clay and glazed from the same batch can turn out completely different just based on their location within the kiln.[9]

These accidents of the kiln were embraced by Japanese potters, who appreciated the imperfections inherent in natural beauty. Japanese ceramics

are often asymmetrical for this reason. Ohr's imperfect forms may have been a response to this popular aesthetic, but the derision of glaze work expressed in the above quote indicates his preference for control. As with most aspects of Ohr, this was contradictory. His disregard for finishes is challenged by the tremendous effort he put into perfecting them—too much of an effort, in fact, to believe that they were as unimportant as he claimed.

Ohr's surfaces are some of the most original and remarkable in the history of American ceramics and, despite their appearance, were not accidents but oft-repeated recipes. To attain these looks, he sometimes had to fire a pot three or four times. This effort is compounded by the fact that Ohr used a wood kiln, which requires constant vigilance to achieve and maintain the proper temperature. His cratered pink bubble glaze is a perfect example (plate 3)—most ceramicists would not consider a graceful vase covered in sharp pits a success, yet Ohr did it deliberately, repeatedly, and through much exertion.

Art potters, whose main goal was visual pleasure, often decorated their surfaces by means of drawing or molding. For them, glazes were only canvases for their artwork, rarely the finished design. In either case, a blistery pink coating was considered a failure. Ohr, on the contrary, spent countless hours, first inventing, then perfecting the recipe for repetition, and finally firing it several times over. That is a tremendous amount of labor for someone who claimed not to think highly of his glazes.

Perhaps the case is being overstated. After all, Ohr's claim that his colorings were secondary does not mean they were inconsequential. Evidently, Ohr did value his glazes but only feigned a casual attitude because contemporary critics all but ignored his forms in favor of his astonishing illuminations. Both, however, took extraordinary amounts of skill and time. His denial was simply a means of diverting and redistributing attention.

While the majority of Ohr's coatings were extremely colorful and vibrant, there are two groups that stand out because they are exactly the opposite of this: his metallic glaze forms and his unglazed vessels.

Metallic Glaze Pots

Much of Ohr's oeuvre pulsates, ripples, and contorts. Most of his forms are organically integrated with a smooth transition at points of direction change. His metallic glaze wares are cold, rigid, and streamlined machine

parts that have been pieced together (plate 51). They are apt to be slender, tall, and vaselike, often standing two to four inches above the rest of his oeuvre. The forms are graceful and show Ohr's expert throwing skill, but their inanimate nature contradicts everything about the man and his body of work.

Coated in a dark, metallic oil, they are akin to lubricated high-friction mechanisms. Certain angles reveal the same kind of rainbow effect that one experiences in an oil puddle on asphalt. At times these have been interpreted as ritualistic totems far separate from the rest of his oeuvre (by Hecht), as pots thrown on top of pots to further boast of his throwing skills (by Ellison), or as sexual puns and anatomical representations that further clarify the meaning of his pottery (by Mohr), but their existence remains a mystery.

Unglazed Vessels

Paradoxically, Ohr's bisque vessels reinforce his skillful glaze application and fit. Ohr left many pots unglazed throughout his career, though the largest quantity was done between 1903, when he ceased glazing because of the undue critical attention given it, and 1907, when he gave up potting completely.

These wares, many made from scroddled clay, often contained folds, twists, and crumples that were more extreme (plate 52). Because of the multiple steps required for his complex glazes, Ohr most likely gave up on them in his old age. The later bare forms are treated violently, resulting in deep crevices, spirals, and creases. Coating these wares would only clog and cover their contortions. Ohr made up for the absence of color with severe manipulations.[10]

His metallic and bisque wares illustrate the customization of finish to form. Even the previously mentioned pink bubble glaze is suited to the structure, which is otherwise free of motifs. Though appearing on curvaceous vases or bulbous teapots, the outlines are relatively uncomplicated, allowing the glaze to shoulder its weight in the design. Ohr's tall vases with spindly arms exhibit a range of vibrant pigments from red to pink to speckled. However, the bodies of the pots were only slightly manipulated, and the finishes, though colorful, are smooth, flat, and shiny (plate 45). A textured or crusty glaze would detract from these forms, so Ohr utilized undulating

handles to define negative space and enliven the surface. Conversely, he used these same shiny, smooth colors to sculpt the surface—light reflected from the curves and folds became deep-shadowed caverns.

Initially, it seemed possible that some of these coatings might provide a means of dating Ohr's oeuvre. His pink bubble glaze, for example, was so unusual that it would have had to come from the same batch and perhaps even the same firing. In studying many examples, however, it becomes clear that he used it too often to be temporally specific.

Ohr's signature glazes have become a point of controversy in recent scholarship as well. After James Carpenter discovered Ohr's trove, it was thought that Ohr's bisque pieces, estimated at about three thousand, were actually unfinished wares. As a result, about five hundred were glazed by unscrupulous dealers and turned up at auctions. It was not until Hecht observed that they were actually fully realized that this practice came to an end. Fakes are easily recognizable, and none come close to the brilliance of Ohr's illuminations. Nevertheless, five hundred pots from an already limited supply have been destroyed.

Studying Ohr's oeuvre in this way provides observations that break down the mythology permeating our current perception of Ohr. The next chapter will build upon these remarks to pinpoint where story has overshadowed fact.

Chapter 9

STRATEGY AND MEANING IN OHR'S POTS

THE 1894 FIRE AND THE DATING OF OHR'S WORK

IN THE SEQUEL TO HIS 1973 MONOGRAPH, *GEORGE OHR AND HIS BILOXI ART Pottery*, Robert Blasberg proposed an inexact and misleading method of dating Ohr's collection that has been largely accepted as fact: "Since all the pottery in the building was destroyed by fire, Jim Carpenter estimates that 95% of the extant Ohr pieces date from the years between 1894 and 1906."[1] Scholars have been willing to accept this generalization because it bolsters the importance of the 1894 fire to Ohr's distinctive style. They agree that this unfortunate event propelled Ohr's designs from interesting yet ordinary to tortured and revolutionary. That Eugene Hecht titled his book *After the Fire* indicates his position: "George was to be reborn: mature, passionate, full-blown like Athena." Garth Clark, too, sees the flames as a "rebirth or resurrection" insisting that "after the fire his [Ohr's] work developed a smoldering radicalism that, in the next decade, produced nearly all of Ohr's true art pots."[2]

This is a difficult theory to prove since Ohr rarely dates his wares. And, as noted in the previous chapter, a stylistic evolution is equally difficult to ascertain. However, it is possible to impose some dating guidelines. Ohr stated that he started signing his pots after 1898:

A visitor asked me for my autograph and since then—1898—my creations are marked like a check. The previous 19 years mark is like any old newspaper type, just like this

 G. E. OHR

 Biloxi, Miss.[3]

So we know that signed pots were made in 1898 or later, and those that bear his stamp were made prior to 1898. Hecht has also observed that there is a much greater percentage dated after 1900 than in the remainder of Ohr's oeuvre, suggesting he started to mark his pots religiously somewhere around 1900 or 1901. Likewise, no glazed examples dated after 1903 have been discovered, which strongly supports the theory that Ohr stopped glazing around this time. Ohr's few chronicled specimens, signature types, documents, photographs, and similar evidence can be used to construct groups of closely related pieces, which can then be dated precisely or within one to two years.[4]

Hecht has created a system to identify specific periods with reasonable assurance. Thus, he distinguishes pots made before 1898 (stamped, not signed), after 1898 (bearing a signature), right around 1897 and 1898 (bearing stamp and signature), between 1901 and 1903 (dated), and after 1903 (dated, signed, and unglazed). This method cannot be applied to every pot, nor can it chronicle Ohr's entire body of work. But it provides a point of reference from which to start, and an alternative to the speculation that has directed the theories of some scholars.

Ohr's statements about when he began to sign his pots, combined with observations of his collection, dismantle the popular idea that he had an "early" mode, generally consisting of derivative and unimaginative forms, and a "late" one characterized by his well-known twists and manipulations. In fact, each approach can be found throughout his career. Robert Ellison cites folded, crinkled, and ruffled vessels charred in the 1894 blaze as "sound evidence that Ohr had begun to alter and manipulate his pots well before the fire," though "how long before the fire is not known." Evidently Ohr's distinctive style developed *before* the 1894 fire. However, it is a story more fitting of an artistic genius if his trademark flamboyance emerged as catharsis to a traumatic event.[5]

SPONTANEITY, STRATEGY, AND WORKING PRACTICES

Ohr's collapsing, twisting, and crumpling processes are often interpreted as expressionistic and emotional gestures, leading scholars to equate his working procedures with the vigorous and intuitive methods of abstract expressionists Jackson Pollock (painter) and Peter Voulkos (ceramicist). To make Ohr a renowned legend, it is necessary to situate him among these heroes of American art. Yet Ohr's oeuvre is not as spontaneous or expressive as it initially appears to be.

Edwin Atlee Barber observed that "the extreme thinness of the pieces and the great variety of forms are their special characteristics," and many writers since have seized on that fact. But it is misleading to believe that all his wares, or even a majority, exemplify this extreme. Those fortunate enough to have handled many examples of Ohr's works will undoubtedly have been surprised at both the lightness and heaviness of his wares.[6]

Ohr's thin walls were not consistent features, but means by which to achieve his astounding effects; it is easier to twist or crumple a thin body than a thicker one. So, when Ohr sat down to begin throwing, he had to have the ultimate design in mind in order to know how thick to make the walls. This observation, though seemingly minor, addresses larger issues about his modus operandi and refutes the image of the madcap potter frantically and intuitively churning out wares, immersed in his own creative trance. Admittedly, existing descriptions of Ohr at his wheel, reproduced within these pages, seem to suggest just such a scenario. However, it is important to note that such observations come from visitors to his studio or other bystanders on whom Ohr was trying to make a certain impression. Their accounts attest to Ohr's remarkable technical skill and fluidity on the wheel, but skillfulness is not the same as an unconscious frenzy of energy.

Ohr's experiments are unique and enthralling, but the most successful have complementary outlines, effects, and finishes that harmonize to create a complete design. Ohr's vases, for example, were not overburdened with effects and have little variation: tall and thin with long spindly handles (plate 53); tall and thin with no handles (plate 54), simple base with effects added (plate 47); and, finally, his machine-like, metallic glaze vases, discussed previously (plate 51). Some of his most beautiful creations are austere, caressed by graceful handles that accentuate shifts in direction. Additional adornments would have destroyed the design's overall harmony. He knew which

combination of elements would be most effective, and he had an image in his mind (and perhaps even on paper, though those designs are no longer extant) before he even began throwing. Ohr's style therefore reflects premeditation and routine.

Ohr's teapots (which were previously examined from the perspective of their "artness") also illustrate his working methods and philosophies. Their infrequency is easy to explain since they are perhaps the most complicated ceramic form. A vase or bowl can easily be completed within an afternoon, or even within one sitting. However, a teapot requires multiple steps. All components (body, spout, handle, and lid) must be thrown separately and dried just enough to be sturdy, but not so much that all moisture is gone and the handle and spout can't be adhered to the body. Further, a lidded form is very difficult to produce because the body and lid may shrink to different degrees depending on the amount of water used in the throwing process. So a lid that was measured to fit may not do so after each piece has dried.

Ohr apparently was not good at throwing lids. A superior lid sits securely on the lip and does not move once it is in place. Ohr's lids often slid around the covering. Both Hecht and Ellison, in interviews with the author on 8 and 9 April 2006, respectively, recounted stories of lids falling off or becoming lost, which would not have happened as often had they been secure (plate 55). Further, an ad for his wares announces "lidless teapots." Ohr did not shy away from complexity, yet the relatively easy, lidded jar form is a rarity in his oeuvre, if not completely nonexistent. In other words, Ohr simply did not like to bother with lids, perhaps due in large part to his indifference toward practicality.[7]

Ohr celebrated his uniqueness and challenged others to test his throwing skills, yet he relied on basic forms and was an inferior lid-maker. All of this suggests that he was more interested in the complexities of his own manipulations than he was in perfecting long-established ceramic techniques. This is not to say that Ohr wanted to sacrifice quality for quantity, which is certainly not the case since, as pointed out, many of his glazes required three or four trips through the kiln to achieve the desired effect. It does, however, imply that Ohr preferred shapes that lent themselves to twisting and crumpling. Clean forms were more conducive to this not only because he could complete more, but also because they allowed him more freedom. As hard as it is to make a lid fit a normal pot, it would be extremely difficult

to coordinate with a warped opening. And why bother? Ohr's art wares were not usually intended to be useful in the traditional sense.

All of this is to say that Ohr's production was not driven by intuition or creative frenzy. His corpus of forms suggests deliberation, repetition, and convenience.

Like his teapots, the rest of Ohr's output is a compromise between the realities of making a living with clay and the commitment to his artistic vision. Ohr's art pottery is intriguing because it simultaneously displays remarkable diversity and similarity. His celebrated proclamation of "no two alike" is quite true. However, many of his works, though different, are obviously part of the same series, exploring a shared motif such as vessel shape, handle design, or manipulation within the body. For instance, a set of handled vases or pitchers may be built on a like structure with only the handle design differing (plates 53, 54, and 47).

FOLK VERNACULAR AND ISSUES OF SOCIAL CLASS

Ohr's style was faulted by many contemporary critics as vulgar and lacking in taste. No doubt Ohr's wild manipulations and disregard for function were a source of such dismay. But there is an edge to their derision, as though they were personally offended by Ohr's grade-school education, improper spelling, uncouth southern diction, and pedestrian upbringing.

In fact, many elements of Ohr's unique approach have implicit social significance. As pointed out, rather than seeking to hide his southern, working-class background, he paraded it. He flaunted it not only in his bizarre persona, but in his clayware as well. Ohr never forgot his clay was dug by hand from local veins, and the rough, handmade look of his pots proudly proclaims his ties with the folk pottery of the South. Permitting an Ohr piece space in a well-appointed Victorian parlor was a bit like inviting a common laborer with mud-spattered overalls to a fashionable tea.

As previously noted, Ohr's style shares fundamental similarities with folk art, sometimes even borrowing its shapes. A case in point is the well-known ring jug: a doughnut-shaped vessel filled with water or liquor and carried on the shoulder. Paradoxically, the ring jug is also a fitting example of how Ohr's work does not fit neatly into folk conventions. In Ohr's rendition of the form, he adds a pedestal foot, graceful handle, and long neck,

thus removing it from the realm of common use. Through his keen sense of proportion, he gives the shape the elegant stylishness of a Grecian urn.

The pitcher is another common folk ware that Ohr borrowed and altered. A typical pitcher was approximately eight inches tall and capable of holding eighty ounces of liquid. Ohr's version had collapsed sides and folded down lips (plate 56). One could still pour from it, though the sides were only about four inches tall. Most significantly, the general sense of collapse makes using it feel risky.

Ohr's methods of surface decoration are also drawn from the folk tradition. He often used sponging, a typical design in which a sponge coated in iron oxide was pressed around the circumference of the body, creating a modest but pleasing pattern. There are instances when Ohr used this motif on traditionally functional forms that were then made nonfunctional, such as pitchers with zigzag handles that are too difficult to grasp and too thin to support vessels. In these instances Ohr creates a jarring juxtaposition of purist utility and visual oddity. In short, while folk pottery often provided a starting point, Ohr twisted it into highly personal statements.

Ohr's glazes at times clash with his objects' functionality, thus moving them out of usual service categories and challenging standard notions of both use and social class. A pitcher appearing slick with mold and slime is an apt illustration (plate 57). Through such unappetizing color choices Ohr was deliberately rejecting the customary use of the object and making it purely an artistic statement. Who would want to drink liquid that came from a container crusted with fetid growth or other grotesqueries?

Ohr's brothel tokens, feces creamer, vagina bank, and various other trinkets likewise shared a similarity to folk forms in their obscenity and vulgarity.

DECODING CLASSICISM

If we start with the notion that Ohr's pottery is a kind of mutant folk art, as virtually everything he produced retains something of this quality, we have a good foundation for analyzing his work. He didn't throw with porcelain, instead using a grainy local clay, and most of his shapes are kin to those of folk. A key aspect of his artistry is that it diverged from perfect shapes, yet another feature shared with folk practices. Each, in its rough and even

careless construction, contrasted starkly with the symmetry and flawlessness popularized by manufacturers like Rookwood.

Yet by the 1890s eccentricity and distinction set his style apart from other southern folk products. This departure does not follow one simple template but is a series of varying strategies. What is striking, however, is how often he borrowed aspects of "high art," creating a strange disjunction between "high" and "low" modes of expression. Ohr's notion of fine art vacillated to include lofty Victorian style, with its heavy decoration; classic designs, such as those of China; and, finally, the effects of art nouveau. However, he did not so much imitate his sources as use them as a jumping-off point for creative experiment.

The previously mentioned photograph (plate 37) shows Ohr standing proudly beside a half dozen of his pieces encrusted with curlicue decoration and a sign that reads "Art Potter." Many motifs made reference to the classical art of Greece and Rome, although their sheer profusion and departure from actual classic prototype gave these objects a Victorian character. Other wares by Ohr are essentially in this vein but have peculiar touches that foreshadow his famed style, for example, the gentility of a tall, handled vase, with an elaborate inscription, decorative roses, gadrooning, and curlicue handles, is disturbed by the ruffled rim at the top. A similarly priggish vase is liberated by a playful flared rim. Many of Ohr's mature works follow these essential templates.

Often revered in this period as prevailing models of impeccable formal achievement, classic Greek and Sung Chinese ceramics also interested Ohr. In the Sung fashion, Ohr threw an extremely long-necked vase with a swollen body—a very difficult form—that he then decorated with formal and intricate designs (plate 34). He deviated from tradition by coating the base with an algal green glaze. The tall, graceful neck is lined with veins and drips blood from a ragged wound that is the rim. The result is refinement turned repulsive, especially when compared to the understated colorations of the Sung dynasty. Ohr borrowed the figure repeatedly, but modified it so that the classic formalism almost disappeared.

Ohr imitated the subdued and classical Greek vase, with smooth surfaces, elongated elegance, and caressing handles (plate 38). The entire object, however, was then coated in a murky streak of running colors marked by silver flecks, mocking the graceful Grecian outline. Ohr both imitated and reinterpreted ancient forms and ideals of classical beauty.

Ohr was not only aware of Chinese, Greek, and Victorian prototypes, but, as these examples suggest, used his strange glazes and shapes to decode them in highly unusual ways. His final inspiration, art nouveau, may have provided the stimulus for much of what is most original about his style: the notion that irregularity rather than symmetry could be pleasing, that color could be rough and unpleasant, and that beauty was inherent to all of nature's diverse modes and expressions. Ohr's use of art nouveau was complex, however, for he did not simply mimic the work of others but explored general principles.

STAGNANT GROWTHS AND REPTILIAN SCALES: OHR'S ART NOUVEAU

Folk and art nouveau pottery share fluidity: the former, in the process by which it was created, made by hand and slightly irregular, and, the latter, by means of an unfixed surface that references natural shapes (human, tree, or vegetal). However, the fabrication of art nouveau ceramics is generally quite rigid. Van Briggle pottery, for instance, was cast in molds, with the result that every piece is exactly alike. Even those establishments that employed artisans, such as Rookwood, insisted on a rigid conformity of shape. Ohr's pottery, on the other hand, is fluid in both conception and construction. He combined the attributes of folk and art nouveau traditions to create a new form of art strikingly different from either of these sources.

Art nouveau is grounded in the metaphorical relationship between practical shapes of bottles and vessels and those of nature. Tiffany's iconic glass vases were modeled to resemble vegetables, trees, roots, or flowers; his lamps usually have tree-trunk bases and shades that recall magnolia blossoms, wisteria, or clusters of flying dragonflies. A Van Briggle vase with a female figure breaking free of the clay is partly a vessel that will hold liquid or flowers, but is also sculpture (plate 58). Such objects are fascinating because they exist in a realm that is half practical, half fantasy. Are they lamps or trees, frozen or moving? Are they manmade or natural? Do they serve a practical purpose or are they objects of art comparable to paintings?

While Ohr generally avoided literal representations of nature, we often feel that the clay has been arrested in the process and we are witness to its "becoming." For example, Ohr created a vessel that appears to be one form giving birth to another (plate 35). Even when what we see are simply abstract

folds, we have a feeling of stopped motion within a larger transformation. In this way Ohr focused on the deepest principles of art nouveau. Rather than mimicking the style of other potters, he is critiquing their translation of nature.

The prototypes of art nouveau that Ohr knew best (or a least made the most reference to), Rookwood and Newcomb, employed painted decoration on relatively standard ground—their work was distinctive for its adornment rather than its shape. Both companies make the flora and fauna of their respective regions the subject of their designs. Rookwood's are more literal, while Newcomb's are more idealized. But both celebrate the beautiful in a fashion that often verges on the sentimental, with scenes of flowering magnolias or oak trees glimmering in the moonlight. Ohr resisted putting painted scenes of this sort on his wares, and to the extent that his glazes serve a representational function, they evoke perceptions of nature that are less benign, such as reptilian scales or decaying plants or animals. Ohr's pieces do not so much represent the nature we are familiar with, but hitherto unknown growths that have been fished out of a stagnant swamp.

Interestingly, even when Ohr emulated vegetative designs, he generally avoided the sinuous, graceful lines characteristic of art nouveau. Rather than daffodils, sunflowers, or lilies, he produced a strikingly realistic representation of a potato with buds growing from its sides (plate 15). He also often introduced an element of menace. Many times the edges of the folds on his vessels were razor sharp or jabbed at the surrounding space (plate 52). The affinity between Ohr's work and that of nature is further corroborated by the way that some of his wares have been "improved" through nature's activity. Several objects stored in a barn for decades became the surface on which mud daubers—insects related to wasps—built cell-like nests out of mud that are remarkably almost indistinguishable from Ohr's own efforts, as though placed by him deliberately.

DELIBERATE DAMAGE: AVOIDING THE POTTER'S TRAP

Della Campbell McLeod noted of Ohr that "he does not claim to be the world's greatest potter in all senses, but he declares he is the greatest living designer of shapes." Ohr exploited a fundamental contradiction of the aesthetic theory of the time. Most writers espoused hand-formed things

over those made by machine, yet they equated "beauty" with pure classical regularity. The potter's wheel tends to standardize shapes, and producing proportioned shapes is the first thing a potter learns to do. However, Ohr recognized that symmetrical perfection was an artistic trap because it is always the same. Individuality depends on irregularity; even a simple pinch of the rim will enliven a boring shape. A ruffle, crumple, indent, or twist immediately endows an ordinary object with a personality different from anything ever made before—the principle of no two alike that Ohr celebrated.[8]

Ohr's contemporaries evidently preferred his wares that were only mildly odd, particularly when they were decorated with colorful glazes. Twentieth-century collectors, however, have been attracted to his most eccentric shapes, with or without color. One of the most notable features of Ohr's formal experiments is that he applied them not to a raw lump of clay but to a finished piece. This gave his work an interesting conceptual twist—it was not so much *construction* as *deconstruction*.

One can break this action down somewhat to analyze what Ohr did to handles and shapes. Ohr moved from molded handles in a Victorian style to those conceived as a single flowing line. This "step forward" was also a step backward since it represented a reversion to earlier craft techniques. Though late nineteenth-century folk potters molded their handles, in a fashion similar to commercial production ware, the earlier practice had been to "pull" the handle, that is, to make each handle individually by hand. Ohr could have extruded his handles. Instead, he cut a thin slab of clay into long strips or, even more simply, pulled the handle out of the side of the vessel, never breaking its attachment to the body. His curvilinear handles are more similar to ironwork than clay, reflective of his blacksmith training under his father (plates 45 and 53).

One of Ohr's greatest innovations was the integral handle (plate 59). To produce them he threw a bowl on the wheel, pinched one side to create a flat protrusion, poked a finger hold into this shape, and then pinched, creating a handle. The handle was no longer simply an appendage, but the vessel was so erratically deformed that it would be virtually impossible to reproduce the form. In other words, it destroyed potential for symmetry. Ohr used this type of handle for pitchers, but not vases. The body, like the handle, became "damaged," and each component complements the others' irregularity. The surface becomes a complex play of different visual rhythms.

Twisting, too, is a kind of deliberate damage because the overly thin walls and weakened structure make it unstable. We know that Ohr threw many thousands of vessels, practicing each maneuver, introducing endless variations, and exploring every variable. He experimented with different stages of fluidity, executing twists and folds not only when the vessel was on the wheel, but afterward, when it had been taken off and allowed to slightly dry. Mastering destructive technique required considerable skill.

MUTATION AND SELF-PROMOTION AS FORMAL INSPIRATION

The question of how Ohr developed his unique shapes is not easy to resolve. Most of his techniques of bending, folding, ruffling, and so forth had been used to some extent before. Some of Ohr's experiments look quite similar to those of Christopher Dresser, the Japanese, classical Greeks, and many others discussed previously. However, in his most daring creations Ohr went far beyond any of his possible sources, discarding established notions of function to produce bizarre, folded inventions that have no purpose or use aside from their sculptural beauty. In short, Ohr took the secondary experimental efforts of other artists and made them a major direction of inquiry.

To look for prototypes for Ohr's various shapes, however, may well misrepresent his creativity. He was surely aware that other potters made unusual vessels, but his wild originality grew from experimentation and play rather than imitation. To grasp Ohr's innovation it is more beneficial to consider another source—his activities as a self-promoter and entertainer.

Much of Ohr's exposure to artistic styles, ceramic or otherwise, came through his attendance at international expositions. There is a logical connection between his radical experimentations in clay and the strategic efforts he employed to draw and entertain crowds at world's fairs. Ohr quickly discovered that changing one shape into another was entertainment. In fact, his activities resembled those of vaudeville performers of the period, whose blackboard drawings would mutate from face to animal in a constant process of metamorphosis. No sooner was an image visible than it would change into something else—often through some surprising shift, such as upending a picture of a vase with a bouquet and having it become a face surmounted by a hat. As McLeod wrote of Ohr in the *Memphis Commercial Appeal,*

To see him take a ball of clay and shape a jug with a corncob stopper in it before your eyes, and convert that into a flower pot with a growing plant in it, and to change this into a tall vase, a squat lamp, a water cooler, and finally mold the whole into a basket of peaches is like watching a magician manipulate an enchanted cloth.[9]

Ohr himself boasted:

This is what [I] do with four pounds of clay on the wheel—blindfolded—turn a jug, put a corncob stopper in it, change the corncob into a funnel, have the funnel disappear, and have a jar, change the jar into an urn and half a dozen other shapes and turn anything that anyone in the U.S.A. can mention that is syndrical [sic] on the potter's wheel.[10]

Ohr's finished creations often suggest a bizarre metamorphosis. He liked to combine shapes unexpectedly, placing one pot on top of another to create a strange crossbreed, or the previously mentioned teapot with two spouts, two handles, and two lids, as if two had collided and fused.

Some of Ohr's more comical methods of self-promotion have parallels with his artistic strategies in pottery. Among his numerous publicity photographs are those that portray him standing on his head—one with a bottle of wine chilling in a bucket next to him while he balances a vessel on his foot and one where he pours a glass of gravity defying beer (plate 60). In fact, these photographs are inverted. Ohr was actually standing on furniture (concealed by cotton and fabric, which looks like clouds) and the bucket and bottle were glued to the ceiling. These images play with the magical effects that can be produced by simply turning things upside down. Many of Ohr's double vessels play with a similar trick. They combine a familiar shape with the same shape inverted upon itself to create a hybrid that is both intriguing and humorous.

Even Ohr's oft-discussed and extravagant moustache, which he twisted into fantastic shapes for publicity photographs and tied back around his ears when making pottery, may have inspired some of the malleable shapes he explored in clay, his strange, curving handles perhaps.

SHAPES AND ICONOGRAPHY: THE GROTESQUE AND MISSHAPEN

Previously discussed was Ohr's fondness for the sixteenth-century French potter Bernard Palissy and the psychological similarities that may have fostered Ohr's appreciation of him. It is helpful to again raise this topic but approach it from a formalistic standpoint and explore the ways in which Ohr alluded to, transformed, and modernized Palissy's work.

Palissy's plates and platters, glazed in a rich blue and green palette, were covered with naturalistic leaves and plant life, as well as representations of a variety of cold-blooded creatures, including snakes, frogs, salamanders, fish, and lobster (plate 39). Palissy's delicacy and illusionistic color effects are quite different from Ohr's visualizations.

Ohr was never greatly interested in painted or decorated ware. There are a few early samples with carefully molded decorative beading, and one vessel with an incised drawing of a skyscraper (identified as the Masonic Temple at State and Randolph Streets in Chicago, designed by Daniel Burnham and John Root in 1892). The name E. E. Pattison Coal Company, which had offices in the building, is inscribed on the surface. A small number of tiles imprinted with illusionistic scenes, such as a tree branch framing a scene of a sailboat and pier and another of a log cabin, are by no means outstanding from the artistic standpoint, but they illustrate Ohr's ability to place pictorial images on a shape. Such specimens, however, are relatively few. Ohr's major interest was working on the potter's wheel.

Ohr did create sculptural replicas of real objects, often with humorous and commercial intention. These may be loosely divided into two categories: those that are relatively crude and have the quality of folk art (like his creamer/chamber pot) and those that display a virtuoso technique. These few deceptively realistic objects, somewhat in the mode of Palissy, include an artist's palette with brush and paint tubes, a hand being pecked by a bird's head, which comes off to uncover an inkwell, a miniature log cabin, an inkwell with an iguana-like creature that hooks into a tree trunk, and models of shells and shoes. Ohr also produced coin banks that take on representational shapes, including a pear, a guitar, and a fantastic creature.

The most interesting of these pieces, a series of top hats, fall somewhere between unassuming forms generated on the wheel and skilled imitations of objects. One pair uses the vicissitudes of a hat to create a little story (plate 61). A perfectly shaped top hat represents its appearance in early evening; a

second, set beside it and badly dented, shows how the same hat would look after a night of wild drinking and entertainment. Ohr titled the set *Nine O'clock in the Evening* and *Three O'clock in the Morning*.

In a fashion resembling modern conceptual art, Ohr also took completely ordinary objects and endowed them with meaning through words. Recall the umbrella stand Ohr donated to the Smithsonian Institution, first discussed in chapter 1 (plate 11). Nothing about the shape of the umbrella stand is particularly memorable. It is a thoroughly ordinary object, made to be placed in an empty corner and forgotten. But with his inscription it became a metaphor for the empty promises of the world, in general, and the Smithsonian, in particular. With such thoughts attached, it ceases to be an umbrella stand. Just as he was interested in the strange beauty of the abject or obscene, Ohr was interested in the notion that the banal could be invested with profound philosophical significance.

So then, how should the expressive content of Ohr's oeuvre be regarded? Are they simply an arbitrary play of shapes, or do they carry deeper iconographic meanings? There is not an absolute answer to this question, but Ohr's engagement with shape and form appears to be profoundly connected with issues of personal identity, played out in both bodily and social terms. He referred to his pots as his "clay babies" and clearly thought of them as invested with personality and life. They weren't so much created as born; this thought was sometimes mimicked in his imagery. Their identity was akin to his own—unrefined creations that never lost their connections with folk traditions. At the same time, their originality and uniqueness put them on par with fine artistic pottery, whether Victorian, Chinese, Greek, or art nouveau. One can also visualize his pieces as a kind of frozen performance, a captured moment of his demonstrations at a world's fair or other forum, in which he transformed one shape into another as a means of entertaining his audience.

Ohr's fusion of social and artistic theory was unprecedented. His pots argue that the humble, the low class, and the ignoble can be elevated through their originality. They are visual proof that the irregular, the misshapen, the grotesque, the distorted, and even the obscene are more beautiful than normalized perfection because they are indisputably genuine.

CONCLUSION

My pottery life-work is only one collection as I alone created it—and if there is a greater variety of Pottery on this Earth emenating from one creature that is and has more extreams for poor and high quality SHAPES sizes—ugly, pretty, odd, queere &c. &c. than I have—I want to see the same and Ile swim and wear out shoes to get there.

—GEORGE OHR, "BILOXI HEARD FROM"

According to the Good Book, we are created from clay, and as Nature had it so destined that no two of us are alike, all couldn't be symmetrically formed, caused a variety to be wabble-jawed, hair lipped, crosseye, all colors, bow-legged, knock-kneed, extra limbs, also minus of the same, all sizes from 30 inches to 75 ditto. Everyone of us sees different, has a different voice, and don't all like cabbage or chew tobacco! . . . I Make disfigured pottery—couldn't and wouldn't if I could make it any other way.

— GEORGE OHR

A PHOTOGRAPH TAKEN APRIL 1896 ILLUSTRATES THE UNCONVENTIONAL world inhabited by Ohr, his pots, and his children (plate 62). The first impression of his studio is simply of clutter—pots are seemingly piled everywhere. But it also boasts of his pride not only in the sheer quantity of pots produced, but in his ability as a hand craftsman to compete with the output of industrial methods.

At first the arrangement seems utterly random, but, in fact, he placed his most prized pots near the center of the photograph, both scattered on the ground and sitting atop the bats. These pieces are the most interesting

in form, and many of them (notably, the large, ambitious urn at the extreme right) show up in other photographs, an indication that Ohr considered them signature examples of his work. Given the frequency with which Ohr photographed some of these pieces, they were most certainly kept in a safe place, away from trampling feet and the work activities of the shop, only to be brought out and strategically placed for such occasions.

As our eye moves into the distance, we discover that the nature of the work changes. Neatly arrayed along the back fence are a group of blackened pots, his "burned babies," which had been damaged in the 1894 fire. Rather than discarding them, Ohr gave them a place of honor in his new studio. Perhaps most interesting from a psychological standpoint is the way that Ohr displayed his children—placed within pots. From several statements we know that Ohr equated the two, and this photograph is a visual representation of that notion. If Ohr conceived of his damaged pottery as "burned babies," then his finished pots were "live babies," essentially equivalent to his own children. His ten offspring and ten thousand pots were evidence of his masculine prowess and fecundity. Like making children, making pottery was at some level for Ohr a sexual process. However, parallels between the two go beyond this simplified view.

It is no surprise that this image, loaded with visual meaning and metaphor, has acted as the jumping off point for many interpretations of Ohr and his wares. The most obvious point made, with its thousands of clay forms and ten biological ones, is the pride Ohr felt in the products of his body and hands. This view is largely biological and situated within paradigms of creation/procreation. Based on the evidence and theories presented in this book, the image is used here to suggest not only the biological connection Ohr had to his pots but, more significantly, the spiritual connection that is manifest in this image. His ceramic creations, like his children, were living, breathing, complex beings navigating the same tumultuous life as himself and his children. More than tools for informing a psychoanalytic interpretation, Ohr's pots are statements about nature, truth, beauty, and purpose as it existed and struggled within his time period. The study presented here is one turned outward rather than inward. This is a subtle point, but one of the utmost significance.

As has been mentioned, Ohr's creations were never purely "abstract" manipulations of clay. He always started with a traditional pottery form that he then subjected to creative distortions. As such they resonate with

complications and meaning. A collapsing bisque bowl (plate 52) embodies the various oppositions that define Ohr's exceptionality: crazy/normal, southern/northern, folk/manufactured ware, low-class/high-class, useful/useless, grotesque/beautiful, and utilitarian object/ work of art.

The bowl is obviously handmade, rough, and left unfinished, causing us to at first associate it with southern folk art. Almost immediately behind this thought is the need to revise our first impressions. True folk forms tend to be simple, practical shapes, and while this started as such, its very purpose has been transformed. Perhaps our most powerful reaction to the piece is that it looks grotesque in both form and (lack of) color. The folds and droops are fleshy, corpulent crevices. The torn rim makes the form look incomplete, as though only part of a larger whole. It is a removed and emptied carbuncle, a dollop of feces in the toilet, skin without internal structure. Yet paradoxically, the fact that the piece looks grotesque makes us take it out of our usual categories of useful pottery and examine it as an aesthetic object. That is to say, we stop for a moment to evaluate its qualities of color and form. And when we do so, we discover that the piece has a strange, slightly crazy sort of beauty. We therefore move from considering the object as a functional form to an impractical but fascinating expression of beauty—that is, something largely useless, except as a work of art.

Of course, our actual reaction is not that logical or considered. Our mind and senses jump from one response and category of judgment to another. Nevertheless, the previous description serves to lay out the essential terms of analysis.

Ohr consciously pulled competing notions from identifiable cultural reference points, like bowls, teapots, and vases, and then shattered our accepted understanding of these forms to create anew. The degree to which Ohr unified these oppositions varies with the extent of contortion and manipulation within a form, but this assimilation was his framework.

THE BEAUTIFUL PEOPLE: EXPERIENCING OHR'S OEUVRE

In the past, art historical methodology treated artists as "geniuses" who worked virtually outside of history. More recent scholarship, however, has moved away from this paradigm and endeavored to study art and artists as products of society rather than gifted outsiders. Artists have been removed

from the ivory tower, and declarations of supernatural genius and talent have been replaced by more concrete forms of explanation. At the least, their work has been seen as a reflection of the culture and values of their time, though perhaps creatively reconfigured to serve special expressive purpose. Such a view does not necessarily eradicate the notion of "genius," or the individual of exceptional expressive aptitude, but it supposes that this talent consists in making creative use of its own culture. George Ohr's work is only enriched when we view it in this way.

Ohr left few instructions on how to understand his pottery. He claimed that the form of the pot is more important than its often amazing finish, the latter merely existing as a means to enhance the former. He directed that his oeuvre should be experienced as a whole, as though each pot was a line contributing to a finished poem. As we recall, Ohr attempted to give a large group of his pots to the Smithsonian, although his wishes were disregarded and they kept only a few.

What this suggests is that our experience of Ohr's work now is a fragment of what he anticipated. There are only a handful of people who have seen Ohr's pots as he intended, and even fewer who are alive today to talk about it. Carpenter's assortment of some six thousand (or more) Ohr pots has been scattered all over the world, so one must rely on the observations and generosity of those lucky enough to have large collections. Even though these groups represent only a small fraction of his entire body of work, his vision that they all form parts of a single whole is still conveyed, only in a more concentrated form. When seen like this, engaged with Ohr's other creations, the distinction and unique personality of each is palpable.[1]

Each pot has a character as definite as any person's. The forms lunge toward, pull away from, attempt to embrace, stand primly, or strike a seductive *contrapposto*. Alone, a pot will talk to the viewer, who often lacks the language to talk back. But in a group of other pots, the conversation is animated. As with any circle of friends, each member's personality becomes more pronounced and obvious when part of a group. The same holds true for Ohr's clay creations, whose interactions flesh out individual personalities much more than if each stood alone and silent. Glazes contribute to their distinctiveness as a pink eruptive surface contrasts with a smooth glaze on a sleek form. When as few as two or three pots are together, they interact and talk as readily as neighbors on a street, making animated complaints or conspiring over a secret.

We recognize that Ohr's "pottery people," when part of a crowd, are not beautiful in a traditional way. They evoke the dark processes of nature, of life and death: they are often scabby and oozing, sexual and irreverent. Like the Post-Impressionists, Symbolists, and Decadent artists of his time, Ohr searched for a beauty that was unconventional, even abnormal. The most common descriptions of Ohr's pottery emphasize their difference— "unique," "odd," "strange," "eccentric," "unusual," "grotesque," "queer," "bizarre," "peculiar"—and revolve around ideas of sexuality, impropriety, rebelliousness, and even vulgarity. Beyond their physical eccentricities, his forms suggest marginal personalities and ideas.[2]

In speaking of his anthropomorphized pots, Ohr echoes the biblical story of creation, observing that just as nature had not created two people alike, so too were all of his pots different. To that end, not everyone could be "symmetrically formed," and many were "wabble-jawed, hare-lipped, cross-eyed, all colors, bow-legged, knock-kneed, extra limbs, also minus of the same." He proudly states that he makes disfigured pottery and "couldn't and wouldn't if I could make it any other way."[3]

Ohr's insistence that the value in his pottery was derived from these imperfections engages significantly with the nineteenth-century society, which was consumed with appearance and status. Social Darwinism justified both the economic and moral position of the upper class and provided a strong rationale for discrimination against the black population. The antebellum South, in particular, would have seized on these inherent genetic "differences" between races in order to justify slavery. The pseudoscience of phrenology even claimed to determine the character and disposition of a person merely based on physical features of the skull and face. Indeed, the success of men like P. T. Barnum, who built much of their fortunes on biological aberrations such as Tom Thumb and the FeeJee Mermaid, preyed on people's fascination with separateness. Simultaneously threatening and comforting, freaks of nature both reinforced the diverse variation Mother Nature was capable of and affirmed the "rightness" of the common person, meaning the white European.

In a world deeply concerned with normalcy and superiority, Ohr's forms were representations of the marginalized and the curious. Ohr even created a persona of this sort for himself, one that if not quite monstrous or freakish was nonetheless disconcertingly off-center. Not only was his appearance bizarre, but his manner epitomized many qualities of the South, which had

become America's Other once the industrial North triumphed over it with both armies and industries. Ohr's pots thus speak to a process of physical and emotional disfigurement. They are crippled, blistered, scabbed, broken, and overly colored (read nonwhite). They embody all the physical traits that are not part of acceptable society and yet, in some curious way, are marvelously beautiful.

Perhaps what becomes most shocking about Ohr's pots, and similarly about outcasts of society, is their perceived inability to be useful. Ohr's pottery is based on traditionally functional forms made with a traditionally functional medium. Yet he purposefully rendered them dysfunctional and, in so doing, believed he was raising them to a higher plane. Their purpose is no longer couched in ideas of use, but in their peculiar beauty.

OHR AS A BOUNDARY CROSSER

One of the greatest oddities of Ohr's career is the way in which his own persona merged contradictory qualities. While he devoted immense effort to marketing his work, often in a manner reminiscent of a commercial huckster, he was reluctant to sell his wares, and most of his production was never sold in his lifetime. This is because Ohr was not chiefly interested in money. He wanted to be a legend. He wanted to be a great artist.

Ohr famously predicted his artworks would be "praised, honored, and cherished" by future audiences. Much Ohr scholarship has taken up that torch. Yet it is unsettling that scholars have allowed Ohr to dictate how future critics and the public should respond to his work. The notion that Ohr was a genius is one he certainly propagated himself, but it is curious that so many recent writers on Ohr have accepted this judgment without thinking more deeply about its implications.

Perhaps because of his unique vantage point, Ohr was particularly sensitive to the tensions and oppositions embedded within late nineteenth-century U.S. culture. The "meaning" of his work resides in the highly creative, unorthodox way he confronted these opposites. For all his formal originality, his art should not be viewed in purely formal terms. The structural originality of his art was a reflection of his sensitivity to the underlying cultural frictions of the late nineteenth and early twentieth centuries. Within this framework Ohr's pottery becomes something not previously considered.

The artistic choices he made, such as type of clay and glaze color, were not simply superficial decisions but embodied cultural and social messages that challenged the status quo.

Ohr was a boundary crosser in many ways. His character probed the tension between the sophisticate and the "rube," between the commercial huckster and the selfless artist uninterested in gain, between the Socialist and the individualist, and between the old-fashioned craftsman of "folk art" and the divinely gifted "artist-genius." His art explored very similar, essentially parallel themes to those of his life: the divide between crude craft and "real art," between the salable commodity and the priceless work of art, between the common or low class and the refined, between the ugly and deformed (or even the obscene) and the beautiful. Above all, in fascinating ways, Ohr was a craftsman who thought and acted like an artist. He thus became the first to cross the art-craft barrier. His eccentric and astonishing achievements as a potter were profoundly indebted to his willingness to challenge the normal boundaries of craft pottery, as was his claim to be a genius.

Plate 1. George Ohr, lopsided vase. Shack collection.

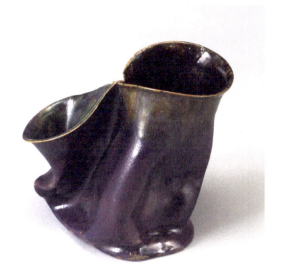

Plate 2. George Ohr, collapsing vase. Rago Arts and Auction Center, Lambertville, NJ, Ragoarts.com.

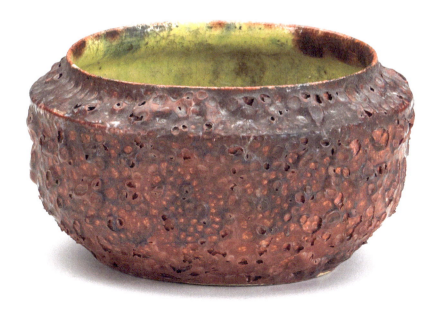

Plate 3. George Ohr, bowl with cratered pink glaze. Rago Arts and Auction Center, Lambertville, NJ, Ragoarts.com.

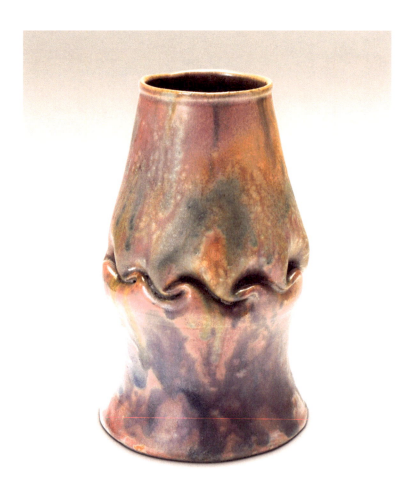

Plate 4. George Ohr, vase with in-body twist. Collection of the Ohr-O'Keefe Museum of Art, Biloxi, Mississippi.

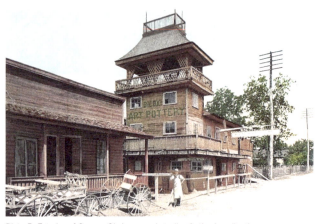

Plate 5. Exterior of George Ohr's second studio. Author's collection.

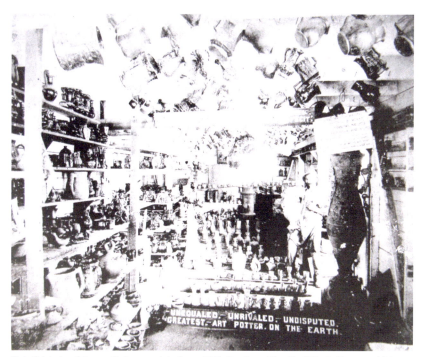

Plate 6. Interior of George Ohr's second studio, c. 1894. Courtesy of the Ohr-O'Keefe Museum of Art, Biloxi, Mississippi.

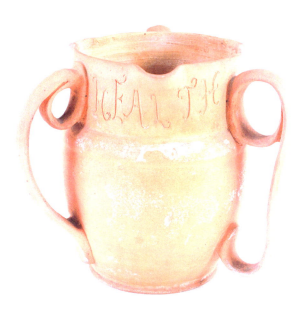

Plate 7. Collaboration of Susan Frackelton and George Ohr, bisque loving cup, 1899. Rago Arts and Auction Center, Lambertville, NJ, Ragoarts.com.

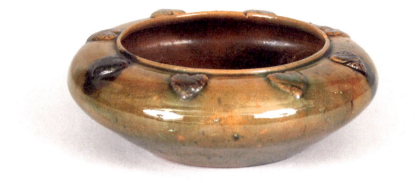

Plate 8. Collaboration of Susan Frackelton and George Ohr, green glaze bowl, 1899. Wisconsin Historical Society, Madison, Wisconsin.

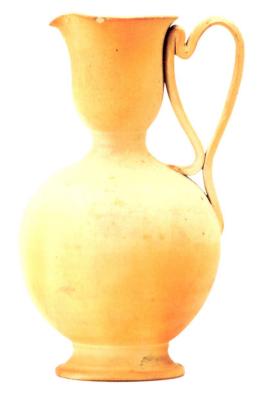

Plate 9. Collaboration of Susan Frackelton and George Ohr, bisque pitcher, 1899. Rago Arts and Auction Center, Lambertville, NJ, Ragoarts.com.

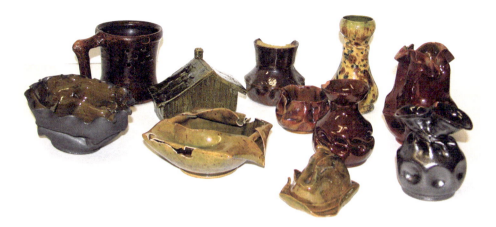

Plate 10. George Ohr, eleven samples sent to the Smithsonian in 1899. Division of Home and Community Life, National Museum of American History, Smithsonian Institution.

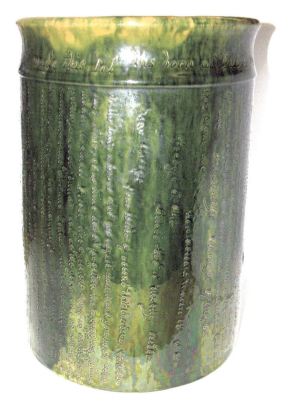

Plate 11. George Ohr, umbrella stand sent to the Smithsonian in 1900. Division of Home and Community Life, National Museum of American History, Smithsonian Institution.

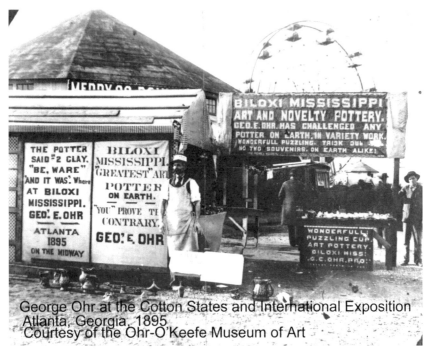

Plate 12. Photograph of George Ohr on the midway at Cotton States Exposition in Atlanta, Georgia, 1895. Courtesy of the Ohr-O'Keefe Museum of Art, Biloxi, Mississippi.

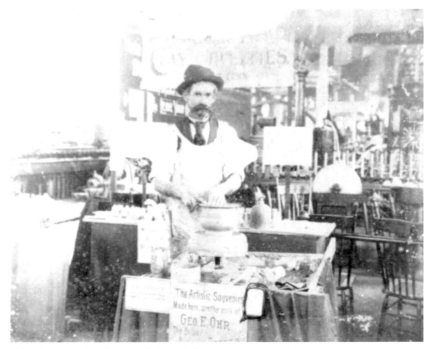

Plate 13. Photograph of George Ohr's display in the machinery building at Cotton States Exposition in Atlanta, Georgia, 1895. Courtesy of the Ohr-O'Keefe Museum of Art, Biloxi, Mississippi.

Plate 14. George Ohr, bisque coin bank. Author's collection.

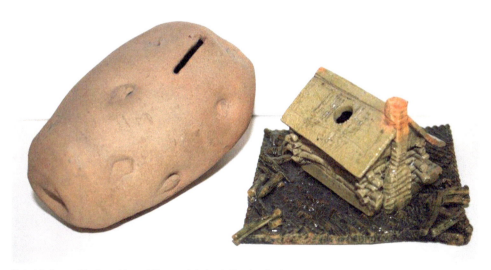

Plate 15. George Ohr, log cabin and bisque potato bank. Shack collection.

Plate 16. George Ohr, feces creamer with canons. Shack collection.

Plate 17. George Ohr, puzzle mugs. Courtesy of the Ohr-O'Keefe Museum of Art, Biloxi, Mississippi.

Plate 18. George Ohr, seashell card holder. Author's collection.

Plate 19. George Ohr, six "brothel tokens." Coins one through five are from the collection of the author. Coin six is from the Shack collection.

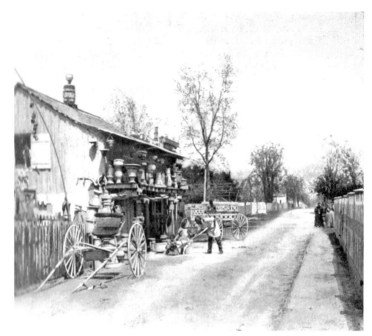

Plate 20. Photograph of the exterior of George Ohr's first studio. Courtesy of the Ohr-O'Keefe Museum of Art, Biloxi, Mississippi.

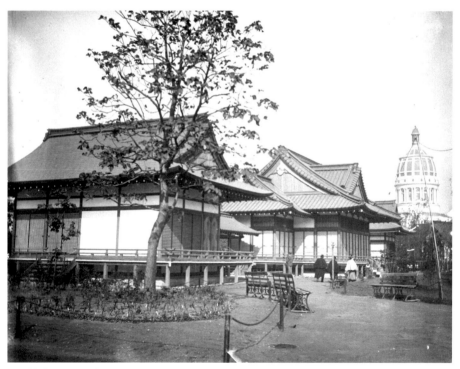

Plate 21. Photograph of the Japanese Ho-o-den building at the Chicago World's Fair, 1893. Chicago History Museum, Chicago, Illinois, by John George M. Glessner, neg. #1186.

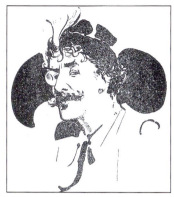

Plate 22. Caricature of James McNeill Whistler, 1894. *The Critic* 25: November 17, 1894.

REV. GEORGE E. OHR begs to introduce himself to the Philistines as

Potter to the Push

also

Originator of the Bug House Renaissance in Life, Letters and Art. Mr. Ohr, like Setebos, makes things out of Mud—and never duplicates. Correspondence solicited. Address,

BILOXI, MISS.

☞ P. S. Mr. Ohr wishes to explain that the prefix Rev. to his name does not signify that he is a preacher. It only means that he is worthy of Reverence, because he does his work as well as he can, and Minds his own Business.

Plate 24. George Ohr's ad from the *Philistine*, 1901. Author's collection.

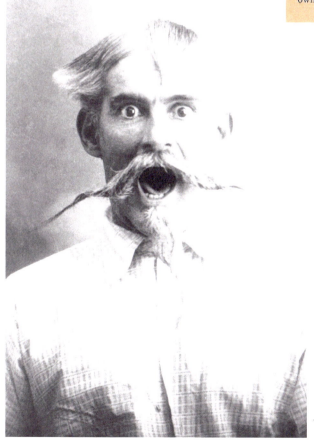

Plate 23. Portrait of George Ohr with trick hair. Courtesy of the Ohr-O'Keefe Museum of Art, Biloxi, Mississippi.

Plate 25. Portrait of Elbert Hubbard. Courtesy of the Roycroft Campus Corporation.

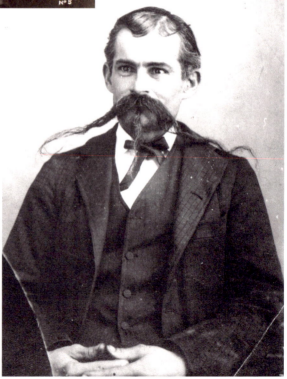

Plate 26. Proper quarter-length portrait of George Ohr. Courtesy of the Ohr-O'Keefe Museum of Art, Biloxi, Mississippi.

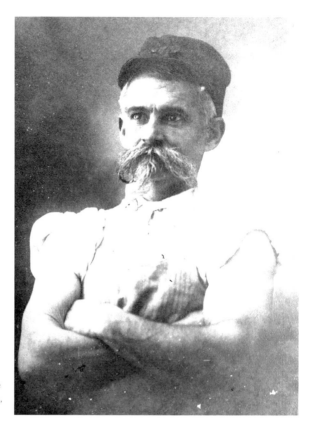

Plate 27. Portrait of George Ohr with arms crossed. Courtesy of the Ohr-O'Keefe Museum of Art, Biloxi, Mississippi.

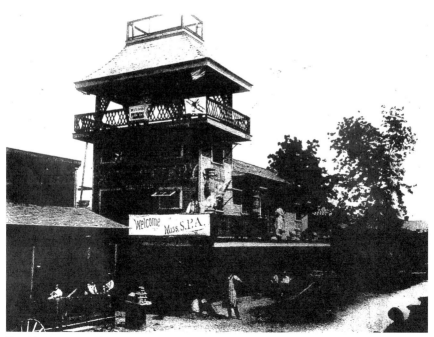

Plate 28. Photograph of George Ohr's studio bearing the Miss S.P.A banner.

Plate 30. Design for prize-winning vase, June 1899. *Appeal to Reason*.

Plate 29. Design for prize-winning vase, May 1899. *Appeal to Reason*.

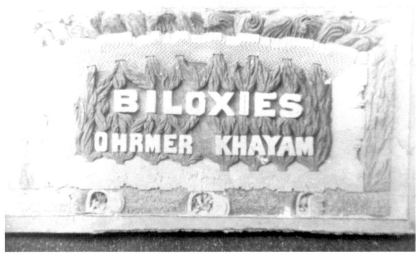

Plate 32. Sign adorning George Ohr's studio. Courtesy of the Ohr-O'Keefe Museum of Art, Biloxi, Mississippi.

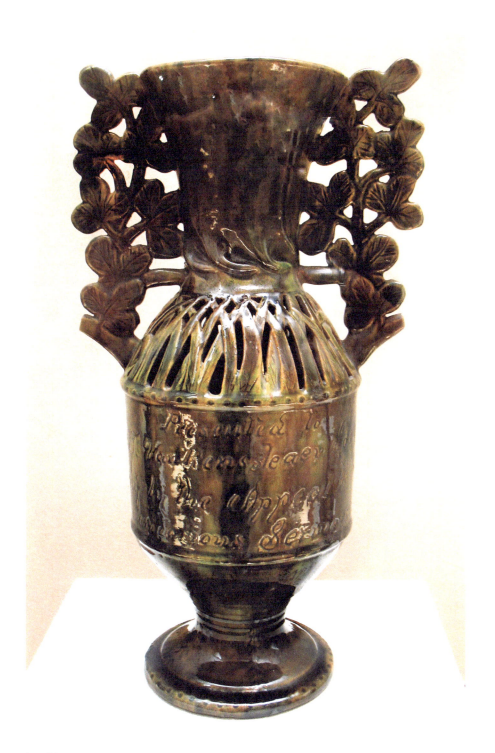

Plate 31. George Ohr, prize-winning vase for June 1899, 13" x 7¼". Private collection.

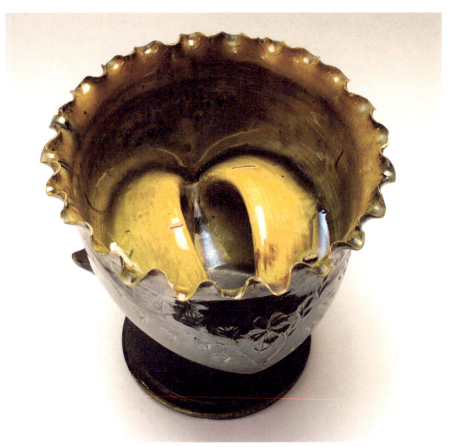

Plate 33. George Ohr, Biloxi lighthouse pot. Collection of the Ohr-O'Keefe Museum of Art, Biloxi, Mississippi.

Plate 34. George Ohr, bulbous vase with deformed rim, 16¼". Shack collection.

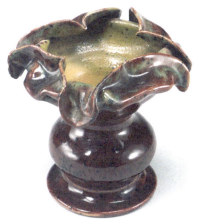

Plate 35. George Ohr, vase with torn and gaping rim. Rago Arts and Auction Center, Lambertville, NJ, Ragoarts.com.

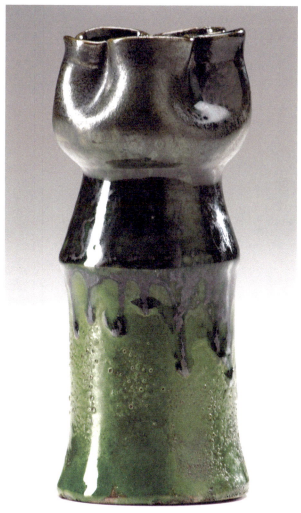

Plate 36. George Ohr, cylinder vase with lobed rim. Rago Arts and Auction Center, Lambertville, NJ, Ragoarts.com.

Plate 37. Portrait of George Ohr with large urn and "Art Potter" sign, c. 1892.

Plate 38. George Ohr, tall, double-handle vase. 15¾". Shack collection.

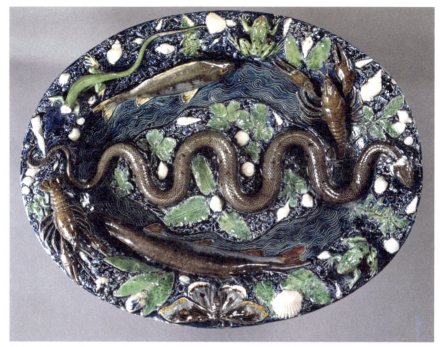

Plate 39. Bernard Palissy, earthenware dish. © The Trustees of the British Museum.

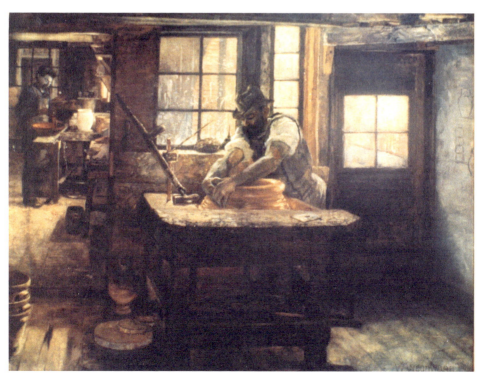

Plate 40. William Woodward, painting of George Ohr and Joseph Meyer at the New Orleans Art Pottery, 1889. Biloxi Public Library and City of Biloxi, Mississippi.

Plate 41. Newcomb Pottery vase featuring Sadie Irvine's oak tree design. Rago Arts and Auction Center, Lambertville, NJ, Ragoarts.com.

Plate 42. George Ohr and Harry Portman, jug, dated 1896. Author's collection.

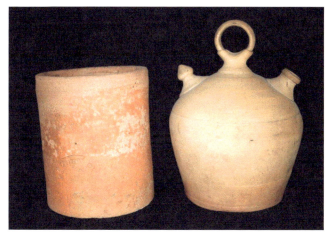

Plate 43. George Ohr, chimney flue and water vessel. Shack collection.

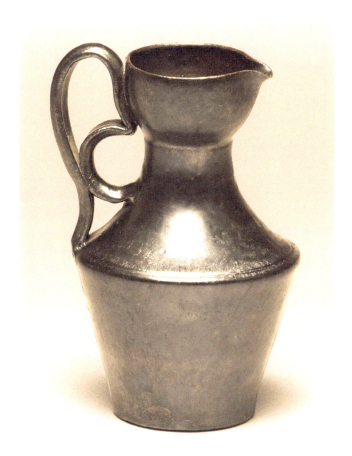

Plate 44. George Ohr, miniature pitcher, c. 1895, 4¾" x 3". Collection of the Ohr-O'Keefe Museum of Art, Biloxi, Mississippi.

Plate 45. George Ohr, double-handle vase, 8¼" x 3¾". Collection of the Ohr-O'Keefe Museum of Art, Biloxi, Mississippi.

Plate 46. George Ohr, teapot. Rago Arts and Auction Center, Lambertville, NJ, Ragoarts.com.

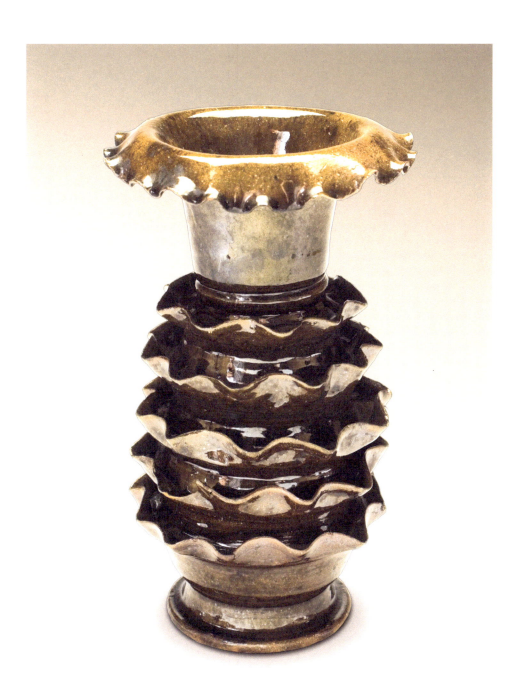

Plate 47. George Ohr, petticoat vase, 7¾" x 4¾". Collection of the Ohr-O'Keefe Museum of Art, Biloxi, Mississippi.

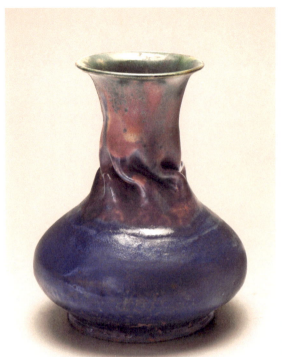

Plate 48. George Ohr, vase with twist, 5" x 4". Collection of the Ohr-O'Keefe Museum of Art, Biloxi, Mississippi.

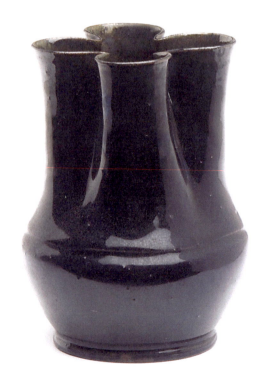

Plate 49. George Ohr, vase with tubing. Rago Arts and Auction Center, Lambertville, NJ, Ragoarts.com.

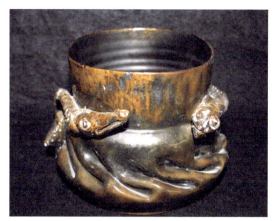

Plate 50. George Ohr, vase with snakes. Shack collection

Plate 51. George Ohr, tall, metallic glaze vase, 14". Shack collection.

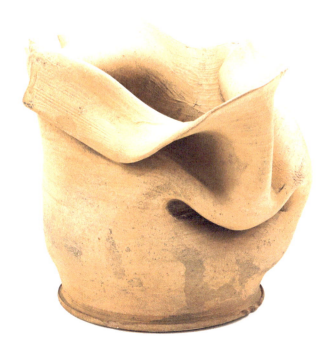

Plate 52. George Ohr, manipulated bisque vase. Rago Arts and Auction Center, Lambertville, NJ, Ragoarts.com.

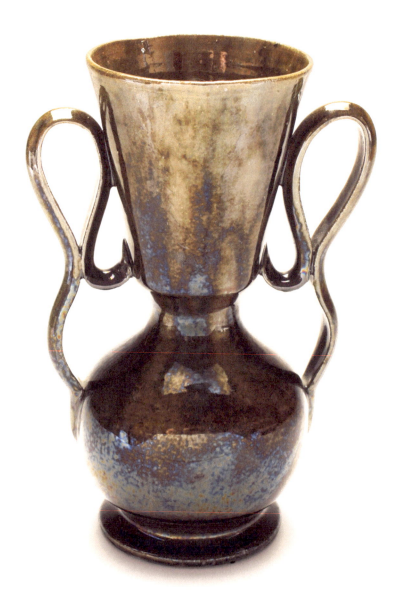

Plate 53. George Ohr, two-handled corset vase, 7¾" x 5¼". Collection of the Ohr-O'Keefe Museum of Art, Biloxi, Mississippi.

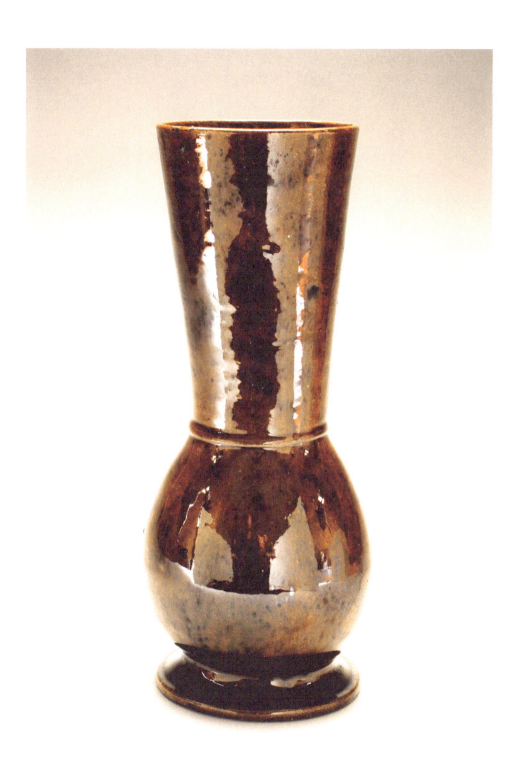

Plate 54. George Ohr, corset vase, 9" x 3¾". Collection of the Ohr-O'Keefe Museum of Art, Biloxi, Mississippi.

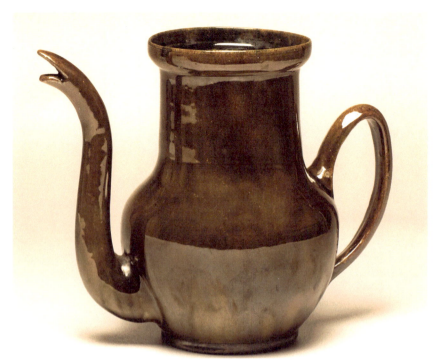

Plate 55. George Ohr, teapot without lid. Courtesy of the Ohr-O'Keefe Museum of Art, Biloxi, Mississippi.

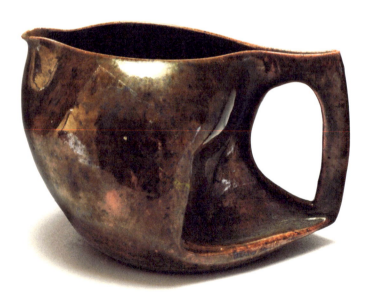

Plate 56. George Ohr, creamer, c. 1899, 4" x 3¼". Collection of the Ohr-O'Keefe Museum of Art, Biloxi, Mississippi.

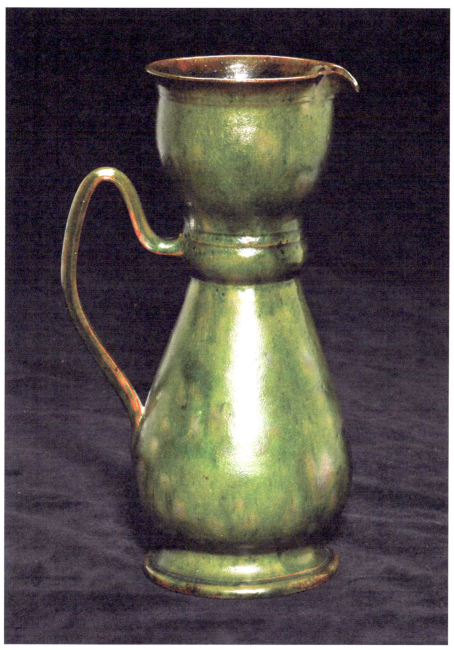

Plate 57. George Ohr, pitcher, c. 1898, 8" x 4½". Collection of the Ohr-O'Keefe Museum of Art, Biloxi, Mississippi.

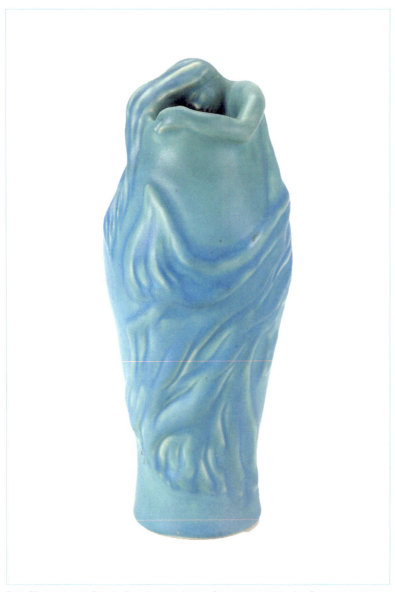

Plate 58. Vase by Van Briggle. Rago Arts and Auction Center, Lambertville, NJ, Ragoarts.com.

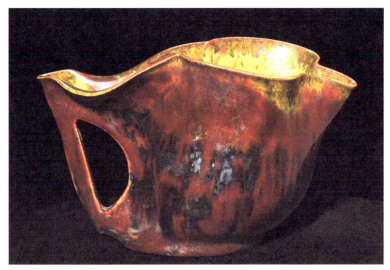

Plate 59. George Ohr, creamer with integral handle, c. 1895, 3⅜" x 5". Collection of the Ohr-O'Keefe Museum of Art, Biloxi, Mississippi.

Plate 60. Trick portrait of George Ohr standing on head. Courtesy of the Ohr-O'Keefe Museum of Art, Biloxi, Mississippi.

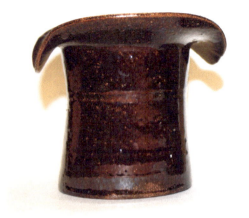 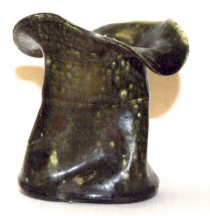

Plate 61. George Ohr, two top hats. Author's collection.

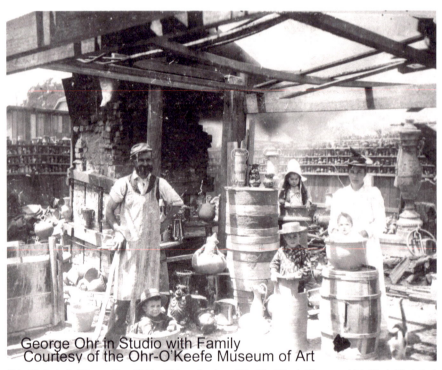

Plate 62. Portrait of George Ohr with his children. Courtesy of the Ohr-O'Keefe Museum of Art, Biloxi, Mississippi.

NOTES

INTRODUCTION

1. The price Carpenter paid for the cache of Ohr pots is rumored to be as high as several million, though $50,000 is the number on which most Ohr scholars agree. The figure of several million is probably what Carpenter made from his investment. Like the purchase price, the actual number of pots Carpenter received is unknown. It is widely accepted to be somewhere between 6,000 and 10,000.

2. To aid in promoting Ohr's pottery, Carpenter commissioned Robert Blasberg to write the first book on Ohr, *George Ohr and His Biloxi Pottery* (New York: J. W. Carpenter, 1973). He heavily romanticizes Ohr, presenting him as a nonconformist prodigy and archetype of the creative personality.

3. Robert Ellison, *George Ohr, Art Potter: The Apostle of Individuality* (London: Scala, 2006), introduction; Eugene Hecht, *After the Fire: George Ohr, an American Genius* (Lambertville, NJ: Arts and Craft Quarterly Press, 1994), introduction, 16; Garth Clark, "George E. Ohr: Avant-Garde Volumes," *Studio Potter* 12 (1983): 19.

4. George Ohr, "Some Facts in the History of a Unique Personality," *Crockery and Glass Journal* 54 (1901): 1. In translation, this means that Ohr was the second oldest child of three sisters and one brother. In these and all other quotes from Ohr, unless otherwise noted, I have not corrected or changed Ohr's words in any way and have even included irregular spacing and random capitalization. The visual and grammatical dynamics of Ohr's words were/are just as important as the actual meaning behind them. Though notoriously difficult to decipher, they capture his eccentricity beautifully.

5. Ohr, "Some Facts in the History of a Unique Personality," 2.

6. After the death of Asa, Ohr adopted an unusual naming practice, devising a first name that was the same as the child's initials, just as George E. Ohr's are his own initials. Lio, born 1893, died in 1914 doing handstands on his motorcycle. Flo, born 1897, died just shy of her second birthday in 1900. Zio, born in 1900, lived only until 1904. The children who survived Ohr were Leo (1890–1970), Clo (1892–1989), Oto (1895–1982), Ojo (1903–1991), and Geo (1906–1986). Information from Ray L. Belland, "The Biloxi Boys: J. F. Meyer, George E. Ohr Jr., and Manual E. Jalanivich," *Mississippi Coast Historical and Genealogical Society*

38 (2002): 8–13. Information about the fire is from "The Flames," *Biloxi Daily Herald*, 13 October 1894, 8.

7. *Times-Picayune*, October 1894.

8. It is possible that Ohr ceased potting earlier than 1908 as there are no known pots dated after 1907.

9. Della Campbell McLeod, "The Potter, Poet, and Philosopher," *Memphis Commercial Appeal*, 27 June 1909, front page.

10. This period was termed the Gilded Age by Mark Twain and Charles Dudley Warner in their novel of that title: *The Gilded Age: A Tale of To-Day* (Hartford, CT: American Publishing Co., 1903).

CHAPTER 1

1. Mary Tracy Earle, *The Wonderful Wheel* (New York: Century Co., 1896); Ray L. Bellande, "Interesting People: Parker Earle," Ocean Springs Archives, 2010, http://oceanspringsarchives.net/node/38 (accessed 21 October 2007).

2. Earle, *Wonderful Wheel*, 1. In William King, "Palissy of Biloxi," *Illustrated Buffalo Express*, 12 March 1899, 4, the author states, "It would appear that he [Ohr] was indeed a hero during a yellow-fever scourge that decimated his native town." In the same article King also makes mention of "a vase made during a yellow-fever scourge and so marked."

3. "A Biloxi Pottery," *Brick* 6, no. 5 (1897): 286.

4. Della Campbell McLeod, "The Potter, Poet, and Philosopher," *Memphis Commercial Appeal*, 27 June 1909, 8.

5. Ethel Hutson, "A Quaint Biloxi Pottery," *Clay Worker* 44, no. 3 (September 1905): 226. The original article has proven difficult to find for me as well as other Ohr scholars. The only bibliographic information available is that the article, entitled "High Art in Biloxi, Miss," was published in a New York paper on 22 December 1898. This information is given in the article "Concerning Biloxi Potteries," *China, Glass, and Pottery Review* (April 1899), which also includes a lengthy excerpt.

6. William Percival Jervis, *The Encyclopedia of Ceramics* (New York: Blanchard, 1902), 420.

7. L. M. Bensel, "Biloxi Pottery," *Art Interchange* 46 (January 1901): 8–9. That Bensel's review was so generous is especially significant because *Art Interchange* was an expensive magazine aimed at the cultural elite.

8. Edwin Atlee Barber, *The Pottery and Porcelain of the United States* (New York: G. P. Putnam's Sons, 1902), 499.

9. Susan Frackelton, *Handbook of Arts and Crafts Milwaukee Biennial* (Milwuakee: Herman, Pfeifer, 1900), 87. It is not clear whether Ohr visited Frackelton in Wisconsin or Frackelton came to Biloxi, though George Weedon concludes she visited Ohr's studio during her twenty-month business trip (1889–1891). See George Weedon, *Susan Frackelton and the American Arts and Crafts Movement* (Master's thesis, University of Wisconsin, Milwaukee, 1975), 70.

10. Information about W. King in "Some Art Pottery in Buffalo," *Buffalo Express*, 25 December 1898, 123. The catalog of the show in which King included Ohr is *Catalogue of the Joint Annual Exhibition of Buffalo Society of Artists, Art Student's League of Buffalo, and the Buffalo Chapter American Institute of Architects including an exhibition of Arts and Crafts* (Buffalo, NY: White-Evans-Penfold Company, 1900), 18.

11. The use of the word "delineator" is probably in reference to an artist's prints, which list the delineator's name along with the artist's.

12. William King, "Palissy of Biloxi," *Buffalo Express*, 12 March 1899, 4. Though King gives a positive review of Ohr and provides some biographical information, he also plagiarized Bensel's article in certain sections.

13. George Ohr, quoted in William King, "Ceramic Art at the Pan-American Exposition," *Crockery and Glass Journal* 53 (1901): 17. It is not known who Pat is, and it may be a random name Ohr assigned to one of his pots.

14. "Major Wheeler: An Experienced Man," *Buffalo Commercial Advertiser*, 28 May 1900, 3.

15. "Industrial Arts of the Americas a Separate Exhibit," *Buffalo Enquirer*, 10 November 1900, 2.

16. George Ohr, "Biloxi Heard From," *Crockery and Glass Journal* 53 (1901): n.p.

17. Information regarding the Smithsonian files on Ohr, pots that he sent to the institution, and dates of receipt and accession were received via Bonnie Campbell Lilienfeld, "George Ohr Continued," personal email, 18 April 2008.

CHAPTER 2

1. Information from Robert W. Rydell, *All the World's a Fair: Visions of Empire at American International Expositions, 1876–1916* (Chicago: University of Chicago Press, 1984), 2.

2. Ibid., 4.

3. Ibid.

4. Southern cities that hosted expositions were Atlanta in 1881 and 1895, Louisville in 1883 and 1887, New Orleans in 1884–1885, Nashville in 1897, Charleston in 1901–1902, St. Louis in 1904. Northern hosts were New York in 1853–1854 and 1918, Philadelphia in 1876, Boston in 1883–1884, Chicago in 1893, San Francisco in 1894 and 1915, Buffalo in 1901, Portland in 1905, Seattle in 1909, and San Diego in 1915–1916. Information from Walter G. Cooper, *The Cotton States and International Exposition and South* (Atlanta: Illustrator, 1896), 77.

5. John E. Findling, *Historical Dictionary of World's Fairs and Expositions, 1851–1988* (New York: Greenwood Press, 1990), 86.

6. Quotes from Rydell, *All the World's a Fair*, 74. Information on Booker T. Washington from Findling, *Dictionary of World's Fairs*, 139–40.

7. Rydell, *All the World's a Fair*, 74. Information regarding the exhibits on the midway at Buffalo's Pan-American is from *Souvenir Booklet of One Hundred Views of the Pan-American Exposition* (Buffalo, NY: Robert Allen Reid, 1901).

8. "A Biloxi Pottery," *Brick*, 287. This describes an encounter at Ohr's studio, but there is no reason to think Ohr did not have the exact same impression at fairs and expositions. (The wording from the signs is taken directly from the photograph of Ohr at the Atlanta Exposition, plate 12.)

9. W. King, "Palissy of Biloxi," 4. Description is printed in this article and given by an unidentified individual.

10. William Leach, *Land of Desire: Merchants, Power, and the Rise of a New American Culture* (New York: Pantheon Books, 1993), 40.

11. Information on prominent journals in the field of display is from Frank Luther Mott, *A History of American Magazines* (Cambridge, MA: Harvard University Press, 1967), 3:27–28. Frank Baum, *The Art of Decorating Dry Goods Windows and Interiors* (Chicago: Show Window Publishing Company, 1900), 147.

12. W. King, "Palissy of Biloxi," 4. Description from an unidentified observer.

13. Ibid., 4.

14. For a discussion on the fair's overall design agenda see Stanley Appelbaum, *The Chicago World's Fair of 1893: A Photographic Record* (New York: Dover, 1980), 13.

15. Applebaum, *Chicago World's Fair*, 28; Judith Snodgrass, *Presenting Japanese Buddhism to the West: Orientalism, Occidentalism, and the Columbian Exposition* (Chapel Hill: North Carolina Press, 2003).

CHAPTER 3

1. Hutson, "Quaint Biloxi Pottery," 265.

2. Information from Joel Shrock, *The Gilded Age: American Popular Culture through History* (Westport, CT: Greenwood Press, 2004), 60, 151.

3. Information from Shrock, *Gilded Age*, 156–57.

4. Frank Luther Mott, *History of American Magazines*, vol. 3 (Cambridge, MA: Harvard University Press, 1967), 2.

5. Sarah Burns, *Inventing the Modern Artist: Art and Culture in Gilded Age America* (New Haven, CT: Yale University Press, 1996).

6. Ibid., 245.

7. Ibid., 223.

8. James McNeill Whistler, *The Gentle Art of Making Enemies* (New York: Dover Publications, 1967), 45.

9. "Whistler, Painter and Comedian," *McClure's Magazine* 7 (1896): 378; Burns, *Inventing the Modern Artist*, 223.

10. "A Biloxi Pottery," *Brick*, 287.

11. McLeod, "Potter, Poet, and Philosopher," front page.

12. Published in Hecht, *After the Fire*, 18.

13. Eugene Hecht, "The Long-Lost 1903 Handbill of G.E. Ohr," *Arts and Crafts Quarterly* (1992): 14–17.

14. "Pottery Wizard Dies in Biloxi," *Biloxi Daily Herald*, 8 April 1918, front page.

NOTES 139

15. Information from Freeman Champney, *Art and Glory: The Story of Elbert Hubbard* (New York: Crown, 1968), 58.

16. Ibid., 58.

17. From Ohr's ad in the *Philistine* 14, no. 1 (December 1901): facing p. 1.

18. Elbert Hubbard, *The Notebook of Elbert Hubbard: A Companion Volume to Elbert Hubbard's Scrap Book* (New York: Wm. H. Wise, 1927), 66.

19. Champney, *Art and Glory*, 61.

20. Neil Harris, *Humbug: The Art of P. T. Barnum* (Boston: Little, Brown, 1973), 23.

21. Ibid., 231.

22. Quote from Frederick S. Starr, *Southern Comfort: The Garden District of New Orleans, 1800–1900* (Cambridge, MA: MIT Press, 1989), 249.

23. Harris, *Humbug*, 72–73.

CHAPTER 4

1. "Biloxi as a Winter Resort," *Biloxi Herald*, 13 October 1888.

2. "Northern Visitors," *Biloxi Herald*, 15 February 1890, 4.

3. Charles Lawrence Dyer's *Along the Gulf: An Entertaining Story of an Outing among the Beautiful Resorts of the Mississippi Sound from New Orleans, LA., to Mobile, Ala.* (William Myers Publisher, 1894), includes accounts of the "thriving Mississippi cities of" Waveland, Bay St. Louis, Pass Christian, Longbeach, Mississippi City, Handsboro, Biloxi, Ocean Springs, Scranton, Pascagoula, and Moss Point Center.

4. "Northern Veteran's Views," *Biloxi Herald*, 25 February 1888, 5.

5. Ethelyn Colcord, "A Northerner's Opinion," in *Facts about the Gulf Coast: Gulfport, Biloxi, Pass Christian*, by W. A. Cox (Gulfport: W. A. Cox & E. F. Martin, 1905).

6. As assessed by James E. Caron and M. Thomas Inge, *Sut Lovingood's Nat'ral Born Yarnspinner: Essays on George Washington Harris* (Tuscaloosa: University of Alabama Press, 1996), 7–8; Henry Watterson, *Oddities in Southern Life and Character* (Boston: Houghton Mifflin Co., 1882).

7. Caron and Inge, *Sut Lovingood's Nat'ral Born Yarnspinner*, 82.

8. Description of Sut from Walter Blair, "George Washington Harris," in *Sut Lovingood's Nat'ral Born Yarnspinner*, by Caron and Inge, 88.

9. Carol Boykin, "Sut's Speech: The Dialect of a 'Nat'ral Borned' Mountaineer," in *The Lovingood Papers*, ed. Ben Harris McClary (Knoxville: University of Tennessee Press, 1965), 38, 40.

10. George Ohr, "Letter & Answer No. 2," 1903, journal unknown, from loose pages found at the Biloxi Public Library.

11. Thomas Inge and Edward J. Piacentino, eds. *The Humor of the Old South* (Lexington: University Press of Kentucky, 2001), 4.

12. Information from Hennig Cohen and William B. Dillingham, eds. *Humor of the Old Southwest* (Athens: University of Georgia Press, 1994), introduction, xvii.

13. Ibid., xvi.

14. Mark Twain, *Life on the Mississippi* (1875; reprint, New York: Oxford University Press, 1996), 44–45.

15. "Concerning Biloxi Potteries," *China, Glass and Pottery Review* 4 (1899): 47–49. According to the author of this article, the quote came from Ohr's handbill.

16. Cohen and Dillingham, *Humor of the Old Southwest*, xxxix–xl.

17. Information regarding where these three magazines were published obtained in Mott, *A History of American Magazines*, vols. 3 and 4.

18. Unless otherwise noted, all the following information regarding the legal turmoil and Ohr's subsequent imprisonment is taken from "Geo. E. Ohr Released from Durance Vile," *Biloxi Daily Herald*, 7 October 1910, front page; George Ohr, "Geo. E. Ohr at Out-of-Law Commission Sale," *Biloxi Daily Herald*, 7 September 1909, 4; and "Ohr Fined for Striking Chancery Clerk Hewes," *Biloxi Daily Herald*, 7 September 1909, 2.

19. "Ohr Fined for Striking Chancery Clerk Hewes," 2.

20. "Geo. E. Ohr at Out-of-Law Commission Sale," 4. Ohr's use of the word "nigger" is the only racist remark encountered by this author in all of the Ohr literature. Ohr did live in the South after the Civil War and probably picked up the racist ideology in which he was enmeshed. Regardless, Ohr would still be considered extremely liberal in comparison to other southerners of the time. Author Richard Mohr also offers another explanation for the word, postulating that "nigger" in this case would be slang for "crazy," therefore losing the malicious undertones. He compares it to the modern use of the word "gay" to describe something that is deemed dumb or ridiculous, rather than as a malevolent term for a homosexual.

21. "Geo. E. Ohr Released from Durance Vile," 1.

CHAPTER 5

1. W. A. Cox, "Biloxi Old and New," *Facts about the Gulf Coast: Gulfport, Biloxi, and Pass Christian* (Gulfport: W. A. Cox & E. F. Martin, 1906), 72.

2. Quotes from Mrs. Stella Buckles and Mrs. H. D. DeSaussure in *WPA County History for Harrison*, series 447, assignment no. 7, 6 May 1936, Jackson, Mississippi, Archives.

3. Information from Stephen Cresswell, *Multiparty Politics in Mississippi, 1877–1902* (Jackson: University Press of Mississippi, 1995), 3; and Stephen Cresswell, "Grassroots Radicalism in the Magnolia State: Mississippi's Socialist Movement at the Local Level, 1910–1919," *Labor History* 33, no. 1 (Winter 1992): 82.

4. Cresswell, "Grassroots Radicalism," 85, 98.

5. Ibid.

6. Ibid., 88.

7. Ibid.

8. Sumner W. Rose, "Gone but Should Not Be Forgotten," *Biloxi Herald* 24, no. 3 (August 19, 1921): 2.

9. Cresswell, "Grassroots Radicalism," 88.

10. Ibid., 90.

NOTES 141

11. *The Grander Age*, October 1903, 2.

12. From signs on a Mardi Gras float, reproduced in Robert Blasberg, *The Unknown Ohr: A Sequel to the 1973 Monograph* (Milford, PA: Peaceable Press, 1986), 59.

13. This saying and the previous are from Ohr's handbill.

14. Information regarding Neilsen's percentage of the vote from Cresswell, "Grassroots Radicalism," 92–93. Rose's name and the Howard Avenue address were part of an ad for the Gulf Coast Musical Headquarters from the *Biloxi Daily Herald*, 13 March 1908, 4. This same address was also given for local socialist meetings in the *Biloxi Daily Herald*, 26 February 1908, 1.

15. Cresswell, *Multiparty Politics*, 166.

16. *Biloxi Daily Herald*, 27 November 1902, 6. Strong oral tradition links Ohr to another local liberal governance experiment, the single-tax colony of Fairhope, Alabama, founded by Henry George in 1894. Ohr made at least one pot out of clay from Mobile, Alabama, which is just across the bay from Fairhope. While I was researching in Biloxi and Fairhope, numerous local historians, scholars, and organization leaders mentioned the as yet unverified link between Ohr and Fairhope. These include Donnie Barrett at the Baldwin County Historical Society, Bonnie Gum, author of *Made of Alabama Clay*, and local historians Sonny Brewer and Martin Lanoux.

17. Information from Ira Kipnis, *The American Socialist Movement, 1897–1912* (New York: Greenwood Press, 1968), 45.

18. Information from Irving Howe, *Socialism in America* (New York: Harcourt Brace Jovanovich, 1985), 4; and Kipnis, *American Socialist Movement*, 45.

19. *Appeal to Reason*, May 20, 1899, 4.

20. *Appeal to Reason*, May 13, 1899, n.p.; Van Rensselaer's essay from *Appeal to Reason*, October 7, 1899, 3.

21. Confirmation of inscription on vase from interview with Richard Van Rensselaer, J. T. Van Rensselaer's great grandson, 8 April 2011. *Appeal to Reason*, June 10, 1899, 4.

22. Kipnis says the *Appeal* hired as a subscription salesman a "socialist" who combined his soapbox orations on socialism with the announcement "Jesus Christ now addresses you through this instrumentality" (Kipnis, *American Socialist Movement*, 250n). Also see Kipnis, *American Socialist Movement*, 249, 44.

23. Regarding Wayland's publications, see Howard H. Quint, *The Forging of American Socialism: Origins of the Modern Movement* (Columbia: University of South Carolina Press, 1953), 185. Carlyle was a Scottish Calvinist who wrote essays intended to appease Victorians struggling with scientific and political changes that threatened the traditional social order.

24. Timothy Messer-Kruse, *1848–1876, The Yankee International: Marxism and the American Reform Tradition* (Chapel Hill: University of North Carolina Press, 1998), 252.

25. Morris Hillquit, *A History of Socialism in the United States* (New York: Dover, 1971), 319–21.

26. For information regarding the proliferation of Bellamy Clubs, see Frederick Highland, *Looking Backward: A Critical Commentary* (New York: American R.D.M., 1965), 31. In 1891 Bellamy founded the magazine *New Nation*, which became the official paper of the Nationalist Party. The Nationalist Party, which joined with the Populists, embraced

most socialist tenets except for the name. It gave the Populist cause a heavy socialist coloring.

27. Alexander McDonald, "Bellamy, Morris, and the Great Victorian Debate," in *Socialism and the Literary Artistry of William Morris*, ed. Florence S. Boos and Carole G. Silver (Columbia: University of Missouri Press, 1990), 86–87.

28. Dolores Hayden, *Seven American Utopias: The Architecture of Communitarian Socialism, 1790–1975* (Cambridge, MA: MIT Press, 1976), 9.

29. John Bruce Glasier, *William Morris and the Early Days of the Socialist Movement* (Bristol, Eng.: Thoemmes Press, 1994), 147–48.

30. Eileen Boris, *Art and Labor: Ruskin, Morris, and the Craftsman Ideal in America* (Philadelphia: Temple University Press, 1986), 20, 32.

31. Morris, quoted in Champney, *Art and Glory*, 189.

32. Hubbard, *Notebook of Elbert Hubbard*, 154–56.

33. Ohr, quoted in Richard Mohr, "Mudpies for Keeps and Usefulness," 16. From Ohr's letter to C. L. Alexander on 31 March 1915, reproduced in this article.

34. John Ruskin, *The Two Paths* (New York: J. Wiley, 1859), 54.

35. Ralph Waldo Emerson, *The Complete Writings of Ralph Waldo Emerson* (New York: Wm. H. Wise, 1929), 2:109.

36. Ralph Waldo Emerson, *Emerson's Essays* (New York: E. P. Dutton, 1955), 30.

37. Henry David Thoreau, *Walden* (New York: Thomas Y. Crowell & Co., 1910), 440, 430.

38. Ohr, "Some Facts in the History of a Unique Personality," 3.

CHAPTER 6

1. Christopher Decker, *Edward FitzGerald's* Rubáiyát of Omar Khayyám: *A Critical Edition* (Charlottesville: University Press of Virginia, 1997).

2. William McIntoch's spoof/poem, *Philistine* 1, no. 4 (September 1895): 125–26.

3. The word "Ramazán" refers to Ramadan, the fourth pillar of Islam, which requires worshippers to fast between sunrise and sunset. This and all subsequent verses are taken from Decker, *Edward FitzGerald's* Rubáiyát of Omar Khayyám, 107–8.

4. Ohr, quoted in McLeod, "Potter, Poet, and Philosopher," front page.

5. From document published in Hecht, *After the Fire*, 28.

6. Decker, *Edward FitzGerald's* Rubáiyát of Omar Khayyám, 102.

7. Hutson, "Quaint Biloxi Pottery," 225.

8. Thoreau, quoted in Joel Porte, *Consciousness and Culture: Emerson and Thoreau Reviewed* (New Haven, CT: Yale University Press, 2004), 9.

9. Richard Mohr, *Pottery, Politics, Art: George Ohr and the Brothers Kirkpatrick* (Urbana: University of Illinois Press, 2003), 152.

10. Ibid., 146 and 129.

11. Julia Kristeva, *Powers of Horror: An Essay on Abjection* (New York: Columbia University Press, 1982), 3.

NOTES 143

12. Ibid., 4.

13. Oscar Wilde, *The Best Known Works of Oscar Wilde* (New York: Blue Ribbon Books, 1927), 188–89.

14. Ibid., 109.

15. Information on Huysmans's early presence in the United States is from George A. Cevasco, *J. K. Huysmans in England and America: A Bilbiographical Study* (Virginia: Bibliographical Society of the University of Virginia, 1960), 3.

16. J. K. Huysmans, *Against the Grain (Á Rebours)*, with an introduction by Havelock Ellis (1884; reprint, New York: Dover, 1969), 121.

17. Ibid., 85–86.

CHAPTER 7

1. *Biloxi Daily Herald*, 29 August 1885.

2. Nancy Owens, *Rookwood and the Industry of Art* (Athens: Ohio University Press, 2001). See chapters 3 and 4, in particular, for an engaging discussion of the ways in which Rookwood provided an enlightened working atmosphere while simultaneously succumbing to the demands of mass production evident in many potteries of the time.

3. To compile a list of potters Ohr may have encountered on his sixteen-state sojourn, Paul Evans's *Art Pottery of the United States: An Encyclopedia of Their Producers and Marks* (New York: Charles Scribner's Sons, 1974) was cross-referenced with Barber's *Pottery and Porcelain of the United States* (1901). Consultations with historical societies, university libraries, and other archival resources, in an effort to find evidence of Ohr's presence, have proven fruitless. This is frustrating because it ultimately tells us nothing. Ohr may have encountered none, some, or all of these potters, but either a record was never kept or has not survived.

4. For more information on Ohr's relationship with the Kirkpatrick brothers, see Mohr, *Pottery, Politics, Art*. For an exploration of the various potters Ellison has linked to Ohr through similar visual motifs, see Garth Clark, Robert Ellison, and Eugene Hecht, *The Mad Potter of Biloxi: The Art and Life of George E. Ohr* (London: Scala, 2006), 65–66. This seminal book continues to be a significant resource in the study of Ohr and his pottery.

5. *Times-Picayune*, October 1894.

6. Hecht notes that the New Orleans city directory for 1889 carries the entry "Ohr George E Potter, r. 249 Baronne" (Hecht, *After the Fire*, 14), so we know he was in residence there for at least that year. We also know that Ohr split his time between Biloxi and New Orleans because his wife, Josie, still in Biloxi, became pregnant with their second son, Leo Ernest, during this time.

7. The two main sources for information about the NOAP are Jessie Poesch, *Newcomb Pottery: An Enterprise for Southern Women, 1895–1940* (Exton, PA: Schiffer Publishing, 1984); and Suzanne Ormond and Mary E. Irvine, *Louisiana's Art Nouveau: The Crafts of the Newcomb Style* (Gretna, LA: Pelican Publishing Company, 1976).

8. Paul E. Cox, "Potteries of the Gulf Coast: An Individualistic Ceramic Art District (first installment)," *Ceramic Age*, no. 25 (April 1935): 118–19. Meyer had no children but "reared the daughter of a servant woman as his own," according to Cox in "Potteries of the Gulf Coast," 119.

9. Poesch, *Newcomb Pottery*, 94.

10. Rose, "Gone but Should Not Be Forgotten," 2. The *Philistine* to which Rose refers was Elbert Hubbard's periodical. The *Christian* is most likely another nineteenth-century journal. "Dawn," "Mirty," and "Nantilus" have proven elusive. They could be character names, novel titles, or other periodicals.

11. Poesch, *Newcomb Pottery*, 10–11.

12. Ibid.

13. Ellsworth Woodward, "The Work of American Potters. II. Newcomb Pottery Typical of the South," *Arts and Decorations*, no. 1 (January 1911): 124–25.

14. Richard Megrew, "The Most Natural Expressions of Locality: Ellsworth Woodward and the Newcomb Pottery," in *Bridging Southern Cultures: An Interdisciplinary Approach*, ed. John Lowe (Baton Rouge: Louisiana State University Press, 2005); and Ellsworth Woodward's 1920 speech, entitled "What Has Art to Do with Practical Things?," quoted in Megrew, "The Most Natural Expressions," 136, 138.

15. E. Woodward, "What Has Art to Do with Practical Things?," 137.

16. Poesch, *Newcomb Pottery*, 21.

17. Ibid.

18. Sadie Irvine, quoted in ibid., 176.

19. Ohr did hire an assistant, Harry Portman, presumably to help with quicker production of wares. However, this arrangement is a far cry from a multiple person assembly-line system.

20. Joy Jackson, *New Orleans in the Gilded Age: Politics and Urban Progress, 1880–1896* (Baton Rouge: Louisiana State University Press, 1969), 259–60.

21. Randolph Delehanty, *Art in the American South: Works from the Ogden Collection* (Baton Rouge: Louisiana State University Press, 1996), 156.

22. Ibid., 3.

23. Ibid., 11.

24. From an excerpt from Dow's letter to the pottery, dated 15 November 1899, published in Ormond and Irvine, *Louisiana's Art Nouveau*, 32.

CHAPTER 8

1. Quote from McLeod, "Potter, Poet, and Philosopher," front page. No sources exist that reveal exactly how many pots Ohr did or did not sell. However, the 6,000 to 10,000 pieces tucked away in his sons' garage, coupled with lukewarm critical reception, makes it safe to assume that Ohr did not sell large quantities.

2. Information regarding the function of brothel tokens is from Louis Crawford and Glyn Farber, *Louisiana Trade Tokens* (Rayne, LA: Hebert Publications, 1982), 11.

3. Perrone insists that Ohr's designs should be considered from a sculptural standpoint (Jeff Perrone, "Madness, Sex, Exhaustion," *Artforum International* 28 [January 1990]: 96), while Koplos denies they take advantage of three-dimensional space (Janet Koplos, "A Thoroughly Modern Potter: George Ohr in Retrospect," *New Art Examiner* 17, no. 5). Perrone also rejects the notion that Ohr's pots were expressive, which is espoused by Clark, Ellison, and Hecht.

4. Contemporary collectors likewise recognize the artistic value of Ohr's teapots. To date, $100,000 is the highest price paid for an Ohr piece, a teapot. A formal citation of this claim is not available; however, upon viewing said pot, the owner confirmed this to be true.

5. "Leather state" refers to a stage in the drying process when the clay is still soft, allowing it to be easily sculpted or carved, but dry enough to support itself.

6. Potter Don Pilcher demonstrated the process of twisting to Mohr, which he published in "Don Pilcher: Rascal Ware with Georgette Ore," *Journal of the American Art Pottery Association* 25, no. 3 (2009): 21. After thinning the area where the twist is to appear, Pilcher/Ohr, with the wheel still turning, grasps the top of the vessel intermittently, thus creating twists at the thinner portions of the pot's wall.

7. Both Eugene Hecht and Richard Mohr suggest that Ohr picked up the snake motif from the Kirkpatrick brothers in Anna, Illinois.

8. The quote is on a sheet of paper full of Ohr sayings discovered while conducting research at the home of well-known collectors and appraisers Ralph and Terry Kovel in Cleveland, Ohio. It seems that this sheet full of Ohr-isms was the flier Ohr was including in the flowerpot shipments he had been hired to do for someone else.

9. Oxblood glaze, or *sang de boeuf*, seen in ancient Japanese pottery, is especially sensitive to all aspects of a firing, which explains in part why it was so difficult to reproduce.

10. The term "scroddled" refers to a pot that has been thrown with at least two different colors of clay. When left unglazed, the light and dark clays create swirl patterns within the pot, providing some color without glaze.

CHAPTER 9

1. Robert Blasberg, *The Unknown Ohr: A Sequel to the 1973 Monograph* (Milford, PA: Peaceable Press, 1986), 16.

2. Clark, Hecht, and Ellison's *The Mad Potter of Biloxi* (1989) has built on this presumption. Only 3 of the 133 pots discussed are assigned specific years. A disproportionate 89 are assigned a date range of c. 1895–1900. The remainder are broken down as follows: 17 in the range of c. 1898–1907 and 5 in the range of c. 1902–1907. The residual are divided into specific years, rather than ranges, dating from c. 1894 to c. 1903; 1 or 2 pots were attributed to each year, except c. 1900, which has 7. Hecht, *After the Fire*, 141.

3. From a sheet of paper full of Ohr sayings, discovered at the Kovel archives, Ralph and Terry Kovel, Cleveland, Ohio.

4. Because Hecht has not published his methodologies, though he plans to in the future, discussion of significant details is here omitted. However, his continuing research has

yielded much valuable information about the dating of Ohr's oeuvre, which has previously been arbitrarily assigned.

5. Ellison, *George Ohr, Art Potter*, 29.

6. Edwin Atlee Barber, *Marks of American Potters* (Southampton, NY: Cracker Barrel Press, 1971), 155.

7. The journal in which this ad appeared is unknown. The document was obtained in the Ohr archives at the Biloxi Public Library.

8. Quoted in McLeod, "Potter, Poet, and Philosopher," 1.

9. Ibid.

10. Ohr, quoted in King, "Ceramic Art at the Pan-American," 17.

CONCLUSION

1. Jim Carpenter, the Kovels, Robert Blasberg, and other early buyers are a rare few who bought straight from Carpenter's trove and were able to see most of Ohr's oeuvre before it was scattered.

2. The following use one or more of the listed terms to describe Ohr's wares: "A Biloxi Pottery," *Brick*, 287; "Concerning Biloxi Potteries," 49; Cox, "Potteries of the Gulf Coast," 140; Hutson, "Quaint Biloxi Pottery," 225; W. King, "Palissy of Biloxi," 4.

3. Ohr, quoted in "Concerning Biloxi Potteries," 448.

BIBLIOGRAPHY

"African-American Artists Picture a New Tradition." *American Artist* 59 (1995): 62–63.

Allen, Ann Ahern. "A Southern Revival Revisited: Arts and Crafts Preserve the Mountain, the Valley, and the Bayou." *Art & Antiques* 19, no. 11 (1996): 95, 97–99.

Anderson, Alexandra. "George Ohr's 'Mud Babies.'" *Art in America*, January–February 1979, 60–63.

Appelbaum, Stanley. *The Chicago World's Fair of 1893: A Photographic Record*. New York: Dover Publications, 1980.

Barber, Edwin Atlee. *Marks of American Potters*. New York: Cracker Barrel Press, 1971.

———. *The Pottery and Porcelain of the United States*. New York: G. P. Putnam's Sons, 1901.

Barnwell, Marion, ed. *A Place Called Mississippi: Collected Narratives*. Jackson: University Press of Mississippi, 1997.

Benfey, Christopher. *The Great Wave: Gilded Age Misfits, Japanese Eccentrics, and the Opening of Old Japan*. New York: Random House, 2003.

Benjamin, Marcus. "American Art Pottery." *Glass and Pottery World* 15 (1907): 28–36.

Bensel, L. M. "Biloxi Pottery." *Art Interchange* 46 (1901): 8–9.

Bergson, Henri. *Creative Evolution*. Translated by Arthur Mitchell. New York: Random House, 1944.

"Biloxi as a Winter Resort." *Biloxi Daily Herald*, 13 October 1888.

"Biloxi Pottery." *Biloxi Daily Herald*, 3 December 1893.

"A Biloxi Pottery." *Brick: The Official Organ of the National Brick Manufacturer's Association* 6, no. 5 (1897): 286–87.

"Biloxi's First Carnival a Success beyond Expectations." *Biloxi Daily Herald*, 4 March 1908, 1.

Birdsong, Mary. "George Ohr." *New Art Examiner* 24 (December 1996/January 1997): 40.

Blanchard, Mary Warner. *Oscar Wilde's America: Counterculture in the Gilded Age*. New Haven: Yale University Press, 1998.

Blasberg, Robert. *George Ohr and His Biloxi Pottery*. New York: J. W. Carpenter, 1973.

———. *The Unknown Ohr: A Sequel to the 1973 Monograph*. Milford, PA: Peaceable Press, 1986.

Bond, Bradley G. *Political Culture in the Nineteenth-Century South: Mississippi, 1830–1900*. Baton Rouge: Louisiana State University Press, 1995.

Boris, Eileen. *Art and Labor: Ruskin, Morris, and the Craftsman Ideal in America*. Philadelphia: Temple University Press, 1986.

Bowman, Leslie Greene. "American Art Pottery and the Ideal Home." *American Ceramics* 1, no. 1 (1993): 34–39.

Brackett, Donald. "Downright Duchampian: The Ironic Ceramics of Richard Milette." *American Ceramics* 12, no. 4 (1997): 14–21.

Brightwell, C. L. *Palissy, the Huguenot Potter: A True Tale*. Philadelphia: American Sunday School Union, 1860.

Buckles, Stella, and H. D. DeSaussure. Interview in *WPA County History for Harrison*. 6 May 1936. From a microfilm file at the Mississippi archives in Jackson, historical research conducted by the Works Progress Administration, Assignment #7, Series 447.

Burns, Sarah. *Inventing the Modern Artist: Art and Culture in Gilded Age America*. New Haven: Yale University Press, 1996.

Campbell Lilienfeld, Bonnie. "George Ohr Continued." Personal email, 18 April 2008.

Caron, James E., and M. Thomas Inge, eds. *Sut Lovingood's Nat'ral Born Yarnspinner: Essays on George Washington Harris*. Tuscaloosa: University of Alabama Press, 1996.

Carr Black, Patti. *Art in Mississippi, 1720–1980*. Jackson: University Press of Mississippi, 1998.

Carter, Paul A. *The Spiritual Crisis of the Gilded Age*. DeKalb: Northern Illinois University Press, 1971.

Cashman, Sean Dennis. *America in the Gilded Age: From the Death of Lincoln to the Rise of Theodore Roosevelt*. 3rd ed. New York: New York University Press, 1993.

Champney, Freeman. *Art and Glory: The Story of Elbert Hubbard*. New York: Crown Publishers, 1968.

Clancy, Jonathan. "Elbert Hubbard, Transcendentalism, and the Arts and Crafts Movement in America." *Journal of Modern Craft* 2 (2009): 143–60

Clark, Garth. *American Ceramics: 1876 to the Present*. New York: Abbeville Press, 1987.

———. "George E. Ohr." *Antiques*, September 1985, 490–97.

———. "George E. Ohr: Avant-Garde Volumes." *Studio Potter* 12 (1983): 10–19.

———. Personal interview, 4 March 2006.

Clark, Garth, and Ron Dale. *The Mad Biloxi Potter: George E. Ohr*. Jackson: University Press of Mississippi, 1986.

Clark, Garth, Robert Ellison, and Eugene Hecht. *The Mad Potter of Biloxi: The Art and Life of George E. Ohr*. New York: Abbeville Press, 1989.

Cohen, Hennig, and William B. Dillingham, eds. *Humor of the Old Southwest*. Athens: University of Georgia Press, 1994.

"Concerning Biloxi Potteries." *China, Glass, and Pottery Review* 4 (1899): 47–49.

Connor, Holly Pyne. "George Ohr's Oriental Aesthetic." *Arts and Crafts Quarterly* 3, no. 2 (1992): 10–12.

Cooper, Walter G. *The Cotton States and International Exposition and South*. Atlanta: Illustrator Company, 1896.

Couch, W. T., ed. *Culture in the South*. Chapel Hill: University of North Carolina Press, 1934.

Cox, Paul. "Potteries of the Gulf Coast: An Individualistic Ceramic Art District, First Installment." *Ceramic Age* 25 (1935): 116–18, 140.

———. "Potteries of the Gulf Coast: An Individualistic Ceramic Art District, Second Installment." *Ceramic Age* 25 (1935): 152–56.

Cox, W. A. "Biloxi Old and New." *Facts about the Gulf Coast: Gulfport, Biloxi, and Pass Christian*. Gulfport: W. A. Cox & E. F. Martin, Publishers, 1906.

Craven, Wayne. *American Art History and Culture*. Boston: McGraw Hill, 2003.

Crawford, Louis, and Glyn Farber. *Louisiana Trade Tokens*. Rayne, LA: Hebert Publications, 1982.

Cresswell, Stephen. "Grassroots Radicalism in the Magnolia State: Mississippi's Socialist Movement at the Local Level, 1910–1919." *Labor History* 33, no. 1 (1992): 81–101.

———. *Multiparty Politics in Mississippi, 1877–1902*. Jackson: University Press of Mississippi, 1995.

Czarnecki, John E. "Gehry Designs Biloxi 'Mad Pot-Ohr' Museum." *Architectural Record* 189, no. 8 (2001): 31.

Dale, Ron. *The Mad Biloxi Potter*. Stamford, CT: JO-D Books, 1983.

Dashti, Ali. *In Search of Omar Khayyam*. London: George Allen & Unwin Ltd, 1971.

Decker, Christopher, ed. *Edward FitzGerald's Rubáiyát of Omar Khayyám: A Critical Edition*. Charlottesville: University Press of Virginia, 1997.

De Kay, Charles. "Art from the Kilns." *Munsey Magazine* 24 (1901): 46–53.

Delahanty, Randolph. *Art in the American South: Works from the Ogden Collection*. Baton Rouge: Louisiana State University Press, 1996.

De Sola-Morales, Ignasi. *Antoni Gaudi*. New York: Harry N. Abrams, 2003.

de Waal, Edmund. "Well Said." *Crafts* 181 (2003): 44–51.

Dixon, Brandt V. B. *A Brief History of the H. Sophie Newcomb Memorial College, 1887–1919: A Personal Reminiscence*. New Orleans: Hauser Printing Company, 1928.

Donelson, Cathy. *Images of America: Fairhope*. Charleston, SC: Arcadia Publishing, 2005.

Duncan, Alastair. *Art Nouveau*. London: Thames and Hudson, 1994.

Earle, Mary Tracy. *The Wonderful Wheel*. New York: Century Co., 1896.

Eddy, Arthur Jerome. *Recollections and Impressions of James A. McNeill Whistler*. Philadelphia: J. B. Lippincott Company, 1903.

Ellis, Havelock. Introduction to *Against the Grain (Á Rebours)*, by J. K. Huysmans, v–xxxii. 1884. Reprint, New York: Dover Publications, 1969.

Ellison, Robert. *George Ohr, Art Potter: The Apostle of Individuality*. London: Scala Publishers, 2006.

———. Personal interview, 9 April 2006.

Emerson, Ralph Waldo. *The Complete Writings of Ralph Waldo Emerson*. Vols. 1 and 2. New York: Wm. H. Wise & Co., 1929.

———. *Emerson's Essays*. New York: E. P. Dutton & Co., 1955.

Evans, Paul. *Art Pottery of the United States: An Encyclopedia of Their Producers and Marks*. New York: Charles Scribner's Sons, 1974.

Facts about the Gulf Coast: Gulfport, Biloxi, Pass Christian. Gulfport: W. A. Cox & E. F. Martin Publishers, 1905.

Findling, John E., ed. *Historical Dictionary of World's Fairs and Expositions, 1851–1988*. New York: Greenwood Press, 1990.

"The Flames." *Biloxi Daily Herald*, 13 October 1894, 8.

Gallertin, Albert Eugene. *Portraits of Whistler: A Critical Study and an Iconography*. New York: John Lane Col, 1918.

Garner, James Wilford. *Reconstruction in Mississippi*. Gloucester, MA: Peter Smith, 1964.

"Geo. E. Ohr Released from Durance Vile." *Biloxi Daily Herald*, 7 October 1910, front page.

"George Ohr Abroad." *Ceramics Monthly* 39 (1991): 30.

Glasier, John Bruce. *William Morris and the Early Days of the Socialist Movement*. Bristol, England: Thoemmes Press, 1994.

Gray, Richard, and Own Robinson, eds. *The Literature and Culture of the American South*. Malden, MA: Blackwell Publishing, 2004.

Greenhalgh, Paul, ed. *Art Nouveau, 1890–1914*. London: Victoria and Albert Museum, 2000.

Greenwood, Janette Thomas. *The Gilded Age: A History in Documents*. New York: Oxford University Press, 2000.

Grootkerk, P. "George Ohr: The Biloxi 'Ohr-na-ment.'" *Southern Quarterly* 24, no. 1–2 (1985): 138–50.

Hall, Donald. "New Pottery Museum Rises out of the Ground." *Art & Antiques* 22, no. 5 (1999): 26.

Harris, Neil. *Humbug: The Art of P. T. Barnum*. Boston: Little, Brown and Company, 1973.

Harris, William. *The Day of the Carpetbagger: Republican Reconstruction in Mississippi*. Baton Rouge: Louisiana State University Press, 1979.

Hayden, Dolores. *Seven American Utopias: The Architecture of Communitarian Socialism, 1790–1975*. Cambridge, MA: MIT Press, 1976.

Head, Heart, and Hand: Elbert Hubbard and the Roycrofters. Produced by MUSE Film and Television and WXXI Public Broadcasting Council in cooperation with Memorial Art Gallery of the University of Rochester and the American Federation of Arts, 1994.

Hecht, Eugene. *After the Fire: George Ohr, an American Genius*. Lambertville, NJ: Arts and Craft Quarterly Press, 1994.

———. Letter to James Carpenter, dated "Tues Feb. 2." From the Ohr archives at the Biloxi Public Library in Biloxi, Mississippi.

———. "Long Lost 1903 Handbill of George Ohr," *Arts and Crafts Quarterly* (1992): 14–17.

———. Personal interview, 8 April 2006.

Held, Peter. "George McCauley." *Ceramics Monthly* 45, no. 1 (1997): 43–46.

Helmholtz-Phelan, Anna A. von. *The Social Philosophy of William Morris*. Durham, NC: Duke University Press, 1927.

Hennessy, Mark. *Oscar Wilde: Complete and Unabridged*. New York: Barnes and Noble Publishing, 2006.

Highland, Frederick. *Looking Backward: A Critical Commentary*. New York: American R. D. M. Corporation, 1965.

Hillquit, Morris. *A History of Socialism in the United States*. New York: Dover, 1971.

Hlutch, Kevin A. "A Revolutionary Concept." *Ceramics Monthly* 46, no. 1 (1998): 98, 100, 102, 104.

Hoare, Philip. *Oscar Wilde's Last Stand: Decadence, Conspiracy, and the Most Outrageous Trial of the Century*. New York: Arcadia Publishing, 1998.

Howe, Irving. *Socialism in America*. New York: Harcourt Brace Jovanovich Publishers, 1985.

Howorth, Lisa Neumann. "Ron Dale: A Review." *Ceramics Monthly*, June–August 1994, 65–68.

Hubbard, Elbert. *Elbert Hubbard's Scrap Book: Containing the Inspired and Inspiring Selections Gathered during a Life Time of Discriminating Reading for His Own Use*. New York: Wm. H. Wise & Co., Roycroft Distributors, 1923.

———. *The Notebook of Elbert Hubbard: A Companion Volume to Elbert Hubbard's Scrap Book*. New York: Wm. H. Wise & Co., 1927.

Huntingford, John. "The Mad Potter of Biloxi." *Crafts* (London, England), July–August 1990, 42–45.

Hutson, Ethel. "Quaint Biloxi Pottery." *Clay Worker* 44 (1905): 225–26.

"Industrial Arts of the Americas a Separate Exhibit." *Buffalo Enquirer*, 10 November 1900.

Inge, Thomas M., and Edward J. Piacentino, eds. *The Humor of the Old South*. Lexington: University Press of Kentucky, 2001.

Jackson, Joy J. *New Orleans in the Gilded Age: Politics and Urban Progress, 1880–1896*. Baton Rouge:: Louisiana State University Press, 1969.

Jervis, William Percival. *The Encyclopedia of Ceramics*. New York: Blanchard Publishers, 1902.

Keefe, John W. "George E. Ohr: The Mad Potter of Biloxi." *Arts Quarterly* 12, no. 2 (1990): 13.

King, Edward. *The Great South*. New York: Arno Press, 1969.

King, William A. "Ceramic Art at the Pan-American Exposition." *Crockery and Glass Journal* 53 (1901): 14–18.

———. "The Palissy of Biloxi." *Illustrated Buffalo Express*, 12 March 1899, 4.

Kipnis, Ira. *The American Socialist Movement, 1897–1912*. New York: Greenwood Press Publishers, 1968.

Knott, Eileen. "George Ohr: Art Potter, Mud Dauber, Mad Hatter." Essay for show at Montgomery Museum of Fine Art, March 7–April 19, 1992.

Koplos, Janet. "A Thoroughly Modern Potter: George Ohr in Retrospect." *New Art Examiner* 17, no. 5 (1990): 32–34.

Kris, Ernst, and Otto Kurz. *Legend, Myth, and Magic in the Image of the Artist: A Historical Experiment*. New Haven: Yale University Press, 1979.

Kristeva, Julia. *Powers of Horror: An Essay on Abjection*. New York: Columbia University Press, 1982.

Leach, William. *Land of Desire: Merchants, Power, and the Rise of a New American Culture*. New York: Pantheon Books, 1993.

Lears, Jackson. *Fables of Abundance: A Cultural History of Advertising in America*. New York: Basic Books, 1994.

Leonard, John William, ed. *Who's Who in America: A Biographical Dictionary of Notable Men and Women of the United States, 1903–1905*. Chicago: Marquis and Company Publishers, 1899.

Loewen, James W., and Charles Sallis, eds. *Mississippi: Conflict and Change*. New York: Pantheon Books, 1974.

Lowe, John, ed. *Bridging Southern Cultures: An Interdisciplinary Approach.* Baton Rouge: Louisiana State University Press, 2005.

"Major Wheeler: An Experienced Man." *Buffalo Commercial Advertiser*, 28 May 1900.

Mandell, Richard D. *Paris 1900: The Great World's Fair.* Toronto: University of Toronto Press, 1967.

Marcus, Leonard S. *The American Store Window.* London: Architectural Press Ltd., 1978.

McClary, Ben Harris, ed. *The Lovingood Papers.* Knoxville: University of Tennessee Press, 1965.

McDonald, Alexander. "Bellamy, Morris, and the Great Victorian Debate." In *Socialism and the Literary Artistry of William Morris*, edited by Florence S. Boos and Carole G. Silver, 74–87. Columbia: University of Missouri Press, 1990.

McLeod, Della Campbell. "The Potter, Poet, and Philosopher: One of the Characters of the Coast." *Memphis Commercial Appeal*, 27 June 1909, front page.

McMullen, Roy. *A Biography of J. A. M Whistler: Victorian Outsider.* New York: E. P. Dutton & Co., 1973.

Messer-Kruse, Timothy. *1848–1876, The Yankee International: Marxism and the American Reform Tradition.* Chapel Hill: University of North Carolina Press, 1998.

Miller, Naomi. *Heavenly Caves: Reflections on the Garden Grotto.* New York: George Braziller, 1982.

"Mississippi Trace." *Studio Potter* 10, no. 2 (1981): 65–83.

Mohr, Richard. "Don Pilcher: Rascal Ware with Georgette Ore." *Journal of the American Art Pottery Association* 25, no. 3 (2009): 21.

———. "George Ohr, Begging, Badgering, and Batting 500: The Letters Part I." *Journal of the American Art Pottery Association* 16, no. 6 (2000): 16–19.

———. "Mudpies for Keeps and Usefulness: George Ohr the Letters Part III." *Journal of the American Art Pottery Association* 17, no. 2 (2001): 12–15.

———. *Pottery, Politics, Art: George Ohr and the Brothers Kirkpatrick.* Urbana: University of Illinois Press, 2003.

———. "Serial Potter Arrested in Biloxi: George Ohr, the Letters Part II." *Journal of the American Art Pottery Association* 17, no. 1 (2001): 8–11.

Mott, Frank Luther. *A History of American Magazines.* Vol. 3. Cambridge, MA: Harvard University Press, 1967.

Mumford, Lewis. *The Brown Decades: A Study of the Arts in America, 1865–1895.* 1931. Reprint, New York: Dover Publications, 1971.

Nelson, Marion John. "Art Nouveau in American Ceramics." *Art Quarterly* 4 (1964): 441–59

Nettles, Brian. "The New Ohr-O'Keefe Museum of Art." *Ceramics Monthly* 49, no. 10 (2001): 22–24.

"Northern Veteran's Views." *Biloxi Herald*, 25 February 1888, 5.

"Northern Visitors," *Biloxi Herald*, 15 February 1890, 4.

Official Catalogue of the Tennessee Centennial International Exposition, Nashville, Tennessee. Nashville: Burch, Hinton & Co., 1897.

Official Catalogue of the Trans-Mississippi and International Exposition. Omaha: Klopp & Bartlett Co., 1898.

Official Catalogue of the United States Exhibit at the Paris Universal Exposition, 1889. Paris: C. Noblet et fils, 1889.

Official Catalogue to the Lewis and Clark Exposition and American Pacific Exposition and Oriental Fair. Illustrations by H. B. Hardt. Portland, OR: Albert Hess & Co. Publishers, 1905.

Ohr, George. "Biloxi Heard From: Geo. E. Ohr Thinks He Is the 'Missing Lynx.'" *Crockery and Glass Journal* 53 (1901): n.p.

———. "Geo. E. Ohr at Out-of-Law Commission Sale." *Biloxi Daily Herald*, 7 September 1909, 4.

———. "Letter & Answer No. 2." Journal unknown. 1903. Loose pages in the Ohr archives at the Biloxi Public Library.

———. "Some Facts in the History of a Unique Personality." *Crockery and Glass Journal* 54 (1901): 1–2

"Ohr Fined for Striking Chancery Clerk Hewes." *Biloxi Daily Herald*, 7 September 1909, 2.

Ormond, Suzanne, and Mary E. Irvine, *Louisiana's Art Nouveau: The Crafts of the Newcomb Style*. Gretna, LA: Pelican Publishing Company, 1976.

Pennsylvania at the Cotton States and International Exposition, Atlanta, Georgia. Harrisburg: Clarence M. Busch, state printer of PA, 1897.

Perrone, Jeff. "Entrées: Diaretics: Entreaties: Bowing (Wowing) Out." *Arts Magazine* 59 (1985): 78–83.

———. "Madness, Sex, Exhaustion." *Artforum International* 28 (1990): 95–99.

The Philistine 20, no. 1 (1904); 15, no. 6 (1902); 14, no. 6 (1902).

Poesch, Jessie. *The Art of the Old South: Painting, Sculpture, Architecture, and the Products of Craftsmen, 1560–1860*. New York: Alfred A. Knopf, 1983.

———. *Newcomb Pottery: An Enterprise for Southern Women, 1895–1940*. Exton, PA: Schiffer Publishing, 1984.

Polk, Noel. *Outside the Southern Myth*. Jackson: University Press of Mississippi, 1997.

Pollock, Griselda, and Rozsika Parker. *Old Mistresses: Women, Art, and Ideology*. New York: Pantheon Books, 1981.

Porte, Joel. *Consciousness and Culture: Emerson and Thoreau Reviewed*. New Haven, CT: Yale University Press, 2004.

"Pottery Wizard Dies in Biloxi." *Biloxi Daily Herald*, 8 April 1918, 1.

Powell, Murella Herbert. Interview with James Carpenter. 11 September 2001. Powell conducted this interview for and at the Ohr-O'Keefe Museum of Art.

Quint, Howard H. *The Forging of American Socialism: Origins of the Modern Movement*. Columbia: University of South Carolina Press, 1953.

Rachels, David, ed. *Augustus Baldwin Longstreet's Georgia Scenes Completed*. Athens: University of Georgia Press, 1998.

Rago, David. Personal interview, 5 March 2006.

Ramsay, John. *American Potters and Pottery*. Clinton, MA; Colonial Press, 1939.

Rawson, Philip. *Ceramics*. London: Oxford University Press, 1971.

Reed, John Shelton. *The Enduring South*. Lexington, MA; Lexington Books, 1972.

Riley, Franklin L., ed. *Publications of the Mississippi Historical Society*. Vol. 6. Oxford, MI: Harrisburg Publishing Co., 1902.

Rose, Sumner W. "Gone but Should Not Be Forgotten." *Biloxi Daily Herald* 24, no. 3 (August 19, 1921), 2.

Rugoff, Milton. *America's Gilded Age: Intimate Portraits from an Era of Extravagance and Change, 1850–1890*. New York: Henry Holt and Company, 1989.

Ruskin, John. *The Stones of Venice*. Boston: D. Estes Publishers, 1851.

———. *The Two Paths*. New York: J. Wiley Publishers, 1859.

Rydell, Robert W. *All the World's a Fair: Visions of Empire at American International Expositions, 1876–1916*. Chicago: University of Chicago Press, 1984.

Saint, Andrew. *The Image of the Architect*. New Haven, CT: Yale University Press, 1983.

Saxon, Lyle. "Pottery Specimens Intrigue Admirers of the Ceramic Art at Biloxi: Wonderful Craftsmanship Shown by Biloxi Potter." *New Orleans Times-Picayune*, 1 October 1922, 5.

Schjeldahl, Peter. "Ceramics and Americanness." *American Ceramics* 11, no. 2 (1994): 40–43.

Sheerer, Mary. "Newcomb Pottery." *Keramic Studio* 1 (1899): 151–54.

Shrock, Joel. *The Gilded Age: American Popular Culture through History*. Westport, CT: Greenwood Press, 2004.

Sielwiesiuk, Valenty. "George Ohr and *The Wonderful Wheel*." *Arts and Crafts Quarterly* 3, no. 2 (1994): 12–13.

Skates, John Ray. *Mississippi: A Bicentennial History*. New York: W. W. Norton & Company, 1979.

Skelly, Heather. "Honoring the Mad Potter of Biloxi." *Crafts Report* 27, no. 301 (2001): 21–22.

Slivka, Rose Karen Tsujimoto. *The Art of Peter Voulkos*. New York: Kodansha International, Ltd., 1995.

Snodgrass, Judith. *Presenting Japanese Buddhism to the West: Orientalism, Occidentalism, and the Columbian Exposition*. Chapel Hill: University of North Carolina Press, 2003.

Socialism: Questions Most Frequently Asked and Their Answers. Brooklyn, NY: New York Labor News, 1972.

"Some Art Pottery in Buffalo." *Buffalo Express*, 25 December 1898, 123–24.

Sommer, Robin Langley. *Frank Lloyd Wright: American Architect for the Twentieth Century*. New York: Smithmark Publishers, 1993.

Souvenir Booklet of One Hundred Views of the Pan-American Exposition. Buffalo, NY: Robert Allen Reid Publishers, 1901.

Spargo, John. *Early American Pottery and China*. New York: D. Appleton-Century Company, 1926.

Starr, Frederick S. *Southern Comfort: The Garden District of New Orleans, 1800–1900*. Cambridge, MA: MIT Press, 1989.

Sullivan, Charles, and Murella Hebert Powell. *The Mississippi Gulf Coast: Portrait of a People*. Sun Valley, CA: American Historical Press, 1999.

Sweezy, Nancy. *Raised in Clay: The Southern Pottery Tradition*. Washington, DC: Smithsonian Institution Press, 1984.

Thorp, Nigel, ed. *Whistler on Art: Selected Letters and Writings of James McNeill Whistler*. Washington, DC: Smithsonian Institution Press, 1994.

BIBLIOGRAPHY 155

Tillim, Sidney. "George Ohr: Pottery and the Liquefaction of Desire." *American Craft* 50 (1990): 32–39.

Tomsich, John. *A Genteel Endeavor: American Culture and Politics in the Gilded Age.* Stanford: Stanford University Press, 1971.

Twain, Mark. *Life on the Mississippi.* 1875. Reprint, New York: Oxford University Press, 1996.

Twain, Mark, and Charles Dudley Warner. *The Gilded Age: A Tale of To-Day.* Hartford, CT: American Publishing Co., 1903.

Twombly, Robert C. *Louis Sullivan: His Life and Work.* New York: Viking, 1986.

"Up Front—George E. Ohr: Exhibition of 35 Objects at Mill College Art Museum in Oakland California." *Ceramics Monthly* 49, no. 1 (2001): 22–24.

Vivas, Antonio. "George Ohr (1857–1918)." *Ceramica* (Spain) 79 (2001): 32–35.

Walker, Robert. *The Poet and the Gilded Age: Social Themes in Late 19th-Century American Verse.* Philadelphia: University of Pennsylvania Press, 1963.

Watson, Bruce. "The Mad Potter of Biloxi." *Smithsonian* 34, no. 11 (2004): 88–96.

Weedon, George. "Susan Frackelton and the American Arts and Crafts Movement." Master's thesis, University of Wisconsin, 1975.

Weidner, Ruth Irwin. *American Ceramics before 1930: A Bibliography.* Westport, CT: Greenwood Press, 1982.

Whistler, James McNeill. *The Gentle Art of Making Enemies.* New York: Dover Publications, 1967.

White, Bruce A. *Elbert Hubbard's "The Philistine": A Periodical of Protest (1895–1915), a Major American "Little Magazine."* New York: University Press of America, 1989.

White, Ken, and Frank White. *Display and Visual Merchandising.* Westwood, NJ: St. Francis Press, 1996.

Wilde, Oscar. *The Best Known Works of Oscar Wilde.* New York: Blue Ribbon Books, 1927.

Woodmansee, Martha. *The Author, Art, and the Market: Rereading the History of Aesthetic.* New York: Columbia University Press, 1994.

Woodward, Ellsworth. "The Work of American Potters. II. Newcomb Pottery Typical of the South." *Arts and Decorations* 1 (January 1911): 124–25.

Yoskowitz, Robert. "George Ohr: Modernist." *Ceramics: Art and Perception* 36 (1999): 35–38.

Zinn, Howard. *The Southern Mystique.* New York: Alfred A. Knopf, 1964.

Zug, Charles G., III. *Turners and Burners: The Folk Potters of North Carolina.* Chapel Hill: University of North Carolina Press, 1986.

INDEX

Address to the Rich and Poor (Hugo), and the *Coming Nation*, 65

Advertising, trends emerging in Gilded Age, 6, 34–35

Aesthetic Movement, 79

After the Fire (Hecht), 114

Alabama, socialist presidential candidates, 59

Albany, New York, 90

Alcott, Louisa May, 34

Anderson, James, 11

Anderson, Peter, 11

Anderson, Walter, 11

Appeal to Reason, 63–65, plates 29–31. *See also* Ohr, George: and *Appeal to Reason*

Art Interchange, 13, 54

Art Nouveau: and Ohr's use of, 120, 121, 122, 127; and Elihu Vedder, 73; and Ellsworth Woodward, 96

Art pottery (movement): as defined, 89; and Ohr, 87–89, 105–6. *See also* Ohr's pottery: art pottery

Arts and Craft Ideal. *See* Arts and Crafts (Movement)

Arts and Crafts (Movement): as defined, 89; and Elbert Hubbard, 40–41; and William Morris, 67–68; and Ohr, 68–69, 71; in the United States, 67–68

Atlanta Compromise Speech, 25

Atlantic Monthly, 34

Baecher, Anthony, 90–91

Barber, Edwin Atlee: on Ohr, 14; *Pottery and Porcelain of the United States*, 13

Barnum, P. T.: background of, 43; and biological aberrations, 132; as humbug, 43–45; *Struggles and Triumphs*, 44

Barse, Clothilde, 11, 12

Barse, Giacomo, and Ohr, 11–12

Baudelaire, Charles, 82

Baum, Frank: theories on merchandise presentation, 29–30. **Works:** *The Art of Decorating Dry Goods Windows and Interiors*, 29; *The Show Window*, 29; *The Wizard of Oz*, 29

Bay St. Louis, Mississippi, 46

Bellamy, Edward: Bellamy Clubs, 66, 141n26; *Looking Backward*, 65, 66–67; and Nationalist Party, 141n26

Bensel, L. M., 13, 54

Biloxi, Mississippi, 11; economy of, 46, 58; Harrison County, 58–59; as home to *Grander Age*, 61; Northern visitors to, 47; North/South tensions, 47–48; as separate from rest of South, 46, 58–59; tourism, 46–47, 49

Biloxi Brick Company, 63

Biloxi Daily Herald, 5, 28, 46, 47, 54, 56, 57, 61, 63, 89, 99

"Biloxi Heard From." *See* Ohr, George: "Biloxi Heard From"

Biloxi Herald. See Biloxi Daily Herald

"Biloxi Pottery, A," 12

Blasberg, Robert, 146n1; *George Ohr and His Biloxi Pottery*, 114, 135n2

Browning, Robert, 77

Bouguereau, William-Adolphe, 25, 106

Boykin, Sandra, 51

Brick Magazine, 12

Brothel coins. *See* Ohr's pottery: brothel tokens

Buddhism, 31

Buffalo Express, 54. See also *Illustrated Buffalo Express*

Buffalo Inquirer, 17

Burke, E. A., 24

Burned babies. *See* Ohr's pottery: "burned babies"

Burnham, Daniel, 31, 126

Burns, Sara, 35

Card holders. *See* Ohr's pottery: card holders

Carlyle, Thomas, 65, 141n23

Carpenter, James, 3, 5, 27, 113, 114, 131, 135n1, 135n2, 146n1

Cassatt, Mary, 25

Centennial Exposition (New Orleans). *See* World's Industrial and Cotton Centennial Exposition (New Orleans)

Chase, William Merritt, 25

Chelsea Keramic pottery, 89

Chicago Exposition. *See* World's Columbian Exposition (Chicago)

Chicago World's Columbian Exposition. *See* World's Columbian Exposition (Chicago)

Chicago World's Fair. *See* World's Columbian Exposition (Chicago)

Christian Socialist Movement, 66

Cincinnati News, 52

Civil War, 6–7, 54, 59

Clark, Garth, 104, 114

Clay Worker, 12

Clemenceau, Georges, 93

Cleveland, Grover, 102

Coin banks. *See* Ohr's pottery: coin banks

Colcord, Ethelyn, 48

Coming Nation. See Wayland, Julius A.: *Coming Nation*

Commercial Appeal, 54

Commercial display, emerging in Gilded Age, 6

Communism, emerging in Gilded Age, 7

Co-Opolis Clay, 63

Cosmopolitan, 35

Cotton States and International Exposition (Atlanta), 14, 22, 24, 25, 26, plates 12–13

Cox, Kenyon, 106

Cox, Paul, 92

Cox, W. A., 48, 58

Cresswell, Stephen, 59; profile of socialists in Biloxi, 59–60

Crockery and Glass Journal, 14, 16, 18, 29, 54

Dante's *Inferno,* 34

Darwinism, 6

Debs, Eugene, 59, 64

Decadents (artists), 6

Dedham Pottery, 96

Degas, Edgar, 82

Delahanty, Randolph, *Art in the American South,* 99

Desporte, Mr. U., 58

Divine Secrets of the Ya Ya Sisterhood, 49

Dow, Arthur Wesley, on Newcomb Pottery, 99

Dresser, Christopher (Linthorpe Pottery), as influence on Ohr, 91, 124

Dry Goods Economist, 29

Dubuque, 90

Dyer, Charles Lawrence, 47

E. E. Patterson Coal Company, 126

Earle, Mary Tracy, 11–12, 54; *The Wonderful Wheel,* 11, 54

Earle, Parker, 11

Edison, Thomas, 42

Ellison, Robert: and influences on Ohr, 90; and Ohr's metallic glaze pots, 112

Emerson, Ralph Waldo: on beauty, 77, 79; and Gilded Age spirituality, 6; on individuality, 83; on Labor, 70–71. **Works:** *Essays,* 34; "Self Reliance," 70; "The Transcendentalist," 70

Engels, Friedrich: and *Coming Nation,* 65; socialism defined, 65, 66

Fairhope, Alabama, 141n16
Faulkner, William, 49
Feces creamers. *See* Ohr's pottery: feces creamers
Fee Jee mermaid, 132
Findling, John, 24
Fitzgerald, Edward, *Rubáiyát of Omar Khayyám,* 72–76, 83–84
Flush Times of Alabama and Mississippi, The (Baldwin), 52
Folk pottery: as defined, 88–89; and Ohr, 118–19, 123
Frackelton, Susan, 3; collaboration with Ohr, 14, 90, 136n9, plates 7–9; description of Ohr, 14; description of Ohr's pottery, 14; and use of snakes, 109
French Impressionism, 106

Gates Pottery, 88
Gehring, Josephine. *See* Ohr, Josephine (Josie)
George, Henry, and single tax, 65, 141n16. *See also* Fairhope, Alabama
Georgia, 59
Georgia Scenes (Longstreet), 52
Gérôme, Jean-Léon, 25, 106
Gilded Age: as context for Ohr, 6–7; emerging advertising trends, 28–31, 34–35; faith, 40; innovations as benefitting the North, 44–45; marketing, 45
Gold Democrat Party, 59
Goncourt, Edmond de, 82. *See also* Huysmans, J. K.: *Against the Grain*
Grander Age, The. See Rose, Sumner
Green Back Party, 59
Grueby Pottery, 16, 88, 96

Haig, Thomas, 90
Harper's, 34
Harris, Neil, 43
Harrison County. *See* Biloxi, Mississippi
Hassam, Childe, 25
Hecht, Eugene, 4, 38; and dating of Ohr's pots, 115; and importance of Ohr's 1894 studio fire, 114; and lidless Ohr pots, 117;

and Ohr's connection to Pison Pottery, 90; and Ohr's metallic glaze vessels, 112; and re-glazing of Ohr's pots, 113
Heth, Joice, as P. T. Barnum stunt, 43
Hewes, F. S., 56
Ho-o-den (Phoenix Temple), 31, plate 21
Howells, William Dean, and preface to Huysmans's writings, 82
Hubbard, Elbert: advertising methods of, 41–43, 45; appearance of, 42–43, plate 25; biography of, 39–40; and labor, 68–69; and quote linking him to Ohr, 33–34; Roycroft Community, 33, 39–41, 55. **Works:** *Fra,* 40; *Little Journeys,* 40; *The Philistine,* 39, 40, 41, 42, 45, 73, 93. *See also* Ohr, George: and the *Philistine*
Huckleberry Finn: and *Life on the Mississippi,* 53; as southern character, 49
Humbug, as method of promotion, 43–45
Hutson, Ethel: and description of Ohr's pottery, 76–77; "Quaint Biloxi Pottery," 54; and quote linking Ohr to Whistler, Hubbard and Barnum, 33–34, 35, 43, 45
Huysmans, J. K.: and the Aesthetic Movement, 79; *Against the Grain (Á Rebours),* 82–83; and decadents, 6; and Degas, 82; and destruction, 82–83; and the grotesque, 83; and prevalence in U.S., 82; and spirituality, 83–84; and Oscar Wilde, 80

Illustrated Buffalo Express, 14, 15, 18
Impressionism, 25
Industrial arts, 92, 94
Industrial Revolution, 35
International Cotton Exposition (Atlanta). *See* Cotton States and International Exposition
Irvine, Sadie, 97, plate 41

Japanese pottery, and Ohr's pottery, 124
Jefferson, Joe, 55
Jervis, William Percival: *Encyclopedia of Ceramics,* 13; and William King, 15; and review of Ohr, 13

Johns, Jasper, and Ohr's pottery in his paintings, 3
Josephus, 34

Kelmscott Press, 40
Khayyám, Omar, 72. *See also* Ohr, George: and Omar Khayyám; Fitzgerald, Edward: *Rubáiyát of Omar Khayyám*
"Killed babies." *See* Ohr's pottery: "killed babies"
King, Grace, 97
King, William: articles about Ohr, 14–18; background of, 15; description of Ohr's pottery, 15–16; and Ohr as "second Palissy," 91; and promoting Ohr, 15–18. **Works:** "Ceramic Art at the Pan American," 16, 18; "The Palissy of Biloxi," 15, 54–55
Kirkpatrick Brothers: and Ohr, 90; and pig flasks, 102; and snake motifs, 109–10
Kovel, Ralph and Terry, 145n3, 145n8, 146n1
Kristeva, Julia, abjection, 78–79

Ladies Home Journal, 35
Louisiana Purchase Exposition (St. Louis), 22, 23
Louisville and Nashville Railroad, 46
Lusitania, 39

Mallarme, Stéphane, 82
Marx, Karl: and *Coming Nation*, 65; and William Morris, 67; socialism defined, 65, 66
Mass production, emerging in Gilded Age, 6
Massachusetts College of Art. *See* Massachusetts Normal Art School
Massachusetts Normal Art School: and Newcomb Pottery, 93; and Gertrude Roberts Smith, 94; and Southern regions, 95–96; and William and Ellsworth Woodward, 94
McClure's, 35
McIntoch, William, 73

McLeod, Della Campbell: "A Biloxi Pottery," 12; description of Ohr and pottery, 12, 122, 124–25; description of Ohr's studio, 6
Medici, Catherine de, and Palissy, 91
Metropolitan Museum of Art, and Ohr collection, 3
Meyer, Joseph: and family, 144n8; and folk pottery, 88; and Newcomb Pottery, 92; and New Orleans Art Pottery, 92, plate 40; and Ohr, 4–5, 92, 93; as worldly, 93
Midnight in the Garden of Good and Evil (Berendt), 49
Midway: and Ohr, 25–28; significance of, 25–26
Mike Fink, as representative of southern humor, 52–53
Milwaukee, Wisconsin, 90
Mississippi Socialist Party of America, 62
Mobile, Alabama, and the Louisville and Nashville Railroad, 46
Mohr, Richard: and abjection, 77–78; and Ohr's metallic glaze pots, 112; and Ohr's trinkets, 104; *Pottery, Politics, Art: George Ohr and the Brothers Kirkpatrick*, 77
Moreau, Gustav, 82
Morehead, F. C., 24
Morris, William: and the Arts and Crafts Movement, 67, 68, 69; and Ralph Waldo Emerson, 70–71; and Elbert Hubbard, 39–41, 68–69; and the Industrial Revolution, 67; *News From Nowhere*, 66–67; and socialism, 67; and the value of labor, 67–68, 69; and Ellsworth Woodward, 94
Munsey's, 35

New Orleans, Louisiana: as cultural center, 97–98, 99, 100; and culture of, 49; and impact on Ohr, 100; and Louisville and Nashville Railroad, 46; and Joseph Meyer, 4–5; and New Orleans Art Pottery, 92, 94; and Ohr seeking

medical treatment, 6; and Ohr's residence in, 92, 143n6; and Ohr's sojourn, 90; and Storyville, 104. *See also* New Orleans Art Pottery; Storyville

New Orleans Art Pottery (NOAP): history of, 92, 94; and Ohr, 92; and William and Ellsworth Woodward, 93, 143n7

New Orleans Cotton Centennial Exposition. *See* World's Industrial and Cotton Centennial Exposition

New Orleans Picayune, 52

New South (promotional agenda), 24

New York, and New Orleans, 98–99

Newcomb College, 33, 92, 94, 97

Newcomb Pottery: as contemporary to Ohr, 3, 100; and Arthur Wesley Dow, 99; and New Orleans Art Pottery, 92; Ohr's history with, 92, 95; and southern art, 95, 99, 122, plate 41; and start of, 92; and William and Ellsworth Woodward, 92, 93–96, 99

Nielsen, Jens, 62

Normal Art School. *See* Massachusetts Normal Art School

North/South tensions and differences, 6–7, 16, 24–25, 30, 45, 47–49, 50, 52, 54–55, 132–33

Northern artists, 48

Northern manufacturing (of pottery), 88

Ocean Springs, Mississippi, 11, 46

Ohr, George: advertising for work, 87; analysis of language, 51; and *Appeal to Reason*, 63–65, 69, plates 29–31; as Art Potter, 88–89, 100, 120, plate 37; articles by, 18; as artist, 134; and P. T. Barnum, 43–45; "Biloxi Heard From," 18; birth and death dates of children, 5, 20, 135n6; as bizarre, 132; as boundary crosser, 133–34; construction of physical appearance, 37, 39; and Co-Opolis Clay, 63; current critical perception of, 4, 7, 130–31, 133, 135n2; death of, 5–6; descriptions of, 12, 13, 14, 16, 30–31, 37, 61, 124–25; as "dumb southerner," 44,

55; evidence of socialist sympathies, 61, 62, 63, 64, plate 28; exaggerations of, 53; and Fairhope, Alabama, 141n16; fates of children, 5; as folk potter, 88–89; on glazes, 110; handbill of, 38, 140n15; and Elbert Hubbard, 33–34, 39, 40, 42–43, 45; as humbug, 43–45; ideas on Art, 38–39; and J. K. Huysmans, 82, 84; and investigating relationships with contemporaries, 143n3; and jail, 56–57; and Omar Khayyám, 72, 73–76, plate 32; and legal issues, 55–57; magazines involved with, 54–55; modern scholarship on, 3–4; and William Morris, 67–69; naming of children, 135n6; "no two alike" philosophy, 12, 71, 100, 118, 123; obituary of, 5–6, 39; and Bernard Palissy, 91, 126; persona as Southern, 49, 51, 54, 55, 132–33; and the *Philistine*, 39, 40, 42, plate 24; portraits of, 42–43, 92, plates 23, 26–27, 40, 60, 62; promotional strategies of, 13, 37–39, 40–45, 124–25; quotes from, 16–17, 18, 38, 51, 53, 56, 57, 68–69, 71, 90, 110, 114, 125, 128, 132; and racism, 140n20; relationship to Biloxi citizens, 55–57; relationship with family, 55–57; and *Rubáiyát of Omar Khayyám*, 72–76, 83–84; and socialism, 72, 65, 69, 71; socialist traits, 59–61; "Some Facts in the History of a Unique Personality," 4, 18, 90; two year sojourn, 90; on value of labor, 68–69, 70, 71; and James McNeill Whistler, 33–34, 35, 37–39; and Oscar Wilde, 79, 81, 84; and William and Ellsworth Woodward, 92, 95–97, 100; and yellow fever epidemic, 136n2

Ohr, Asa, 5, 20

Ohr, Ella, 5

Ohr, Flo, 20

Ohr, Josephine (Josie), 5, 143n6, plate 62

Ohr, Leo, 3, 143n6

Ohr, Ojo, 3

Ohr's glazes: emphasis of form over glaze, 13–14, 131; importance of, 117; metallic, 111–12, 116, plate 51; and re-glazing,

113; types of, 110–12; unglazed (wares), 112–13, plate 52

Ohr's pottery: as abject, 127, plate 34; and abstract expressionism, 106; as art, 130; and Art Nouveau, 121–22, 127; art pottery, 105–7; and art vs. craft debate, 106–7; author's descriptions of, 19–21; and beauty, 107, 127, 130, 132–33; brothel tokens, 27, 103–4, plate 19; "burned babies," 5, 75, 129; cadogan forms, 107; card holders, 27, 103, plate 18; categories of, 101; "clay babies," 102, 127; coin banks, 27, 101, 103, 109, 126, plates 14–15; critical descriptions of, 12, 13, 14, 15, 16, 27, 76–78, 114, 116, 125, 132; as crossing boundaries, 133–34; and crumpling, 108, 109, 116, 117, plates 1–2; as Dada, 104; and dating, 101, 102, 113, 114–15, 145n2, 145n4; as deconstructions, 123–24; as disfigured, 128, 132–33; as dysfunctional, 106, 107, 133, plates 3, 44, 56; early/derivative, 101–2; and emphasis of form over glaze, 14, 110–11; as experimentation, 124–25, 127; as expressions of nature, 9, 132; feces creamers, 27, 103–4, plate 16; and folk art, 118–20, 126, 127; as folk pottery, 118–19, 123, 130, plate 42; functional wares, 102, 107, plate 43; as Funk, 104; as future art, 3, 4; as grotesque, 130, 132–33; as human, 131–32; influences of, 90–91; inkwells, 126; inscriptions on, 20, 136n2; inspired by ancient Greek pottery, 91, 120–21, 124, 127, plate 38; "killed babies," 5, 75; "live babies," 129; log cabins, 27, 101, 103, 126, plate 15; loving mugs, 103; as marginalized, 132–33; meaning of, 75–76, 77–79, 84, 127, 133–34; "mudbabies," 75, 77; as nineteenth century cultural references, 133–34; the Other, 31, 48; personalized pots, 103; pig flasks, 102, 109; puzzle mugs, 27, 101, 103, plate 17; quantity of, 135n1, 144n1; and ruffling, 108, 109, 124, plate 47; as sculpture, 106, 145n3; as sexual process, 129; signature and

stamps on, 90, 115; social significance of, 118–19; sold during lifetime, 27, 144n1; and surface snakes, 107, 109–10, 145n7, plate 50; and symmetrical perfection, 122–24; teapots, 105, 107, 109, 112, 117–18, 145n4, plates 46, 55; as tourist attractions, 12; trinkets, 101, 103–5, 119; and tubing/lobing, 107, 109, plates 36, 49; and twisting, 107, 108–9, 116, 117, 124, 145n6, plates 1, 4, 48; and value of, 135n1, 145n4; and wall thinness, 116, 124; and working methods, 116–18

Palissy, Bernard, 91, 126, plate 39
Palissy: The Huguenot Potter, 91
Pan-American Exposition (Buffalo), 14, 15, 16, 17, 22, 23, 26, 37
Pascagoula, Mississippi, 46
Pass Christian, Mississippi, 46
Philadelphia Museum of Art, 110
Philistine, The: Ohr's ad in, 39, 40, plate 24. *See also* Hubbard, Elbert: *The Philistine*
Phrenology, 132
Piaget, Violet, 99
Pison Pottery, 90, 102
Pollock, Jackson, 106
Populist Party, 59, 60, 61, 63, 66, 141n26
Portman, Harry, 144n19, plate 42
Post-Impressionism, 132
Prohibition, 59

"Quaint Biloxi Pottery." *See* Hutson, Ethel

Rabelais, François, 93
Reconstruction, 44, 46, 52, 58
Redon, Odilon, 82
Republican Party, 59
Richardson, Edmund, 24
Rip Van Winkle (1859), 55
Robineau, Adelaide, 3
Rockefeller, John D., 42
Rookwood and the Industry of Art (Owen), 89, 143n2
Rookwood Pottery: and Arts and Crafts Ideal, 89; and William King, 15, 16; as

rival/contrast to Ohr, 3, 38, 40, 61, 69, 95, 120, 122
Root, John, 126
Rose, Sumner: background of, 61–63; and Co-Opolis Clay, 63; as friend of Ohr, 61, 93; and the *Grander Age*, 61–62; as politician, 62
Roycroft. *See* Hubbard, Elbert: Roycroft Community
Roycroft, Samuel and Thomas, 39
Rubáiyát of Omar Khayyám. See Fitzgerald, Edward; and Ohr, George: and *Rubáiyát of Omar Khayyám*
Ruskin, John: and William Morris, 67–68; and Newcomb Pottery design, 95; and Ohr, 69; and J. A. Wayland, 65; and James McNeill Whistler, 36

Scribner's, 34
Scroddled, 112
Setebos, 40
Shakespeare, William, 40
Shearwater Pottery, 11
Sheerer, Mary Given, 92
Smith, Gertrude Roberts, 94
Smithsonian Institution: and Ohr's sample of eleven pots, 18–21, 131, plate 10; and Ohr's umbrella stand, 20–21, 127, plate 11
Snodgrass, Judith, 31
Social Darwinism, 132
Socialism: in America, 65–67, 71, 72; and *Appeal to Reason*, 63–65; and Biloxi, 59–62; as emerging in Gilded Age, 6; and Ralph Waldo Emerson, 70–71; and *Grander Age*, 61–62, 63; and *Looking Backward*, 65, 66–67; and Mississippi, 59–61; William Morris, 66, 67; and *News from Nowhere*, 66–67; and Sumner Rose, 61–63; and Henry David Thoreau, 70–71. *See also* Ohr, George: and evidence of socialist sympathies; Ohr, George: and socialism; Ohr, George: socialist traits
Socialist Industrial Union Government, 65

"Some Facts in the History of a Unique Personality." *See* Ohr, George: "Some Facts in the History of a Unique Personality"
South, politics and economy of, 58–61
South Carolina, 59
Southern, as distinct from North, 24–25
Southern art, 98–99
Southern artists, 48
Southern humor, 50–54
Southern Quarterly, 54
Southern type, 48–49
Southerner, as redefined by Civil War, 6
Spacey, Kevin, 49
Spirit of the Times, 52
St. Louis Reveille, 52
Storyville, 104
Studio, Ohr's: descriptions of, 28, 30, 47; fire (1894), 5, 20, 75, 114–15, 129; pagoda design, 5, 31, plate 5; signs adorning, 4, 15, 26, plate 6; visual display trends employed, 28–31
Sullivan, Louis, 31–32
Sung Dynasty pottery, 91, 120, plate 38
Sut Lovingood, language as representative of southern character, 50–51
Sut Lovingood's Yarns (Harris), and southern humor, 50, 52
Symbolism (artistic movement), 25, 73, 107, 132
Symbolists, 6

T'ang Dynasty pottery, 91, plate 38
Tanguay, Eva, 42
Tchoutacabouffa River, 13, 88
Teco Pottery: as art pottery, 89; as rival of Ohr, 3, 61, 69
Thoreau, Henry David: and beauty, 77, 79; and Gilded Age spirituality, 6; and individual purpose, 70–71; and individuality, 83; *Walden*, 70–71
Tom Thumb, 132
Tulane University: and the Decorative Arts League, 92; and its effect on New

Orleans, 97; and William and Ellsworth Woodward, 92, 93
Twain, Mark: and availability in Gilded Age, 34; *Life on the Mississippi*, 53; and southern humor, 49, 53, 54

Universelle Exposition (Paris), 22, 26

Van Briggle Pottery: as Art Nouveau, 121; as art pottery, 89; as rival to Ohr, 40, 61, 69; as sculpture, 121, plate 58
Van Rensselaer, J. T., 64, plates 30–31
Vedder, Elihu, 25, 73
Visual display: Gilded Age trends, 6; Ohr's use of, 28–31
Volkmar Pottery, 16
Voltaire, 93

Wannamaker, John, 28
Warhol, Andy, 2
Washington, Booker T., 25
Washington, George, 41, 43
Watterson, Henry: *Oddities in Southern Life and Character*, 50; and southern humor, 50, 52
Wayland, Julius A.: *Appeal to Reason* (see *Appeal to Reason*); *Coming Nation*, 63, 65; history of, 63–64; relationship to Ohr, 64–65; Ruskin Commonwealth Association, 63
Welty, Eudora, 49
Wheeler, Major A. M., 16, 17, 18, 37, 54
Whistler, James McNeill: and appreciation of J. K. Huysmans, 82; and commodified self, 35–37; *Gentle Art of Making Enemies*, 36; and importance to Gilded Age consumer culture, 33–34, 45; and innovative art, 25, 106; persona of, 36–37, 39, 80; physical appearance of, 37, 42, plate 22; and quote linking him to Ohr, 33, 43
Wilde, Oscar: and appreciation for J. K. Huysmans, 80, 82; as decadent, 6; 1882 lecture tour, 79; 1895 libel suit, 80; and

gay culture, 80; and the grotesque, 80–81; persona of, 42, 81; *Picture of Dorian Gray*, 80–81; and spirituality, 84
Wisconsin School of Design, 14
Wonderful Wheel, The. See Earle, Mary Tracy
Woodward, Ellsworth: and Ethel Hutson, 33; involvement with and philosophy of Newcomb pottery, 93–97; and no-two-alike philosophy, 97, 100; and Ohr, 92; and southern locality, 99
Woodward, William: and Newcomb College, 93; and Newcomb Pottery, 93–94; and Ohr, 92, 96, plate 40
World's Columbian Exposition (Chicago): architectural agenda of, 23, 31; artistic diversity of, 25; Ho-o-den (Phoenix Temple), 31; midway, 26; and Ohr, 14
World's Fairs and Expositions: agenda of, 23–25; and influence on Ohr's pottery, 127; and Ohr's attendance, 5, 22; Ohr's promotional tactics at, 124–25; Ohr's signs and visual display at, 26–28, plates 12–13; Ohr's wares sold at, 27; southern cities as hosts, 137n4; southern displays in, 24
World's Industrial and Cotton Centennial Exposition (New Orleans), 11, 23, 94
Wright, Frank Lloyd, 31

Printed in the United States
by Baker & Taylor Publisher Services